PAINTING SCHOOL

Illustrated by Tanya Emelyanova

Welcome to Painting School!

Painting is a colorful way to create your own world on paper. This book teaches you about the tools and materials you'll need to get started—and it shows you fun ways to play with paint! It's also packed with hundreds of step-by-step projects, from cute animals and yummy food to planes and planets. Check out all the cool subjects below!

Tools & Materials

Ready to set up your painting space?
Lay down some newspaper and gather these important materials!

Paintbrushes
Gather a variety of shapes and sizes! For more on brushes, see page 19.

Paint Palette
This makes a great spot for mixing your paints. A plastic plate works too!

Jars or Cups of Clean Water
You'll need one for adding water to paint and one for rinsing your brushes.

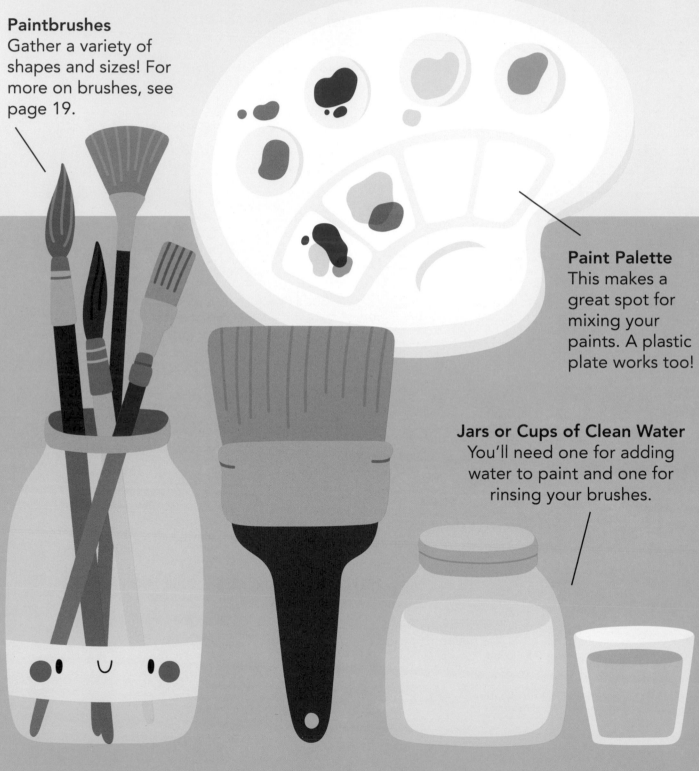

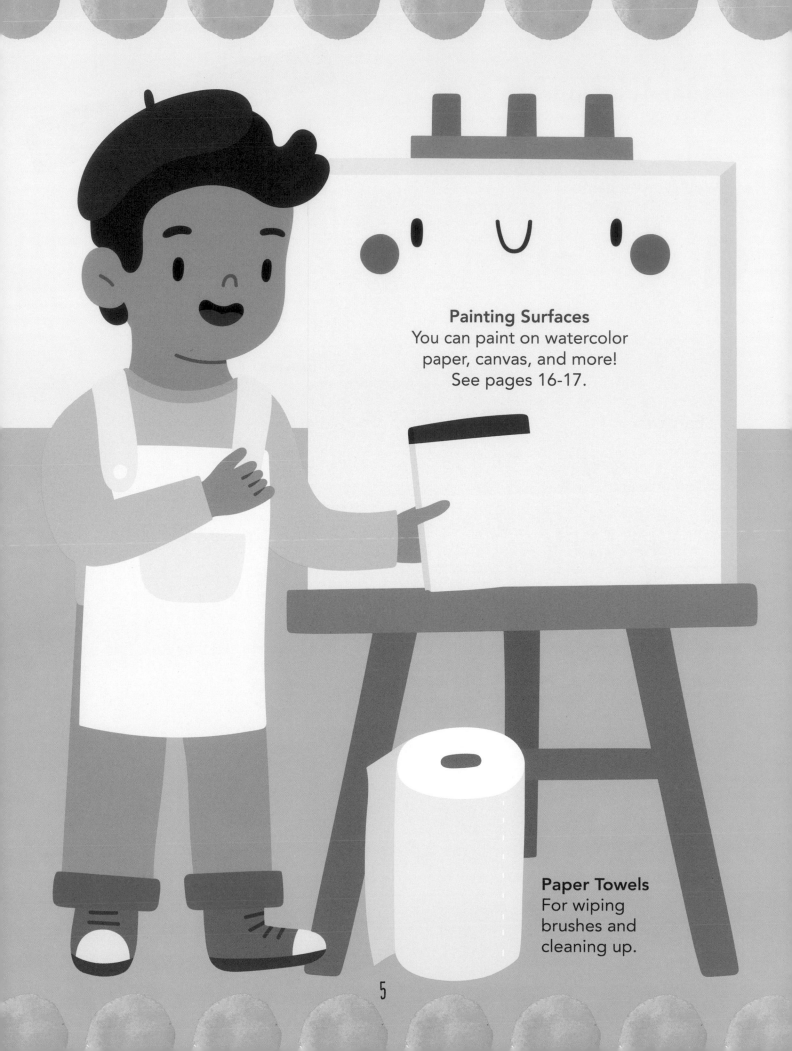

Painting Surfaces
You can paint on watercolor paper, canvas, and more! See pages 16-17.

Paper Towels
For wiping brushes and cleaning up.

5

BEFORE YOU PAINT

Pencils
For creating sketches
before you paint.

Sketchpad

Erasers

Sharpener

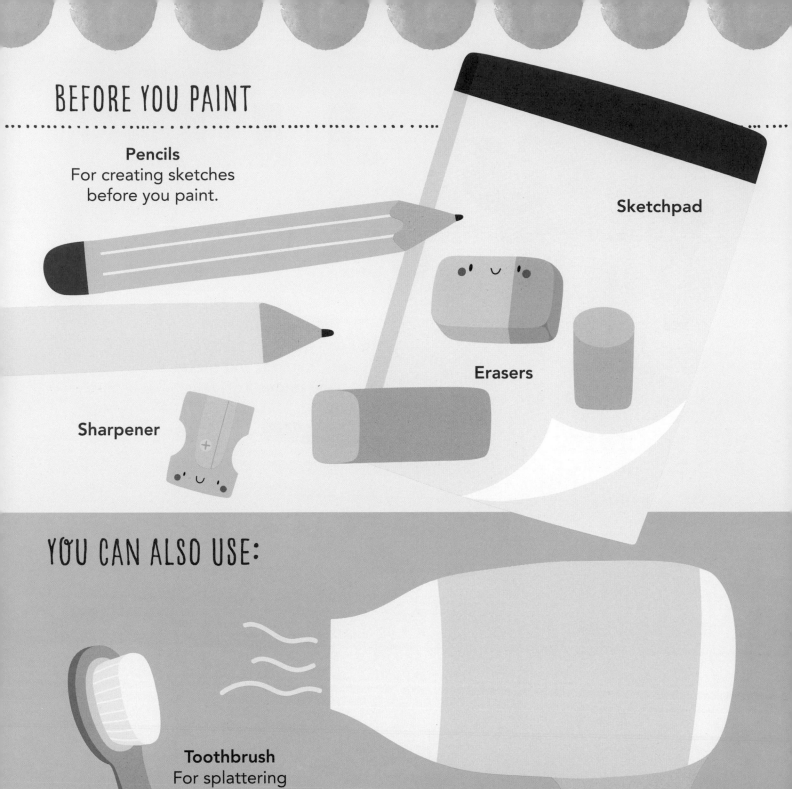

YOU CAN ALSO USE:

Toothbrush
For splattering
paint.

Hairdryer
To help paint
dry faster.

6

ADDING DETAILS

Fine Black Marker and White Gel Pen
For adding fun details.

Colored Pencils
For shading and adding details.

Sponges and Sponge Brushes
For creating cool textures.

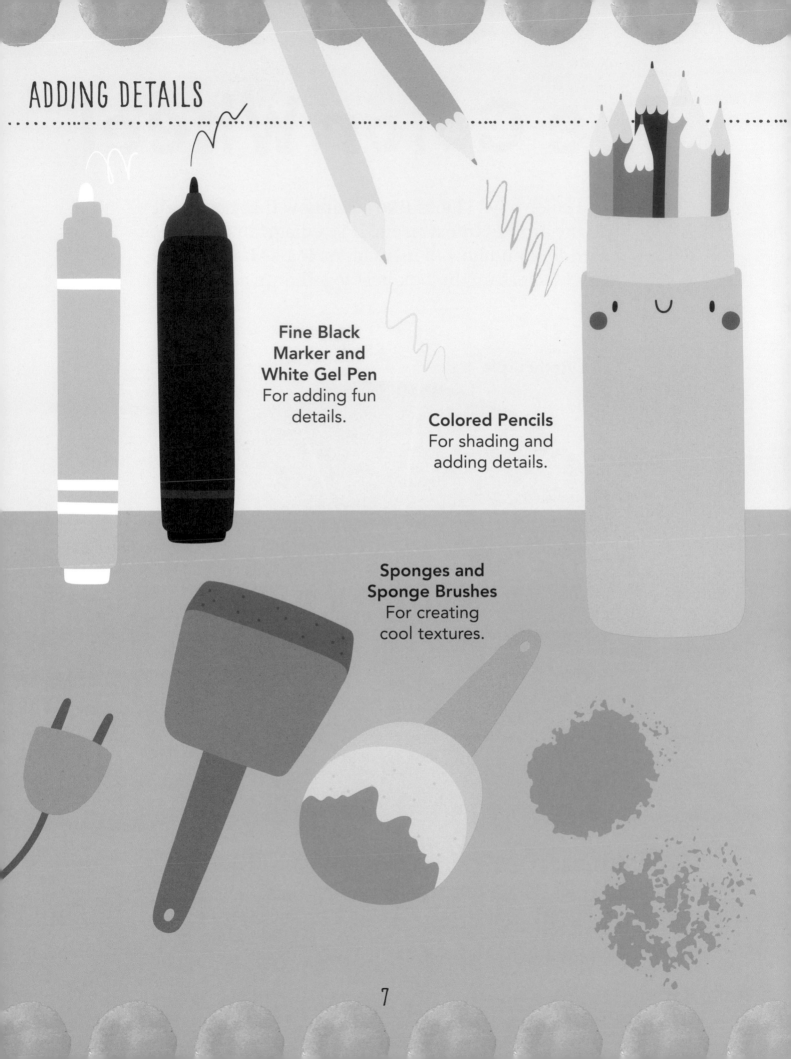

The Color Wheel

The color wheel looks like a rainbow that bends all the way around into a circle! It is a diagram that helps us understand how to mix colors. It also helps us see which colors might look best together in a painting!

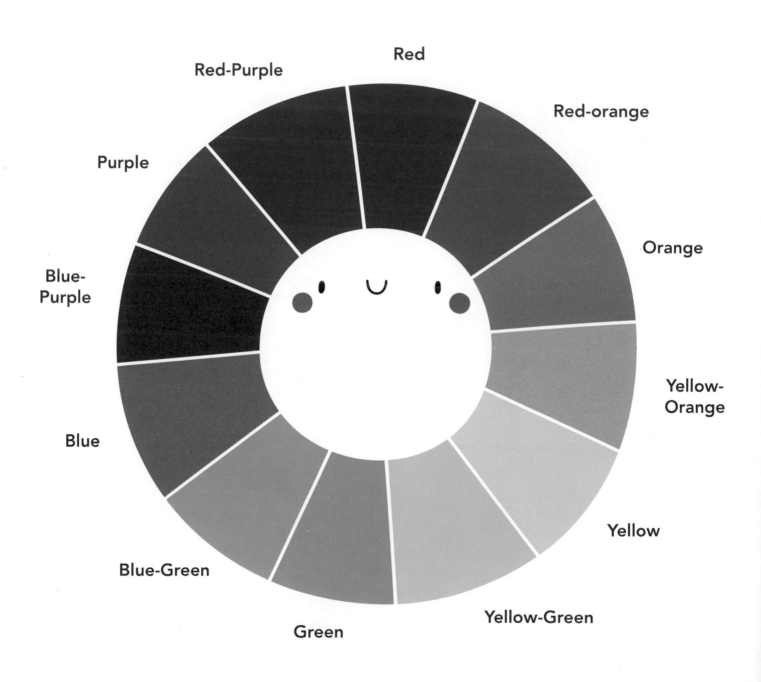

PRIMARY COLORS

There are three primary colors on the color wheel: red, yellow, and blue. These colors cannot be made by mixing other colors. But you can use primary colors to mix just about any other color you want!

SECONDARY COLORS

There are also three secondary colors on the color wheel: orange, purple, and green. You can make these colors by mixing two of the primary colors.

COMPLEMENTARY COLORS

Complementary colors sit on opposite sides of the wheel. Complementary colors make each other look brighter and more exciting when they're next to each other in a painting!

Purple & Yellow

Orange & Blue

Red & Green

MIXING COLORS

One of the most exciting things about painting is being able to mix new colors. You can mix your own secondary colors (orange, green, and purple) by mixing two primaries.

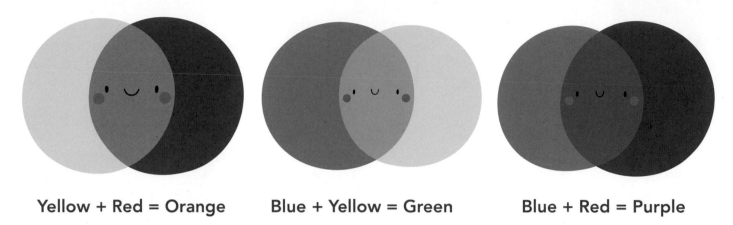

Yellow + Red = Orange **Blue + Yellow = Green** **Blue + Red = Purple**

When you mix a primary color with a secondary color, you create a tertiary color. Tertiary (ter-she-air-ee) colors are yellow-orange, red-orange, red-purple, blue-purple, blue-green, and yellow-green.

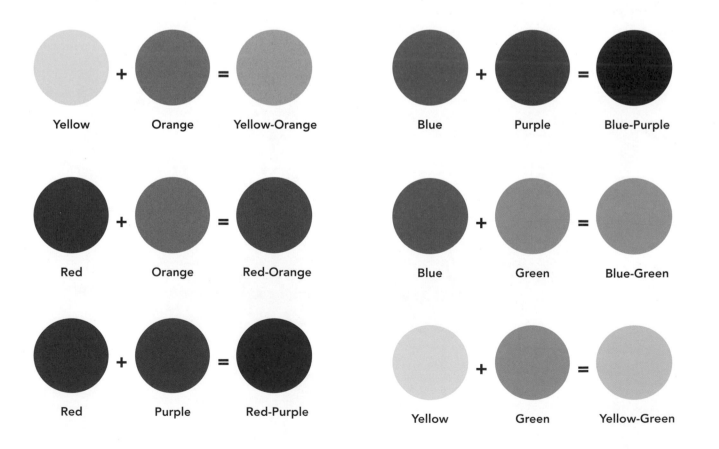

Yellow + Orange = Yellow-Orange Blue + Purple = Blue-Purple

Red + Orange = Red-Orange Blue + Green = Blue-Green

Red + Purple = Red-Purple Yellow + Green = Yellow-Green

COLOR & VALUE

Value is the lightness or darkness of a color. Adding white to a paint color creates a "tint" of the color. Tints are light and soft.

Red + White = Pink

Green + White = Mint Green

Purple + White = Lavender

Orange + White = Peach

Blue + White = Sky Blue

Yellow + White = Pale Yellow

Adding black to a paint color creates a "shade" of the color. Shades are deep and powerful.

Green + Black = Forest Green

Red + Black = Burgundy

Orange + Black = Rust

Purple + Black = Plum

Yellow + Black = Goldenrod

Blue + Black = Navy

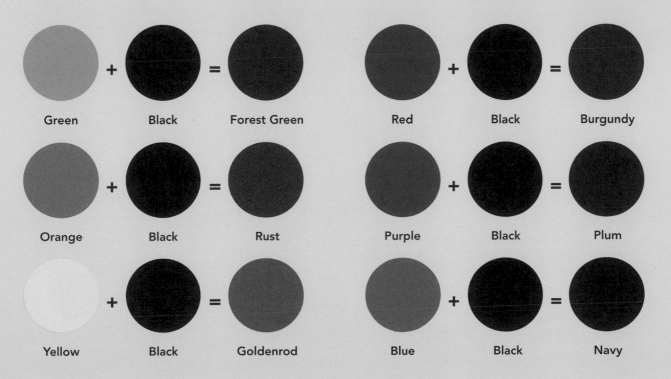

Learning About Paint

WATERCOLOR

Watercolor is a popular type of paint. Just add water to create beautiful, wet washes of color! It's best to use this paint on watercolor paper, which is made so the paper doesn't wrinkle and the paint doesn't sink in too quickly.

Some watercolors come in tubes of moist paint. Squeeze out a dot onto a palette or plastic plate, and then add water!

Watercolors also come in pots of dried paint. Stroke over a pot with a wet brush to activate the paint!

ACRYLIC & TEMPERA

Unlike watercolor, acrylic and tempera are opaque paints. This means that you can paint light colors over dark colors, and the dark colors won't show through! These types of paints work well for the projects in this book. They come in tubes, squeeze bottles, and pots with lids.

Acrylic is very thick, heavy paint that you can thin with water. You can clean your brushes and palettes using soap and warm water. But watch out—acrylic stains clothing! It is also waterproof once dry.

Tempera (also called "poster paint") is thick and fluffy. It is harder to paint details with tempera, and some tempera paints aren't as opaque as acrylics. But many types of tempera are easy to clean up. Some are even washable!

WATERCOLOR vs. ACRYLIC

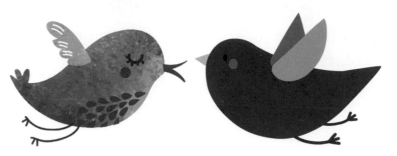

Watercolor paint on paper is a bit see-through. You can make colors lighter by adding more water to the paint.

Acrylic is great for painting colors on top of each other. You can even paint light colors over dried dark colors!

WATERCOLOR

Adding Water
The more water you add to watercolor paint, the more the paper shows through, and the lighter the color will be.

Smooth Painting
Mix watercolor paint with a little bit of water. Use a paintbrush to stroke across the paper, overlapping the strokes to create an even color.

Dark to Light
Mix a little bit of water with watercolor paint, and start with dark strokes. Dip the brush in water as you add more strokes, making the paint lighter and lighter as you go.

Blending
Paint with one color at a time, rinsing your brush each time you pick a new color. The colors will blend smoothly together.

ACRYLIC

Thick or Thin
You can paint with thick acrylic paint or thin it with water. When acrylic paint is thin, it feels like watercolor paint.

Smooth Painting
Mix a little bit of water with paint. Use a large paintbrush to evenly paint the paper.

Blending
Paint with one color first. Then dip your brush in a second color and overlap the strokes. Here, red and blue make dark purple.

ONE MORE THING ABOUT WATERCOLOR!

The more colors and layers you paint over watercolor, the darker it gets. For this reason, watercolor makes great backgrounds—but it's not the best choice for painting light colors over dark colors. You can use acrylic or tempera for that!

What to Paint On

Watercolor and tempera paints work best on thick art paper, such as watercolor paper or mixed media paper. You can use acrylic on paper too, but it also works well on many other surfaces, including canvas, rock, wood, and even fabric!

An easel props up your painting surface so you can paint at an angle. Acrylics work best with easels! Watercolor is too wet and can drip down your painting.

Canvas is a type of fabric that is stretched over a wooden frame. It has a grooved surface that gives your paint a cool texture!

Acrylic paint also works on wood. You can paint scenes on wooden boards, and you can even decorate picture frames!

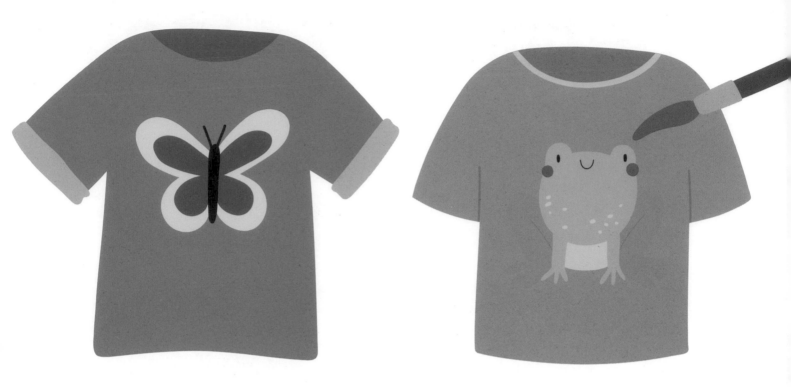

You can wear your own artwork by painting on T-shirts!
Special acrylics designed for fabric will stay flexible when dry.

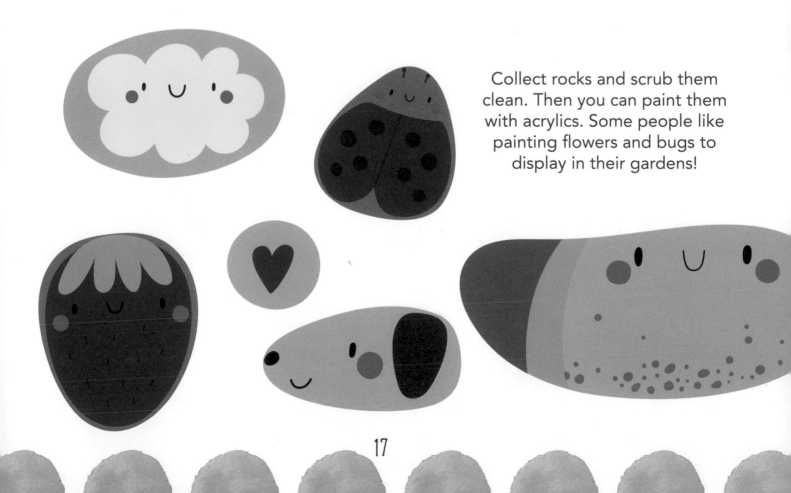

Collect rocks and scrub them clean. Then you can paint them with acrylics. Some people like painting flowers and bugs to display in their gardens!

Getting Started

This book is filled with tons of things to paint, but first make sure you are comfortable working with your paint and brushes. The more you practice, the more confident you will be when creating each painting.

PRACTICE MIXING COLORS

Start with the three primary colors—red, yellow, and blue—and then practice mixing them to create your own color wheel like on page 8.

Experiment with thickness and texture and paint a full page of circles in a lot of different colors.

PAINTING LINES, DOTS, STROKES & WAVES

Brushes come in many different sizes and shapes. Practice
painting lines from thick to thin. Try painting wavy or zigzag lines.
Paint dots of different sizes. These will all be helpful when painting details!

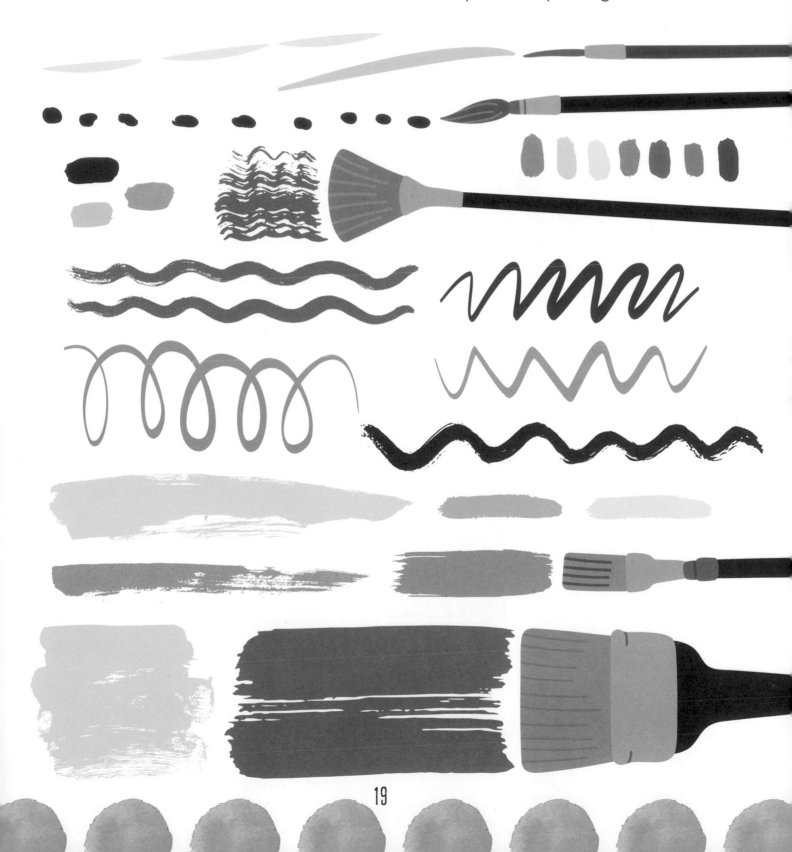

Seeing Shapes

Before you begin to to paint, look for the shapes
and lines that make up what you're trying to paint.

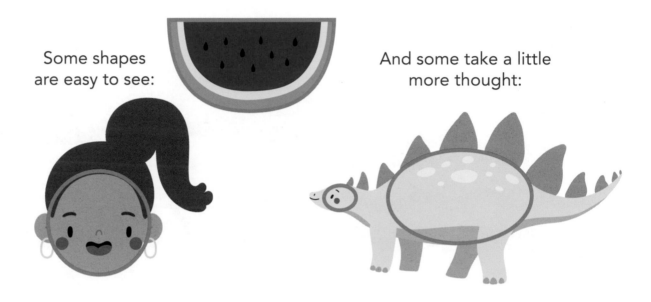

Some shapes
are easy to see:

And some take a little
more thought:

These are some shapes you should get to know
so you can recognize them easily when you're painting!

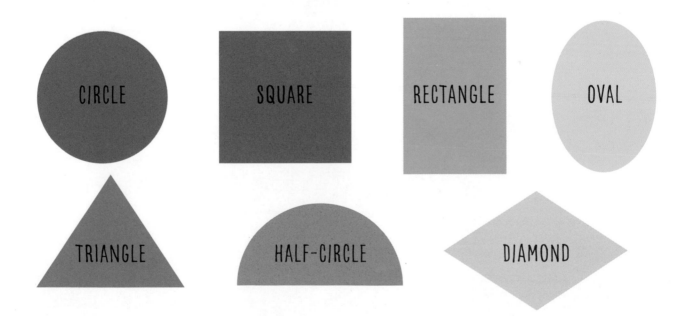

CIRCLE

SQUARE

RECTANGLE

OVAL

TRIANGLE

HALF-CIRCLE

DIAMOND

Sometimes you'll see other shapes too, like these:

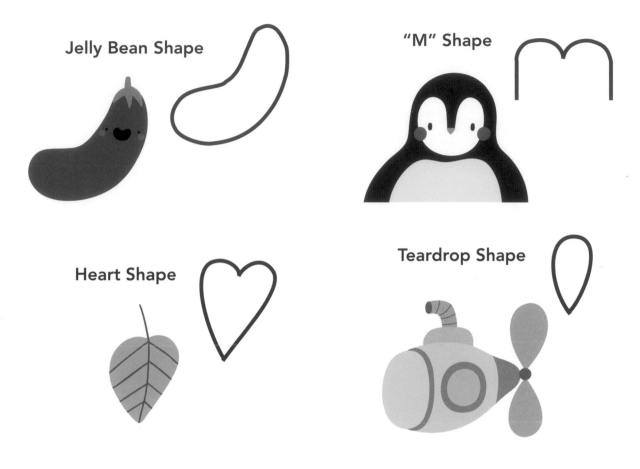

Jelly Bean Shape

"M" Shape

Heart Shape

Teardrop Shape

You'll also see a variety of lines and edges!

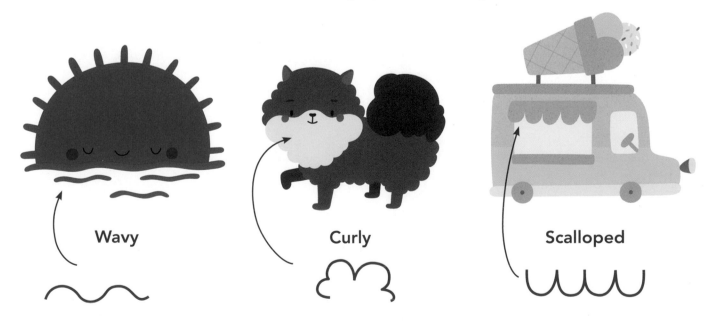

Wavy

Curly

Scalloped

How to Use This Book

Wear old clothes or an apron. Set up your paints, painting surface, and brushes, and open the book to the project you'd like to follow.

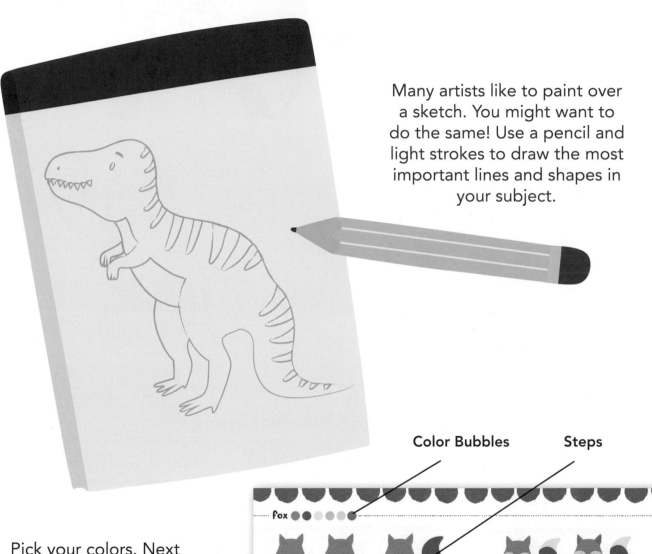

Many artists like to paint over a sketch. You might want to do the same! Use a pencil and light strokes to draw the most important lines and shapes in your subject.

Color Bubbles **Steps**

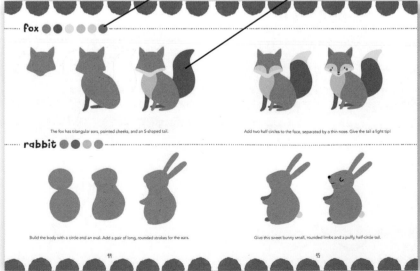

fox

The fox has triangular ears, pointed cheeks, and an S-shaped tail.

Add two half circles to the face, separated by a thin nose. Give the tail a light tip!

rabbit

Build the body with a circle and an oval. Add a pair of long, rounded strokes for the ears.

Give this sweet bunny small, rounded limbs and a puffy, half-circle tail.

44 45

Pick your colors. Next to the project name, you'll see a row of color bubbles. These show you what paint colors we used in each project. But remember, you can use any colors you want!

The color bubbles for each project are just suggestions. Do you want to to paint a purple cat? A blue apple? That's fine too! Take a look at the paintings below. How does each one make you feel compared to the others?

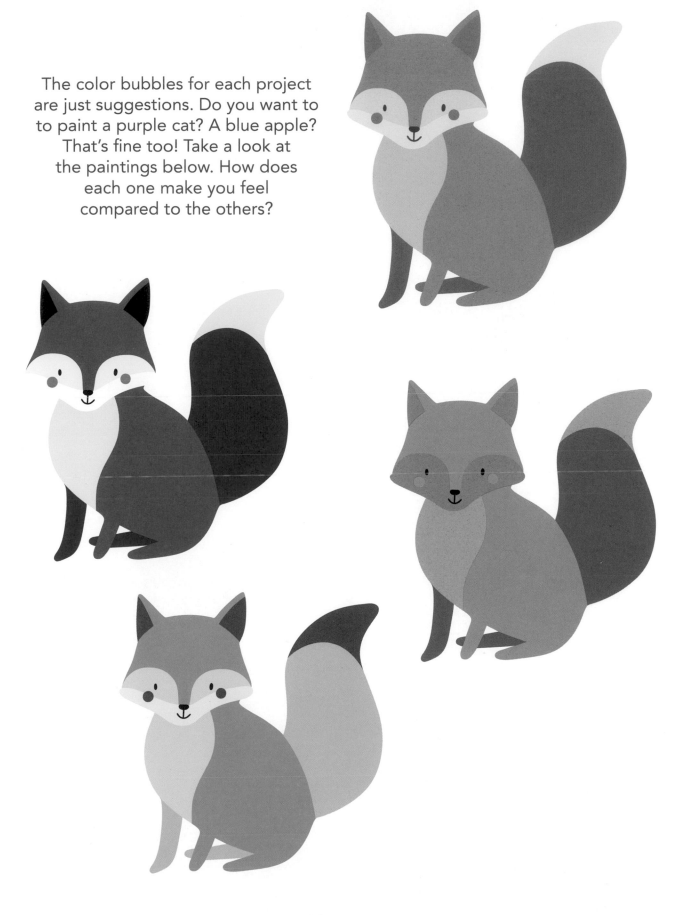

23

FOLLOWING THE STEPS

Now follow the steps in order, and watch your paintings come to life!

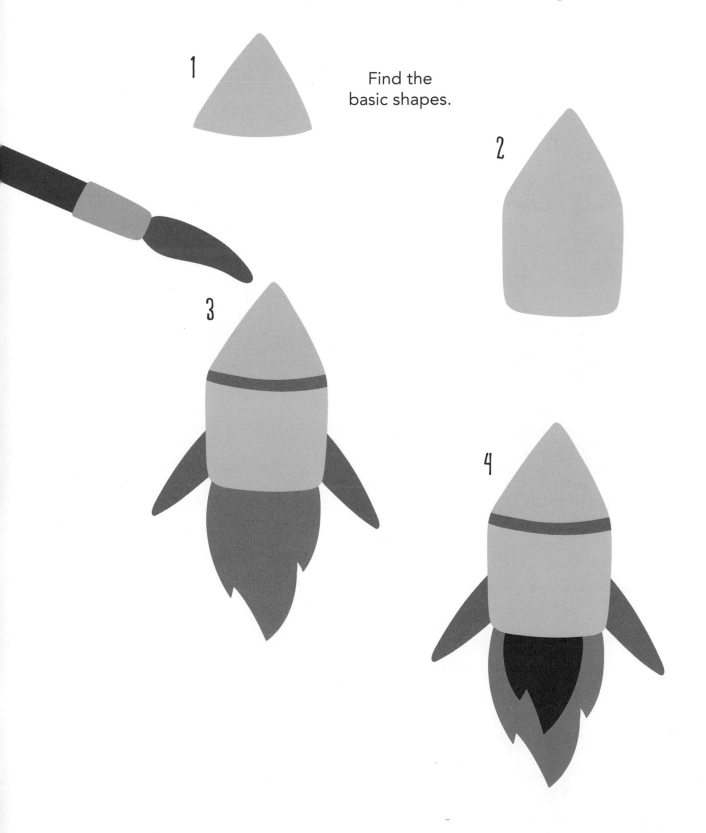

1

Find the
basic shapes.

2

3

4

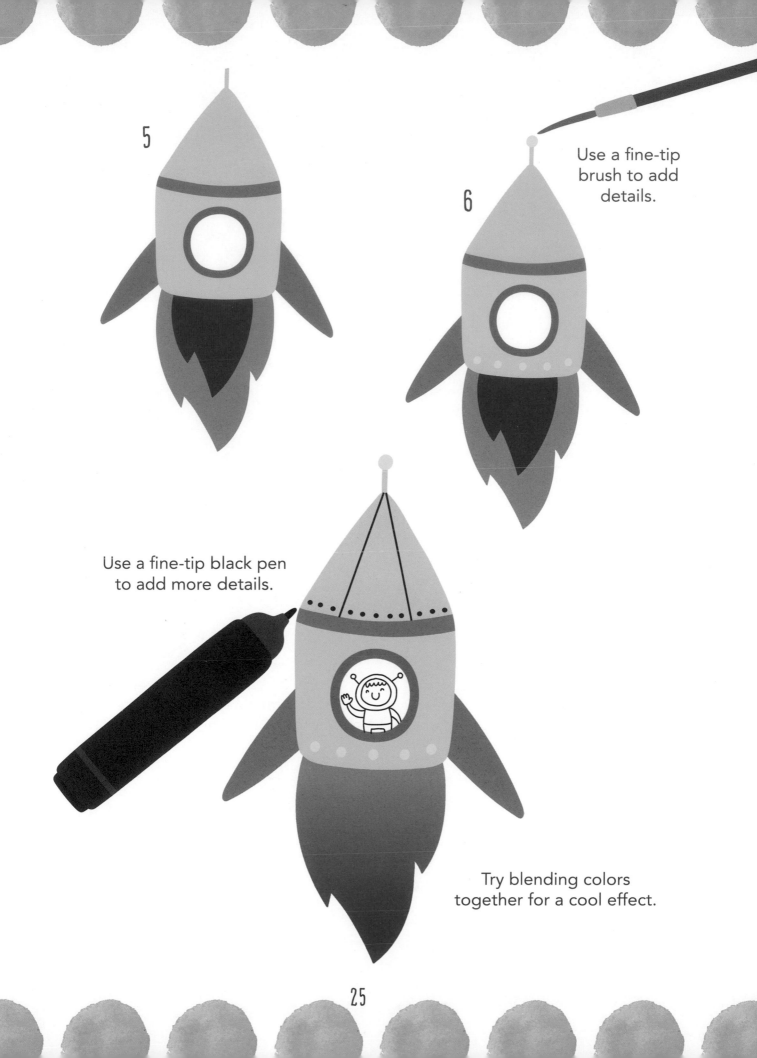

5

6

Use a fine-tip
brush to add
details.

Use a fine-tip black pen
to add more details.

Try blending colors
together for a cool effect.

fingerprint painting

horse

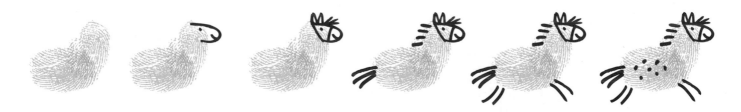

Start by making two fingerprints on your paper that overlap each other.
Then draw a long face. Use short lines for the mane and tail hair. Add dots for spots!

sheep

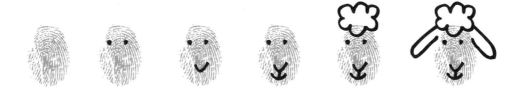

The sheep has a U-shaped nose and a curly tuft on top of its head.

26

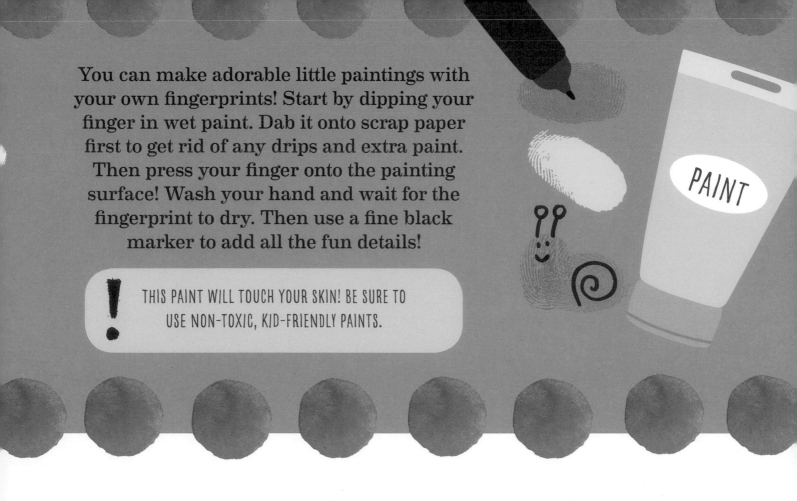

You can make adorable little paintings with your own fingerprints! Start by dipping your finger in wet paint. Dab it onto scrap paper first to get rid of any drips and extra paint. Then press your finger onto the painting surface! Wash your hand and wait for the fingerprint to dry. Then use a fine black marker to add all the fun details!

! THIS PAINT WILL TOUCH YOUR SKIN! BE SURE TO USE NON-TOXIC, KID-FRIENDLY PAINTS.

goat

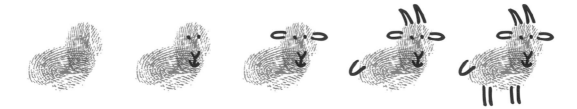

Use two fingerprints for this goat.
Add ovals for ears, a "U" for the tail, and two pointed horns.

cow

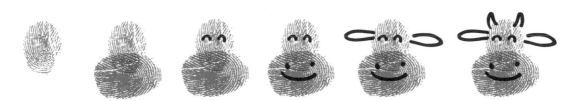

Paint this cow using two different fingerprint colors! Use your thumbprint to make the wide mouth area.

hen

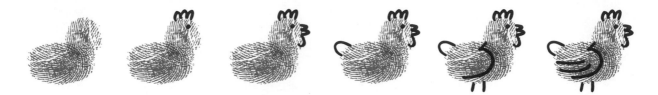

Use just a few curved lines to show the wing and feathers. Add a half-circle tail.

pig

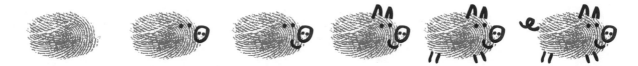

Use one fingerprint for this pig! Give your pig triangular ears and a curly tail.

cat

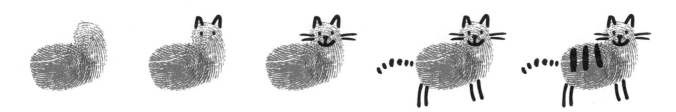

Draw whiskers, stripes, and a skinny tail for this orange tabby!

dog

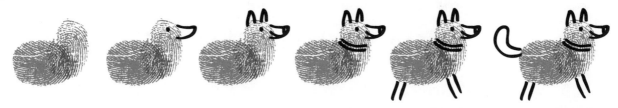

Add a snout, upright ears, and a perky tail. Don't forget two scooped lines for the collar!

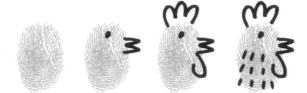

Add a curly comb on top of the head and a waddle below the beak. Use short lines for neck feathers.

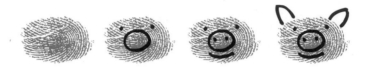

Make the pig's snout with a simple circle, and add two dots for nostrils.

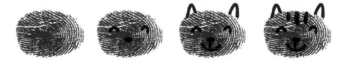

Draw triangular ears and three stripes on top of the head.

mouse

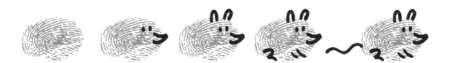

Give this tiny mouse round ears, a pointed nose, and a squiggly tail.

raccoon

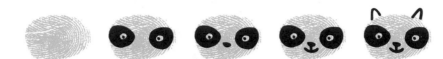

Draw two black circles for the raccoon's eye "mask." Add a tiny nose, mouth, and ears.

fox

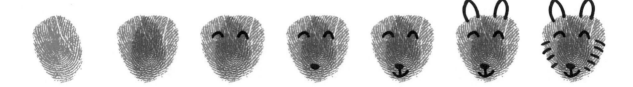

Use two fingerprints to make a triangular head. Finish with short lines for cheek fur!

rabbit

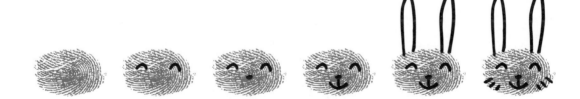

This rabbit has tall, skinny ears and tufts of fur on its cheeks.

bear

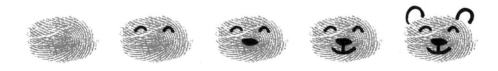

Give your bear a wide nose and two round ears.

deer

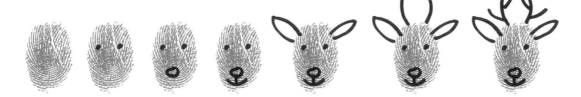

The deer has two dots for the eyes and pointed ears. Top its head with a pair of antlers!

owl

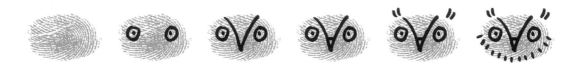

The owl has a V-shaped marking between its eyes. Add ear tufts and neck feathers!

hedgehog

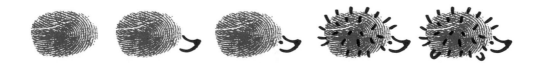

Draw a small, pointed face, and then add short lines over the body for quills.

frog

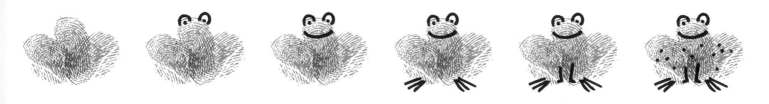

This frog is made of three fingerprints. It has eyes on top of its head,
a wide mouth, and big feet! Add a few dots for spots.

spider

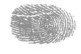 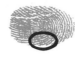 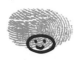 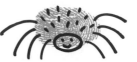 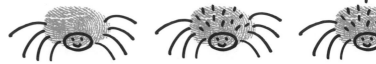 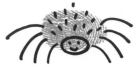

Draw an oval for the head and eight curved legs. Add short lines on the body for hair.

grasshopper

 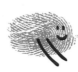 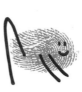 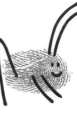

The grasshopper has long, bent back legs for jumping. Add tall, curved antennae.

bee

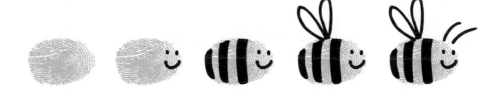

Stripes, wings, antennae, and a smile are all this bee needs!

butterfly

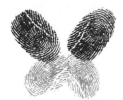 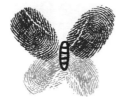 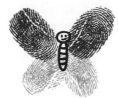 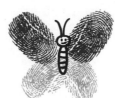 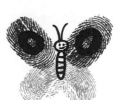 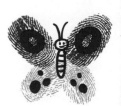

Use four fingerprints for the wings. Draw a body and detail the wings with circles and dots!

snail

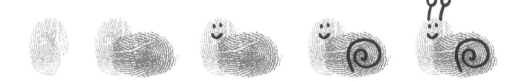

A snail has two antennae with a circle at each end. Draw a spiral for the shell!

ladybug

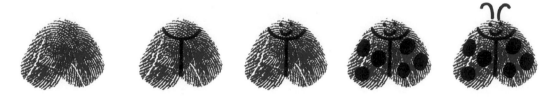

Use two fingerprints for this ladybug. Add large black dots to each wing!

ant

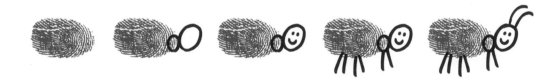

Draw two circles for the middle of the body and head. Then add six legs and two antennae!

caterpillar

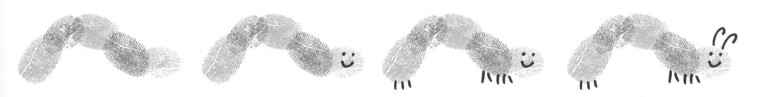

Connect a row of fingerprints to make the body. Use little strokes for tiny feet!

flowers

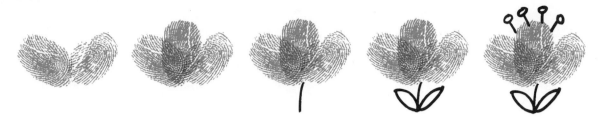

Build the flower with three overlapping fingerprints. Detail with a stem, leaves, and stamen.

leaf

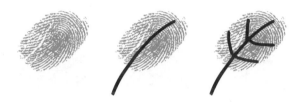

A stem and V-shaped veins are all you need to bring this leaf to life!

whale

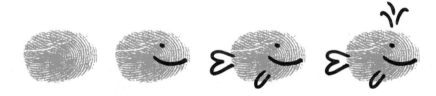

Draw a wide mouth, a tail, and a fin. Add a splash of water coming out of the spout!

jellyfish

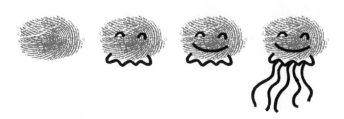

Add a curly bottom to the head. Then use wavy lines for tentacles.

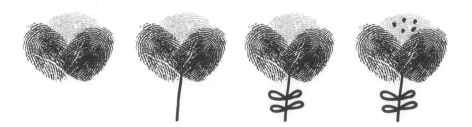

Use two colors and three fingerprints for this blossom. Add four loops for leaves and a dotted center.

fish

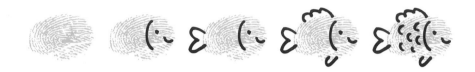

Add a scooping gill, a tail, and two fins. Detail with C-shaped scales!

octopus

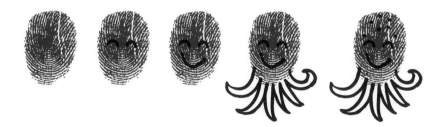

Give this octopus lots of curved tentacles. Finish with dots for spots.

seal

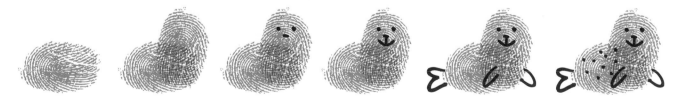

Start by drawing the seal's cute little face. Then add small U-shaped flippers and a tail.

lion

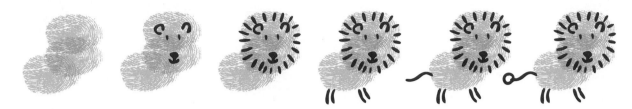

Build the head and body with three fingerprints. His tail has a little tuft of fur at the end!

elephant

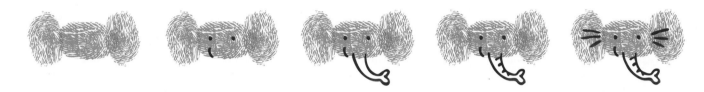

Use one fingerprint for the head and two for ears! Add the curved trunk and skin folds in his ear.

crocodile

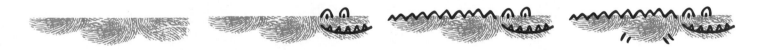

Use the edge of scrap paper to block the top half of your fingerprints
from getting on your paper. Make the back bumpy!

submarine

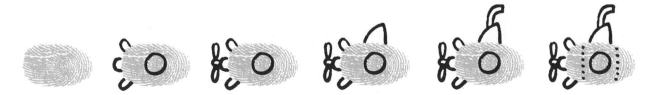

Draw a circular window, propeller, and periscope. Detail with two rows of dots!

 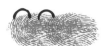 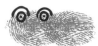 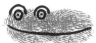 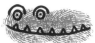 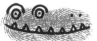

Add a long nose and lots of little lines around his head for the mane.

giraffe

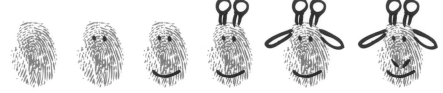

The giraffe has two "ossicones" that look like horns. Add skinny ears, a wide smile, and big nostrils.

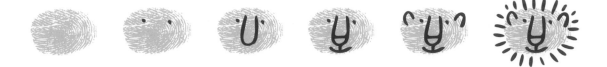

The eyes are on top of the head. Add a wide mouth, tiny triangles for teeth, and dots for nostrils.

tractor

 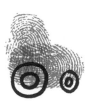 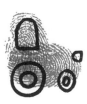 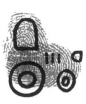 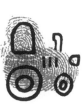

Create an "L" shape with two fingerprints. Add wheels, an arched window, and a smoke stack.

fire truck

 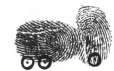 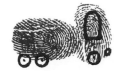 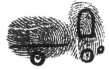 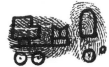

Add circles for wheels and a tall arch for the window. Don't forget the ladder!

concrete mixer

Tilt your fingerprint to make this truck's barrel. Detail it with diagonal lines.

car

 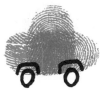 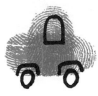 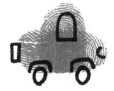

Draw circles for wheels and an arch for the window. Detail with a headlight and back bumper!

plane

Draw diagonal "U" shapes for the wings and a C-shaped tail. The propellers form a cross!

school bus

 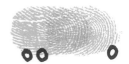 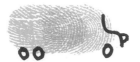 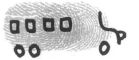 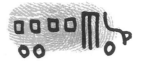

The body of the school bus is long! Add bump to the front and a row of tiny squares for windows.

delivery truck

 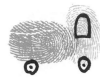 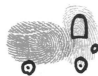 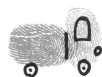 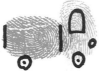

Draw wheels and an arched window. Add two vertical lines on the left thumbprint.

helicopter

 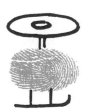 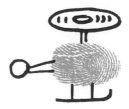 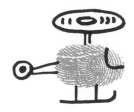 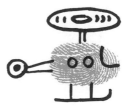

Draw landing gear and add an oval for the rotor. Finish with a tail and a couple windows!

tank

Draw the inside of the track using an oval and three circles. Use dots for its bumpy edge!

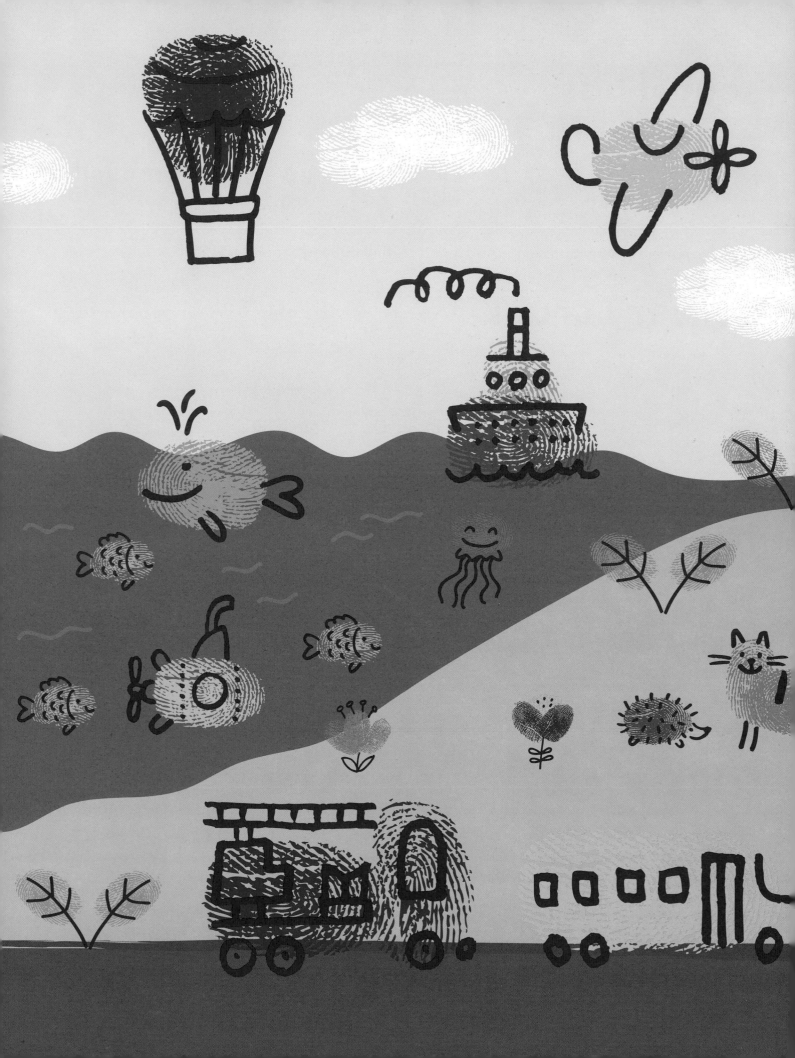

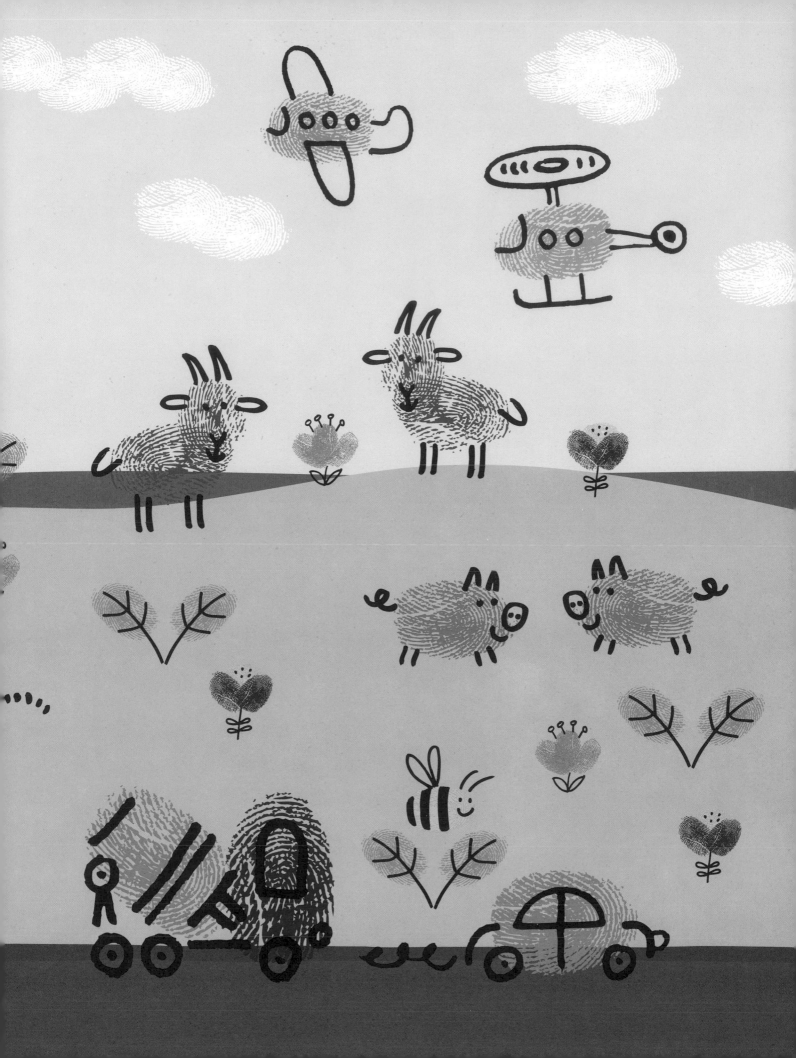

Animals

bear

Start with a circle for the head and an oval for the body. The ears and tail are half circles.

Of all the things in the world you can paint, animals just might be the most fun! You'll love bringing them all to life and giving each one its own personality. From cuddly pets to wild animals and sea creatures, you'll find them all in these irresistible projects!

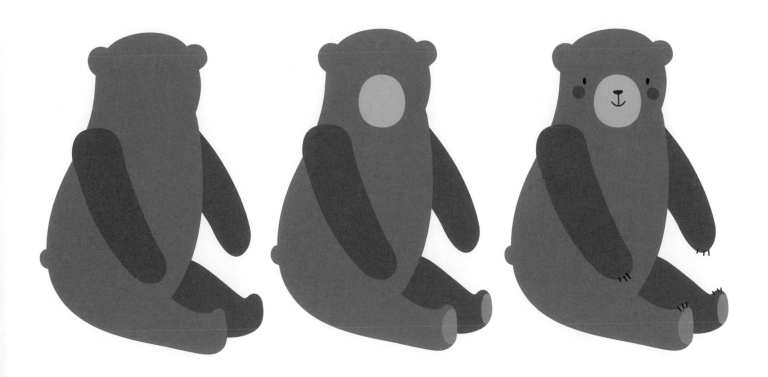

Paint the arms and legs. The bottoms of the feet and muzzle are ovals! Use tiny lines for claws.

fox

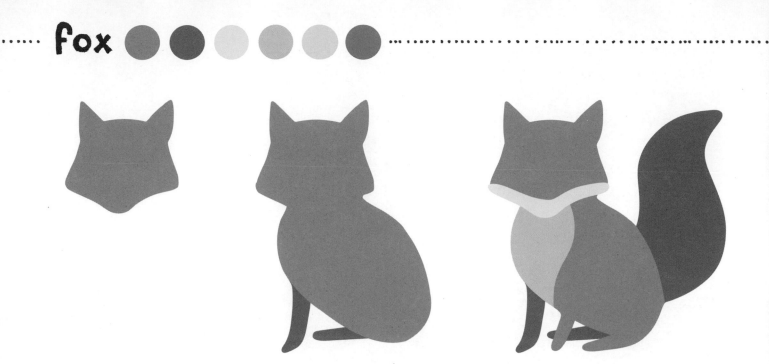

The fox has triangular ears, pointed cheeks, and an S-shaped tail.

rabbit

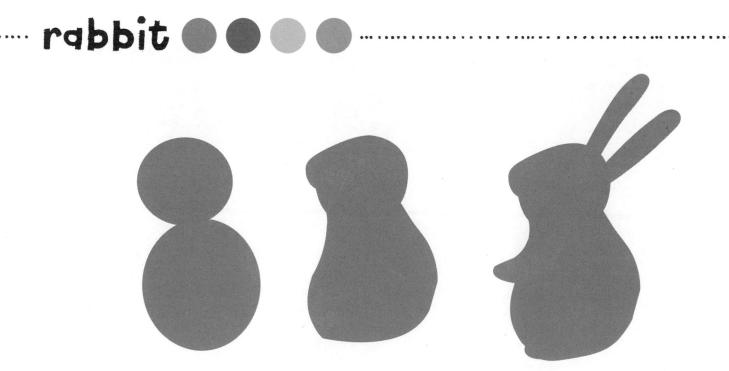

Build the body with a circle and an oval. Add a pair of long, rounded strokes for the ears.

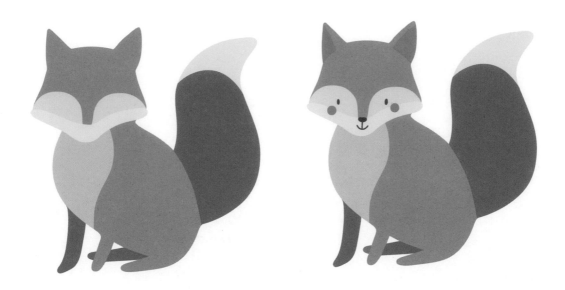

Add two half circles to the face, separated by a thin nose. Give the tail a light tip!

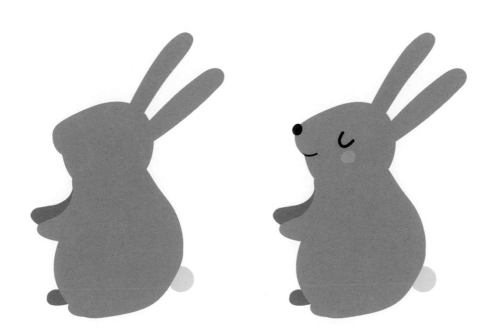

Give this sweet bunny small, rounded limbs and a puffy, half-circle tail.

mouse

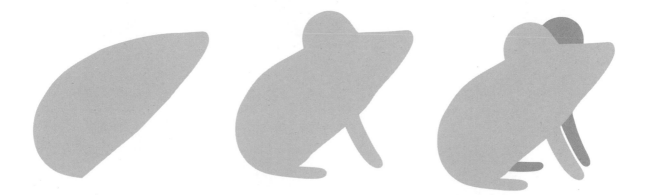

The mouse's body is shaped like a teardrop. Use half circles for the ears.

owl

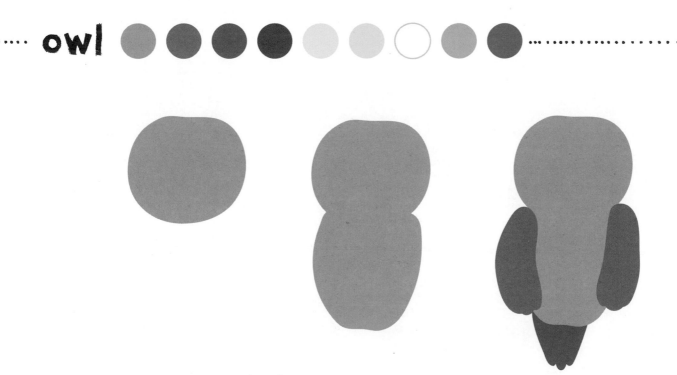

Use a flattened circle for the head and tall oval for the torso. The wings are like jelly beans!

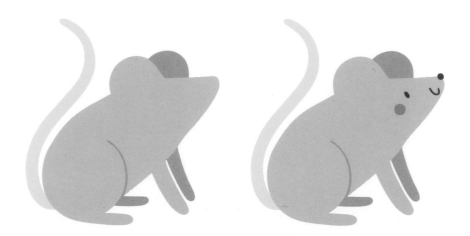

Draw a thin, scooping line to show the back leg. The long, skinny tail is a backward "S" shape.

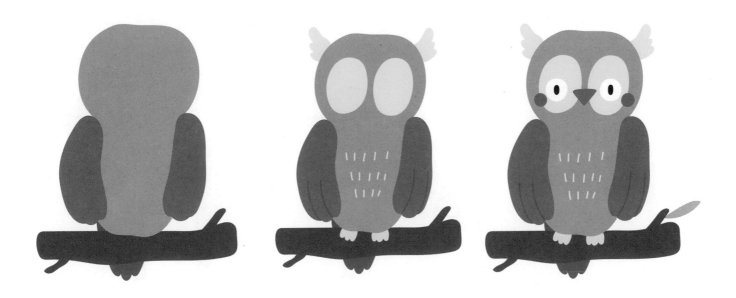

Paint a long rectangle for the branch, and add two short twigs and a leaf. Give the owl pointed ears and two oval eye masks. Paint thin lines up the wings and short lines on the chest for feathers!

raccoon

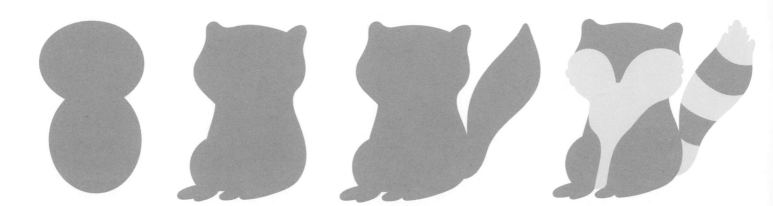

The raccoon's light markings make a heart shape! Paint thick, light bands across the fluffy tail.

deer

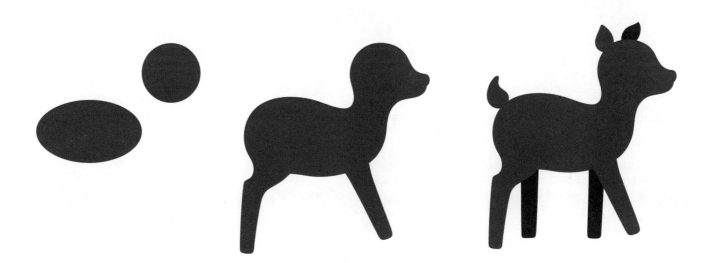

Give your deer a pointy face and tall, straight legs. Its ears and tail are curvy triangles!

Paint ovals for the eye mask. It appears to be wearing gloves and socks on its hands and feet!

Paint the light underside and build antlers with short, thin strokes. Add spots!

cow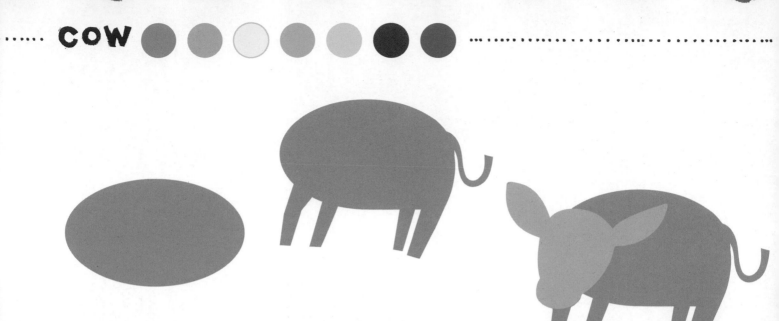

The cow has an oval body, triangular ears, and a U-shaped tail.

horse

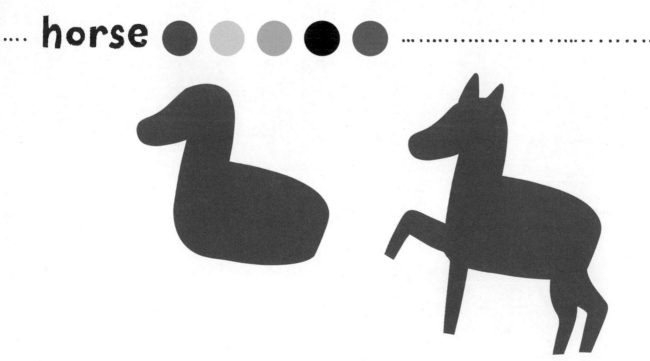

This prancing horse has a long face, triangular ears, and one front leg in the air!

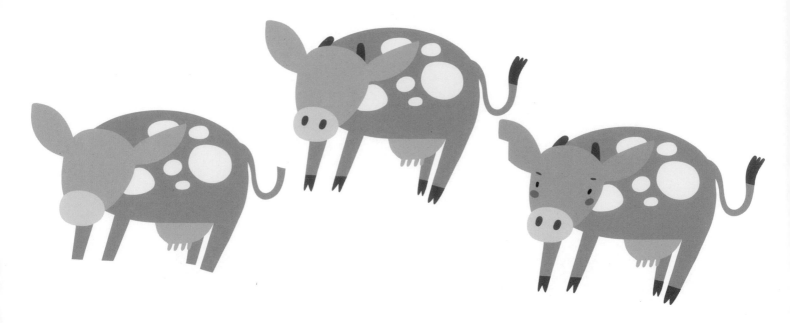

Detail the face and add the udder and round spots. Finish with horns and pointy hooves!

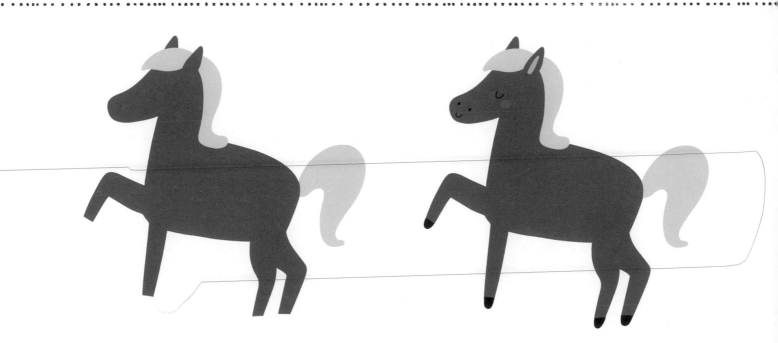

Add a flowing mane and a high, curving tail. Detail the ears and tiny hooves!

goat

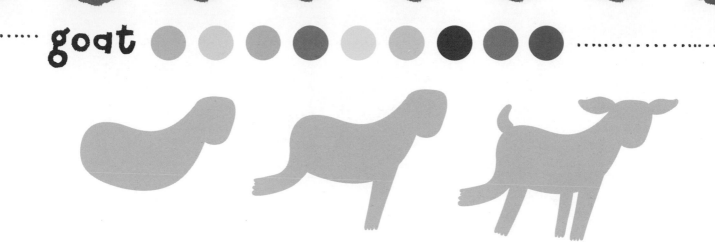

The goat's body dips a bit like the letter "U." Add a tail, ears, and limbs—with a back leg in the air!

goose

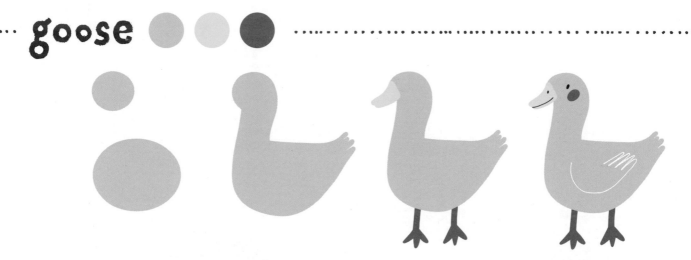

The goose has a long neck, a triangular beak, and a little tail fluff. Use thin lines to detail the wing.

pig

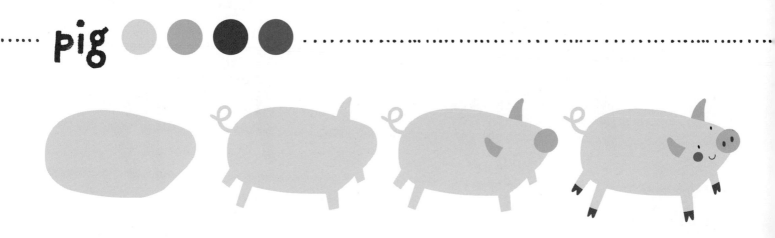

Start with an oval. Add short legs, triangular ears, and a curly tail! Give it a round snout and hooves.

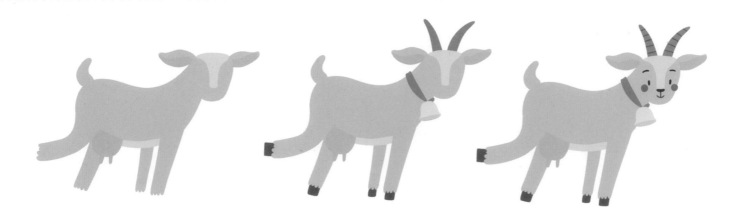

Paint light markings on the face and underbelly. Add the udder, a bell, and sharp, curved horns.

hen

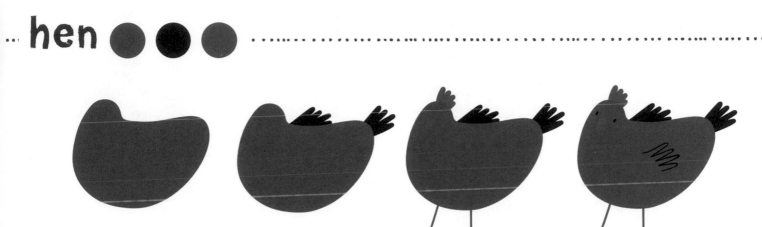

Start with a bean shape. Add wing feathers, a tail, and a comb on top of the head.

sheep

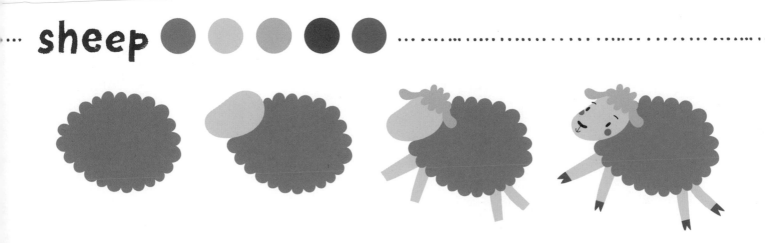

Paint a circle with scalloped edges. Give him floppy ears and a curly tuft on top!

dog faces

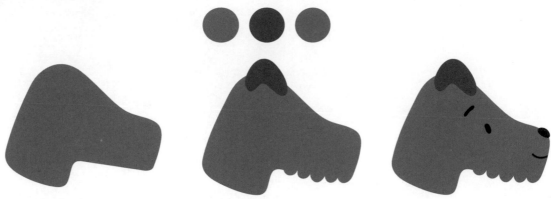

This pooch has a boxy muzzle and perky ears. Use a scalloped edge along the jaw for fur.

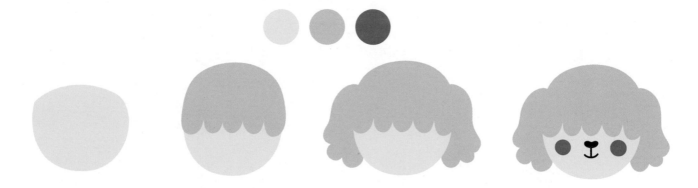

Use scalloped edges to paint this dog's coat. The curly hair covers its eyes!

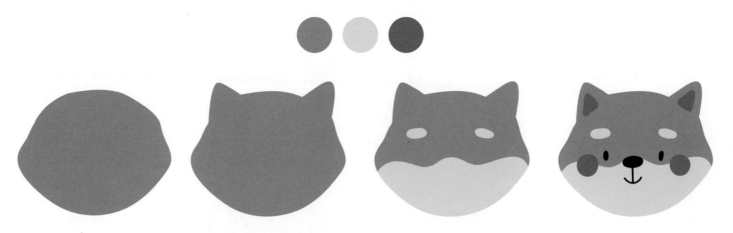

This pup has triangular ears and pointed cheeks!

Dog breeds can look very different, from the colors of their coats to the shapes of their ears!
Try painting more furry friends.

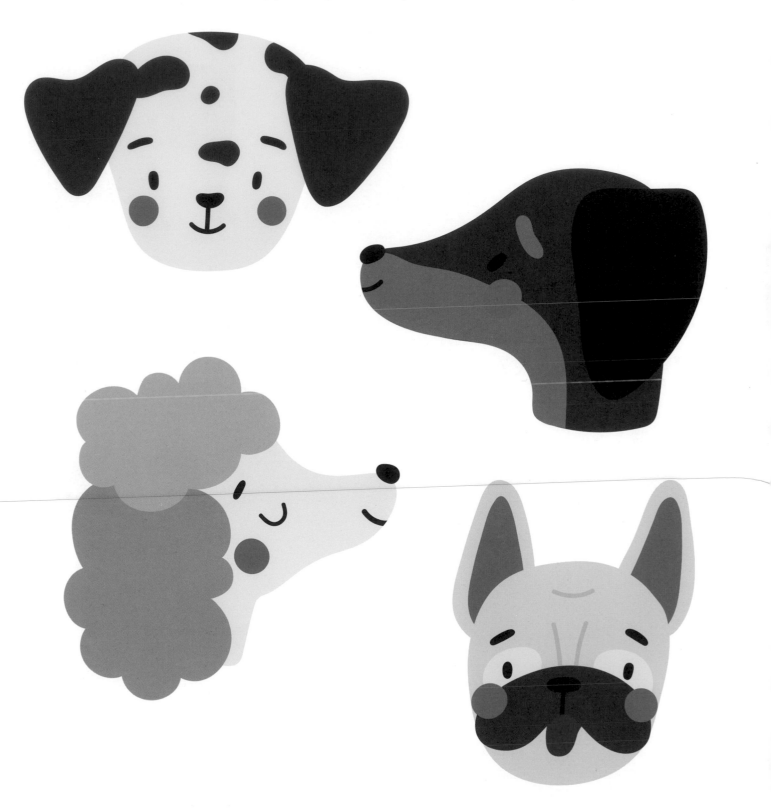

bulldog

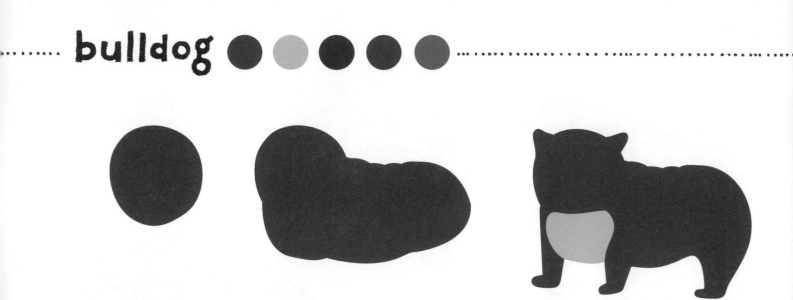

Start with a circle for the head and add a long body. Its legs are very short!

pug

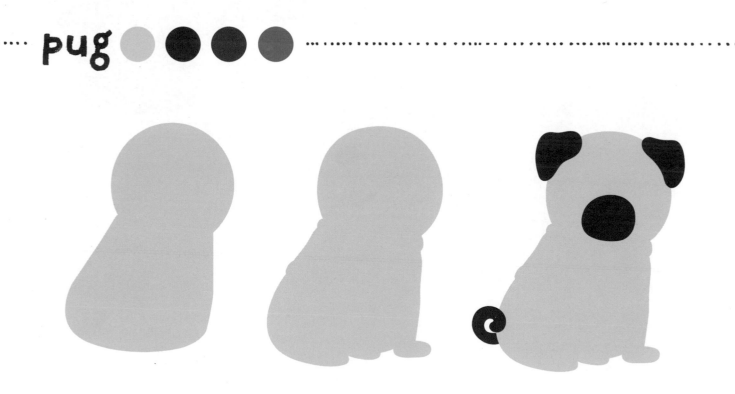

Pugs have big heads and little bodies. Add dark, triangular ears and a circular snout.
The curly tail makes a "C" shape.

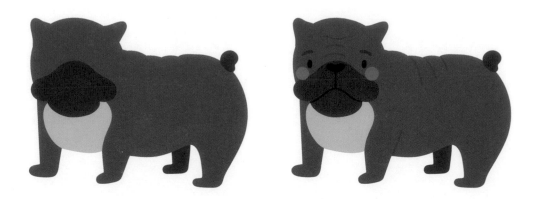

Add a large, droopy mouth and a stubby little tail. Add wrinkles with thin lines!

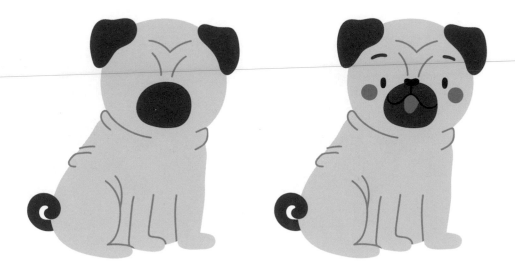

Paint thin lines (or use a marker) to outline the legs and add wrinkles.

corgi

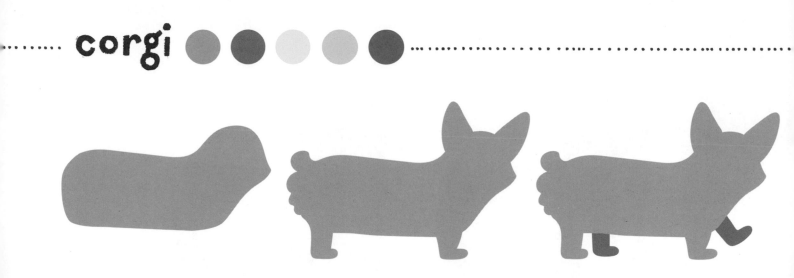

The corgi has a very long body, short legs, and large triangles for ears.

pomeranian

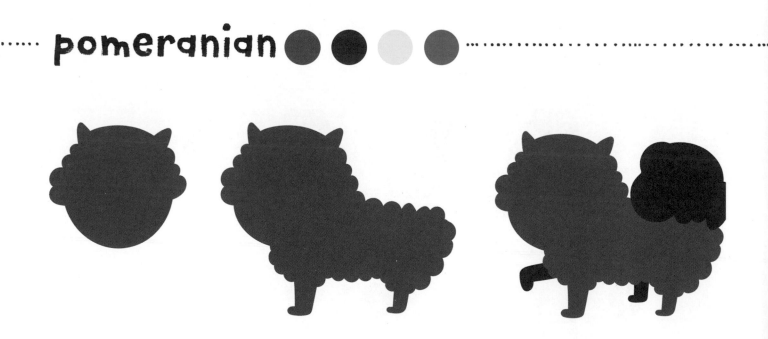

Build the head and body with curly edges. Add tiny ears, short legs, and a poofy tail.

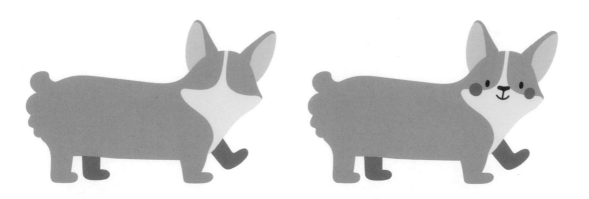

Paint light markings down the head, across the face, and down the chest.
Lighten the insides of the ears.

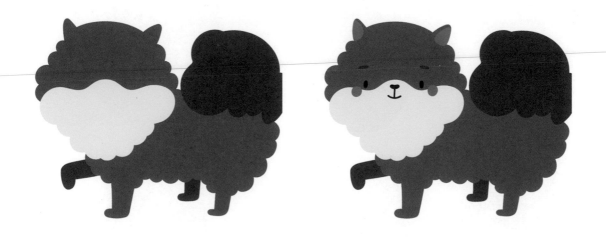

Lighten the bottom half of its face with a large, curly shape.
Paint the insides of its ears and add a tiny face!

cat faces

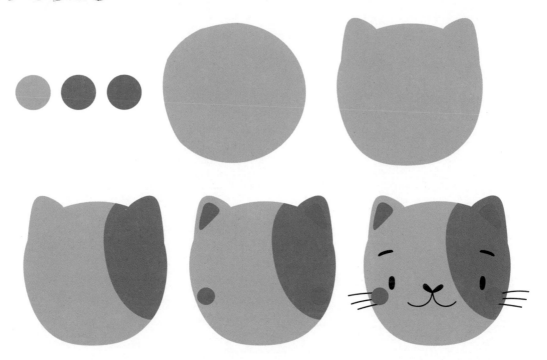

Start with a circle and add two bumps for ears. Paint a marking that covers one eye!

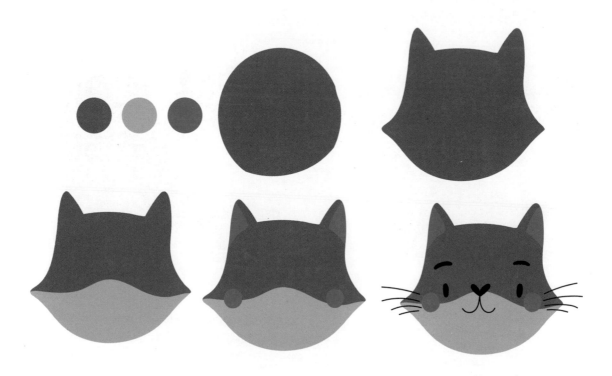

This cat has pointy cheeks and upright ears. Add lines for whiskers.

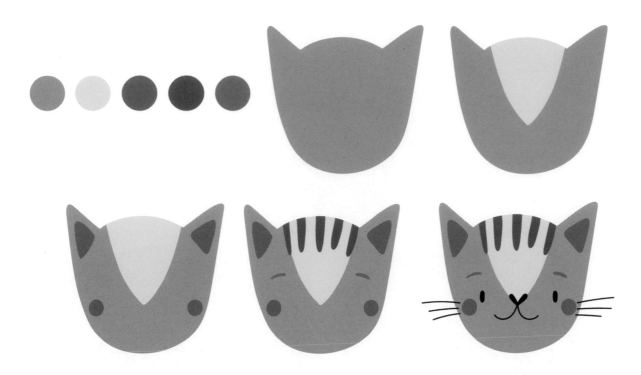

This cat has a triangular marking from the top of its head to its nose. Add vertical stripes!

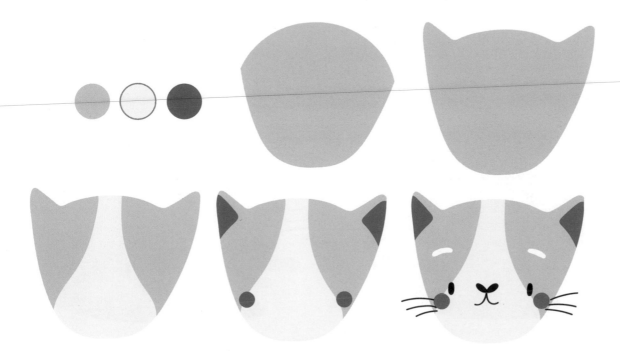

This cat's head is wider on top than the bottom. Paint a white marking down the center of the face.

cat bodies

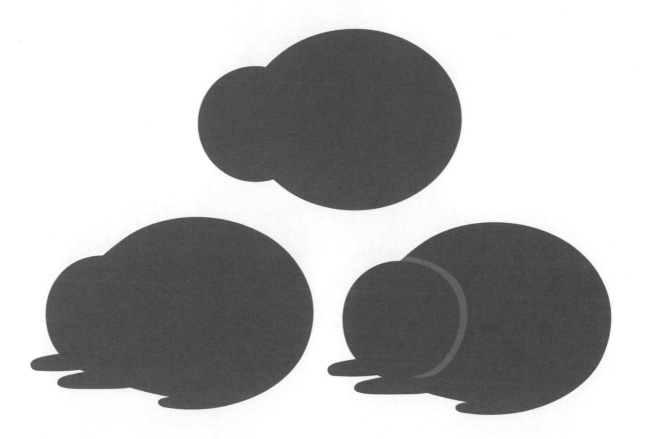

This curled-up cat is full and round with little feet. Add a scoop for the collar.

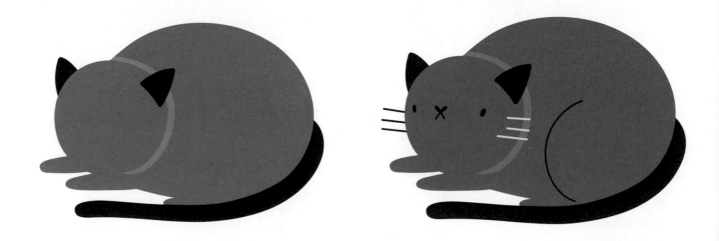

Paint triangles for ears and a long, thin tail. The nose and mouth make an "X" shape!

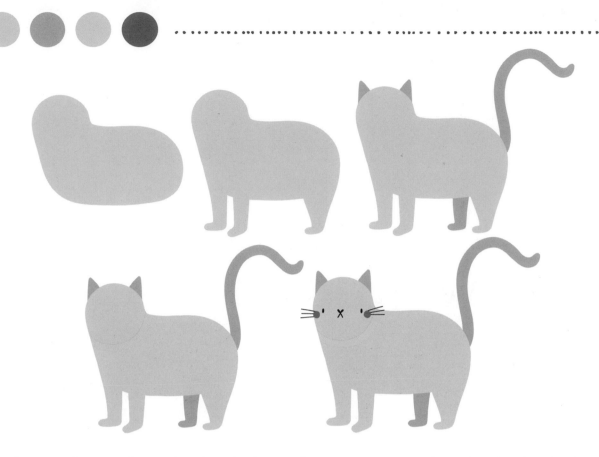

This standing cat begins with a thick "L" shape. Give it a perky tail with a hooked tip.

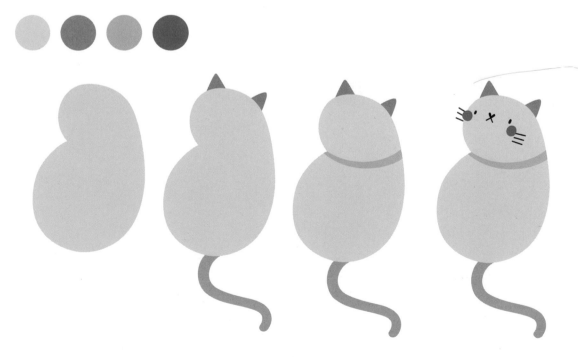

This cat is sitting pretty! Start with a bean shape and add an S-shaped tail to the bottom.

frog

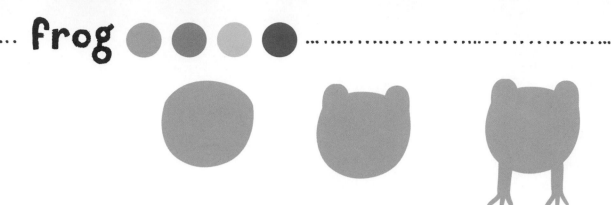

Begin with a circular head and add round eyes to the top. Paint two front legs and long toes.

turtle

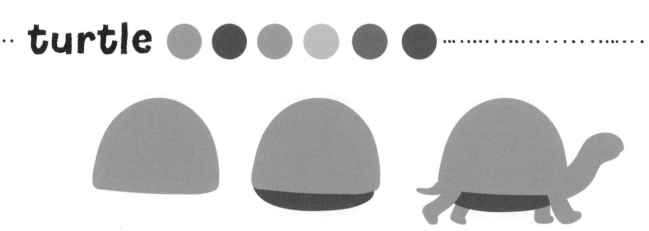

Start with a half circle. Then add the rounded underside, limbs, tail, neck, and head.

parakeet

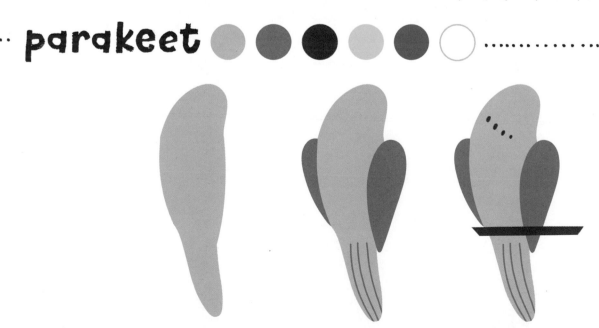

Paint a tall, rounded shape and add teardrops for the wings. Add tail and neck feathers for detail!

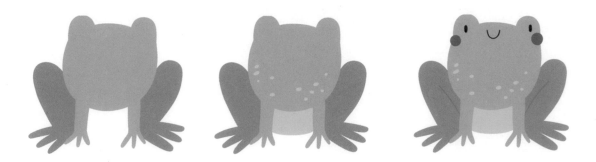

Now add the frog's large back legs and underbelly. Use dots for spots!

Make the shell's pattern with rounded rectangles. Finish with a thick rim along the bottom.

Paint little feet over the perch and a triangle for the beak. Use thin strokes for the head markings.

whale

Start with a fat teardrop shape.

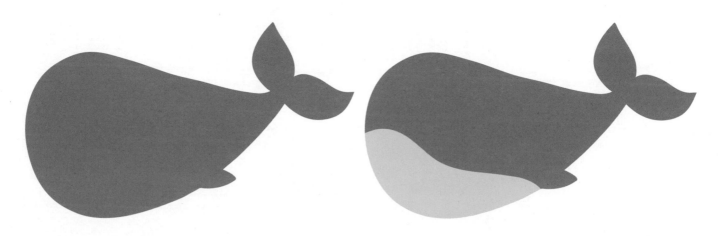

Build the tail using smaller teardrop shapes. Add a fin and paint a light underbelly.

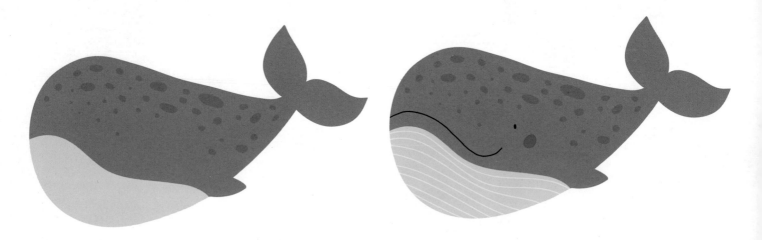

Use small circles for spots over the body, and use thin lines to make grooves on the underbelly.

Begin with a skinny teardrop shape.

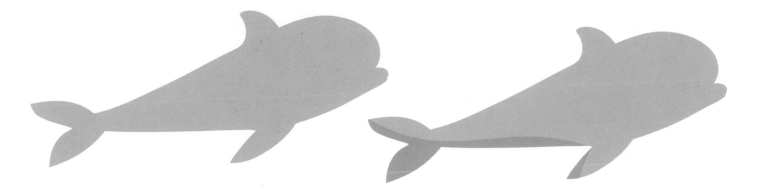

Paint a pointy tail, fin, and flipper, plus a bump for the mouth and nose! Add a shadow to the underside.

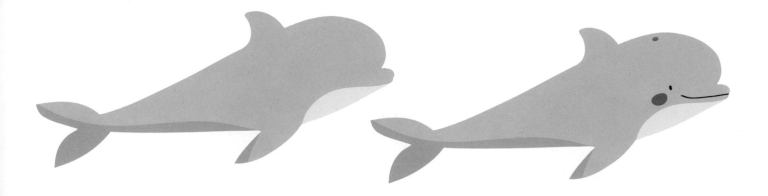

Paint the light underbelly and add a dot on the top for the blowhole!

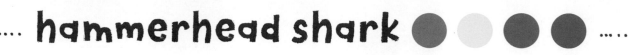

hammerhead shark

Start with a thick "J" shape. Add a tail and widen the head. Then paint a light underbelly.

great white shark

The nose and body of the shark look like a leaf! The fins and tail are hooked.

whale shark

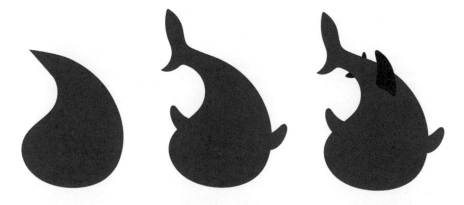

Start with a curved teardrop shape. Then add a tail and pointy fins.

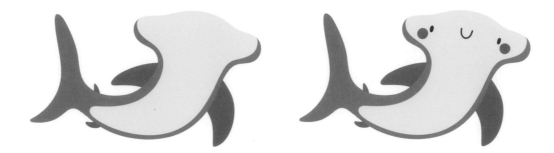

Paint two sets of pointed fins—one large pair and one small pair near the tail.

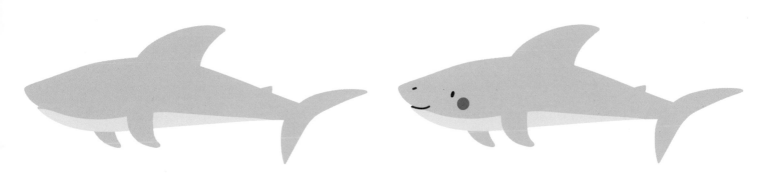

Paint the light underbelly and detail the face!

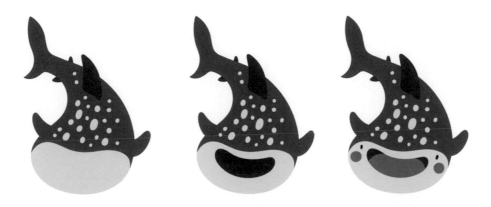

Use a jelly bean shape for the wide face. Finish with spots and a giant smile!

octopus

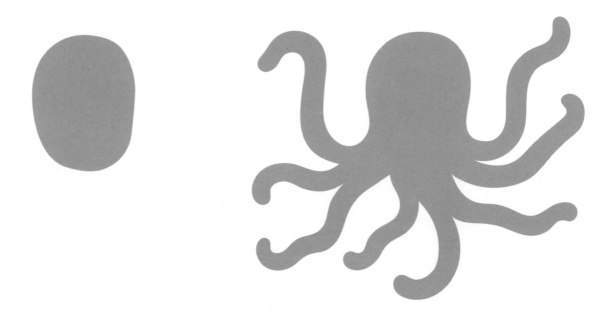

Start with a tall oval and add eight long, wiggly tentacles to the bottom.

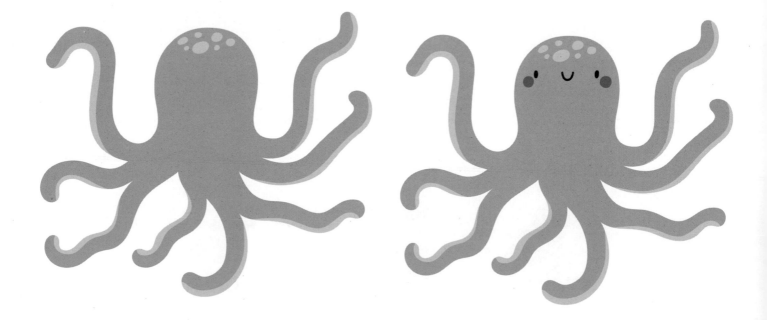

Paint the light underside of each tentacle with a thin stroke. Top the octopus with spots!

narwhal

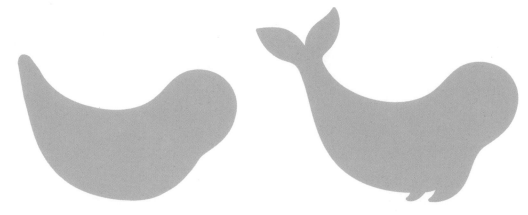

Begin with a scooping shape. Add a pair of fins and a tail!

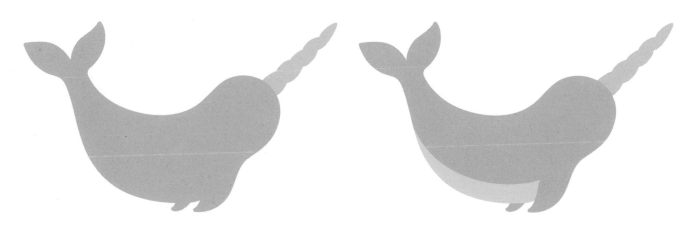

Paint a long, bumpy tusk on the head. Then add a light underbelly.

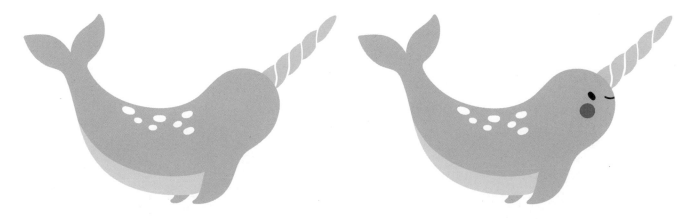

Use thin, diagonal lines for grooves on the tusk, and add spots on the narwhal's back!

sea star

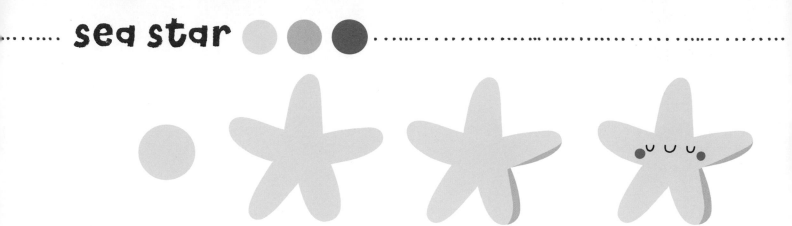

Paint a circle for the center and add five rounded "arms." Add some shadows to make it look 3D!

jellyfish

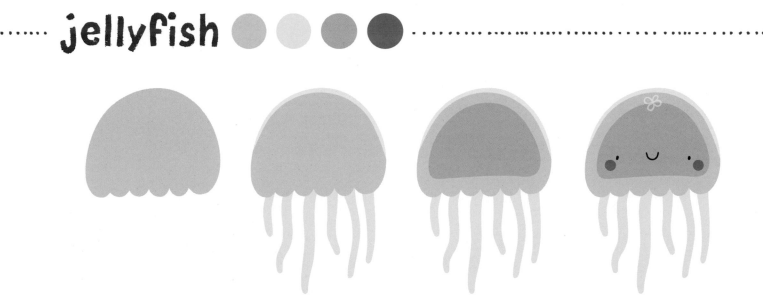

Paint a half circle with a scalloped bottom. Add six wavy lines for tentacles. Paint another half circle inside!

sea turtle

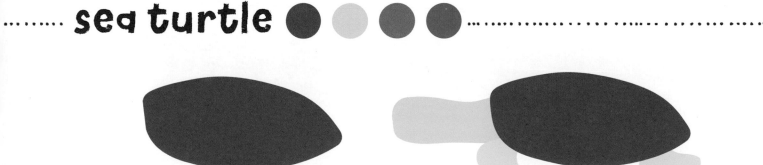

The sea turtle's shell looks like a leaf. Add flippers and a head with a long neck.

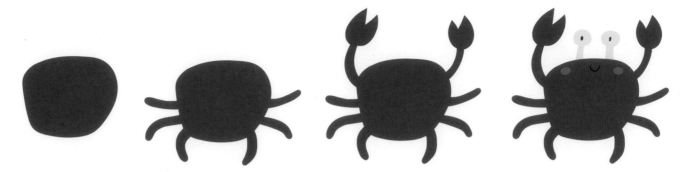

Start with a round body. Add pairs of curving legs and pointy pincers! Finish with eyes above the head.

sea urchin

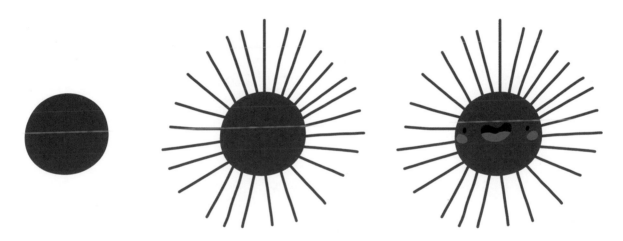

Start with a simple circle, and then surround it with thin strokes. It looks like a sun with rays!

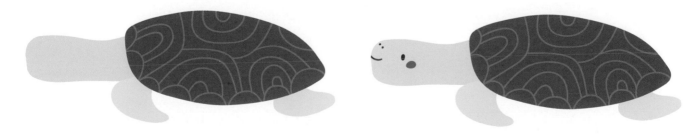

Use very thin strokes (or paint marker!) to add a curvy pattern to the shell.

fish

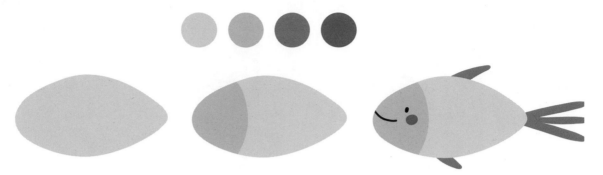

Start this simple fish with an oval. Use short strokes to paint the fins and tail.

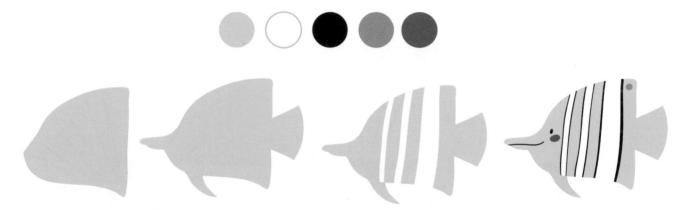

This angelfish has a triangular body, a pointy nose, and tall stripes.

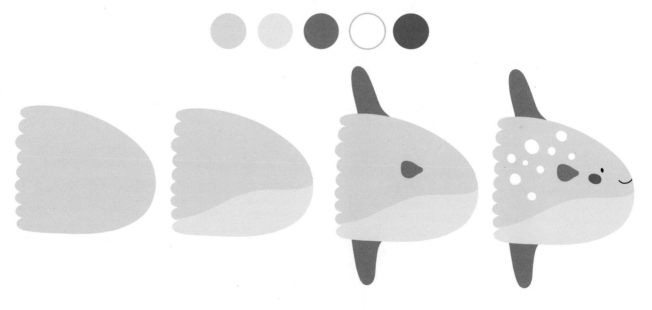

This sunfish is a half oval with a scalloped edge. Add three fins and a sprinkling of spots!

From coral and tiny shelled creatures to giant whales, the ocean is home to a variety of life! Try painting these other ocean-dwellers.

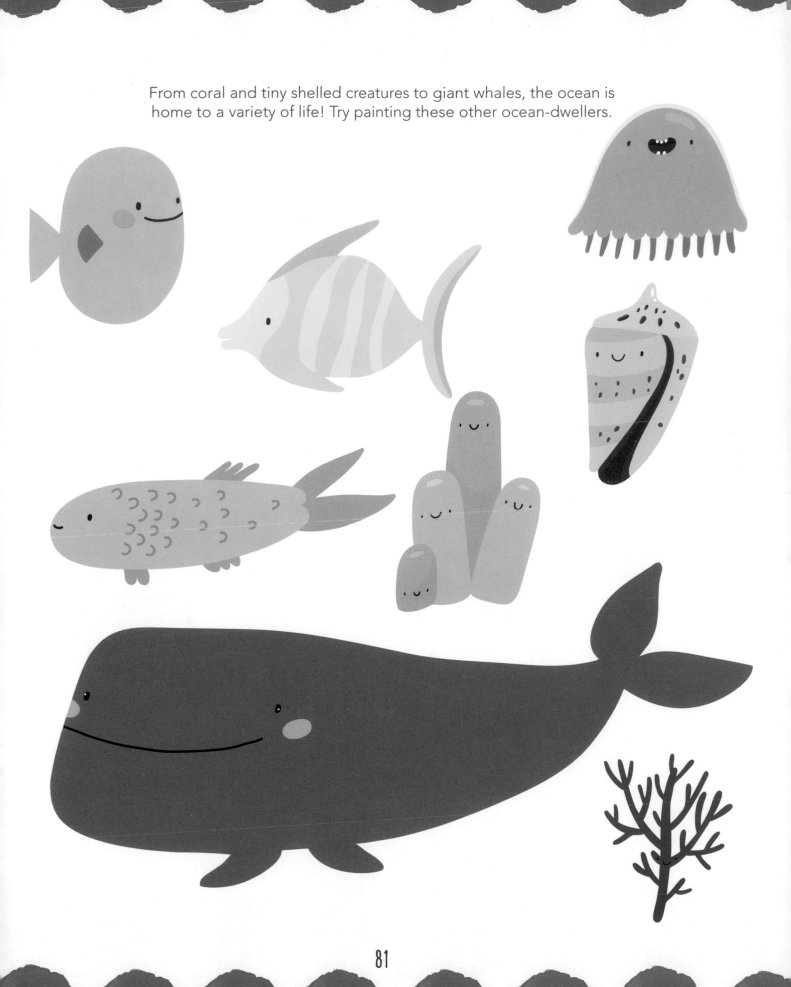

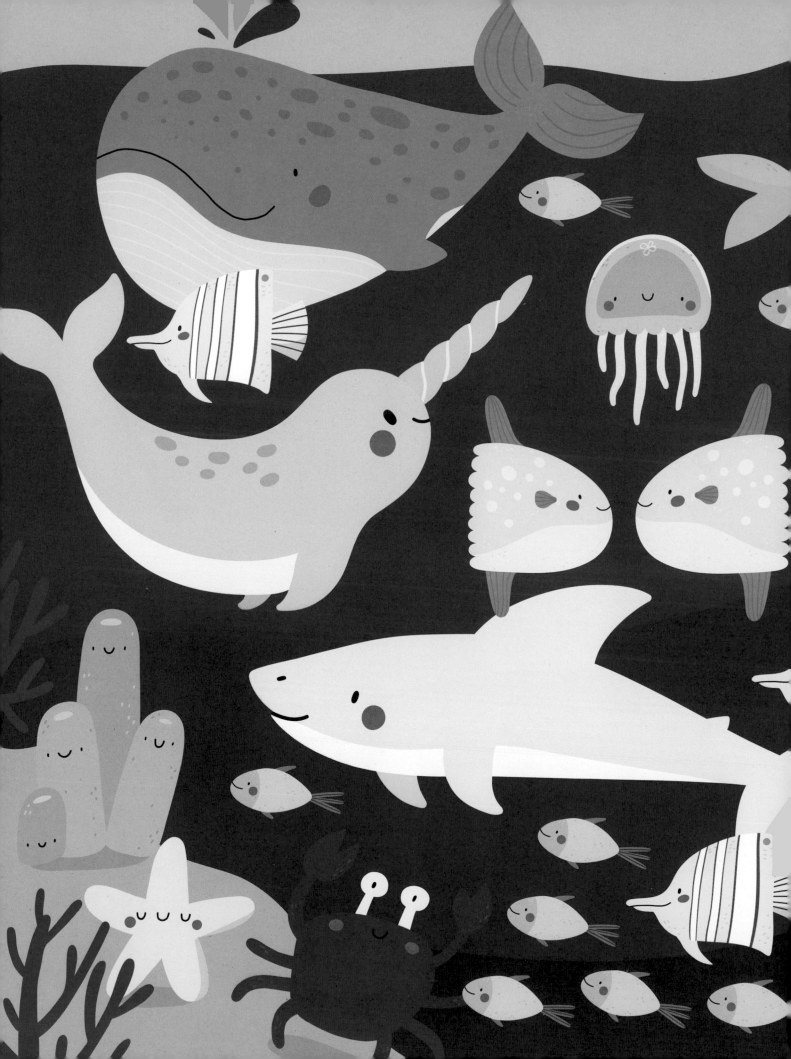

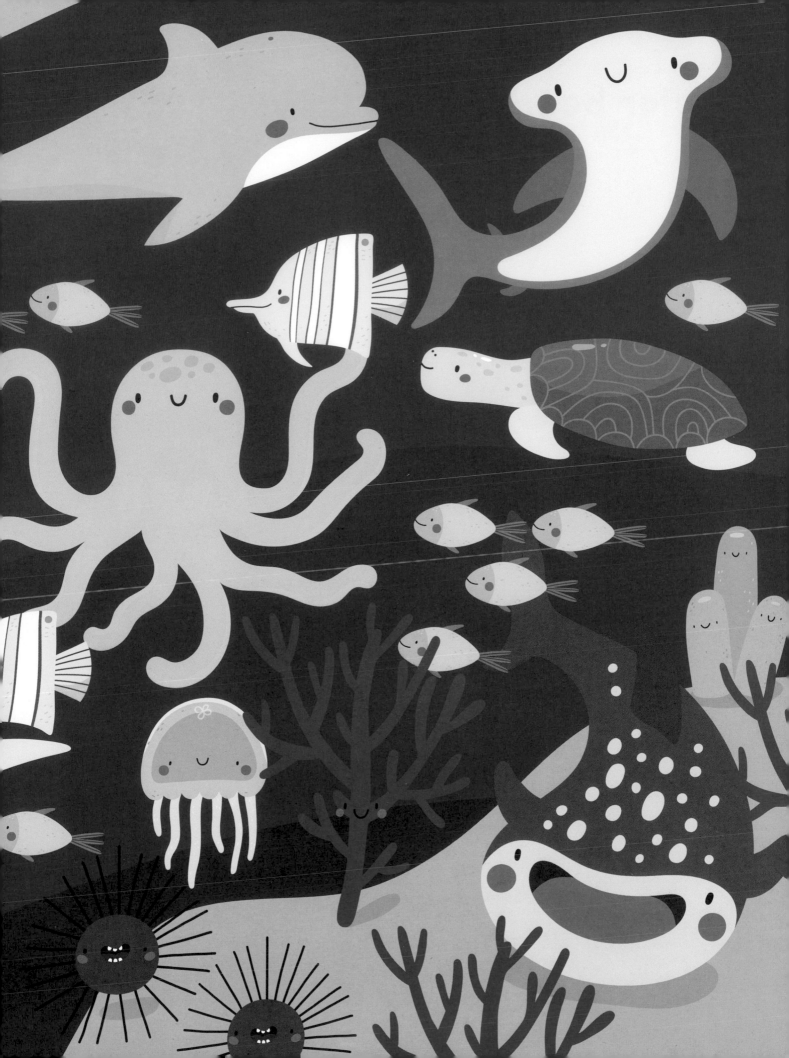

polar bear

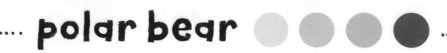

This cute bear has a pointed muzzle and a rounded backside.

penguin

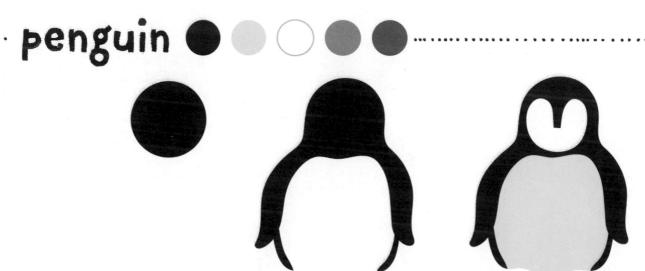

Start with a circle for the head and add a round body. The face is almost a heart shape!

seal

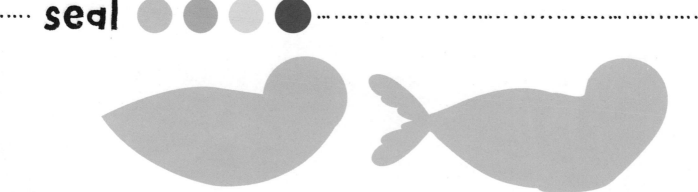

Combine a circle with a teardrop-shaped body. Add a bumpy "V" for a tail.

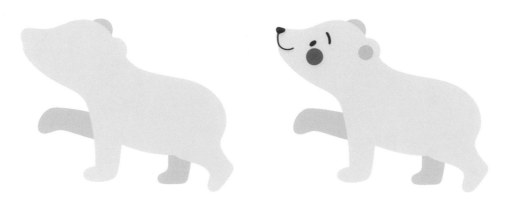

Paint the front leg up in the air. Add the ear and detail the face!

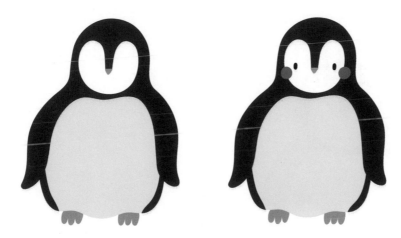

Paint three tiny strokes for each foot and add a tiny beak.

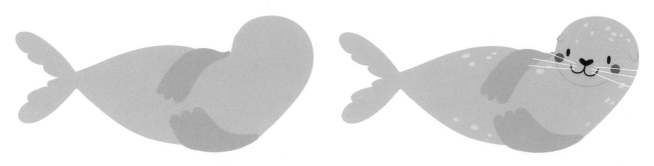

Paint curved flippers, stroke lines for whiskers, and add a few dots to the skin!

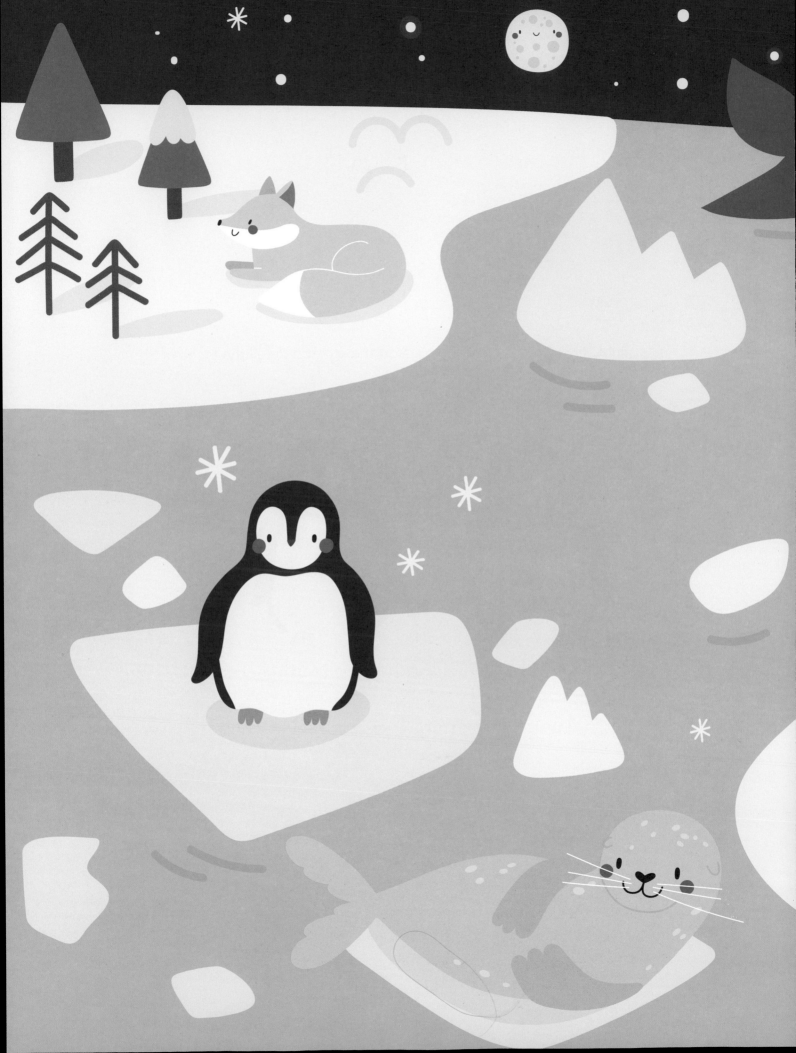

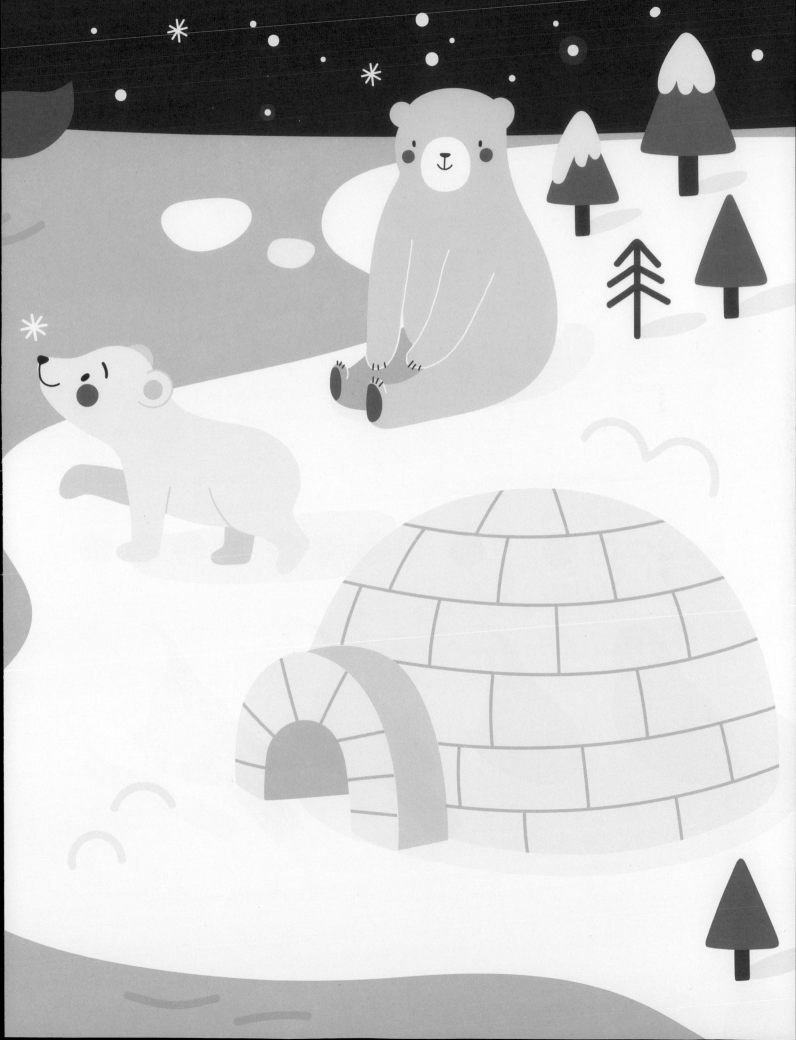

flamingo

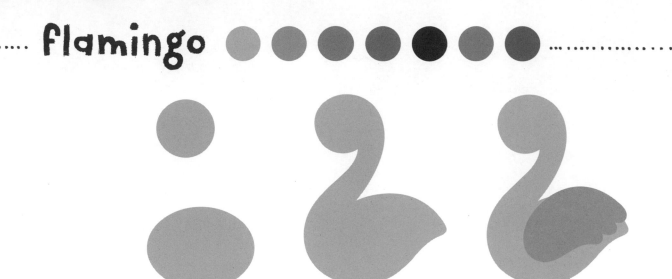

Connect the head and body with a long, curving neck. The body comes to a point at the tail.

toucan

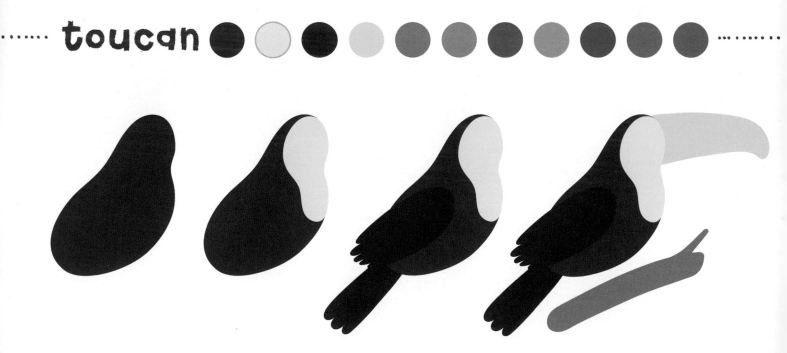

Use peanut shapes to create the bird's head and neck. Add a wing, tail, and long, hooked beak.

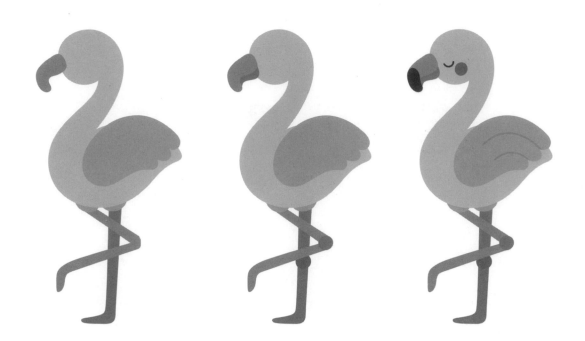

Add a hooked beak and tall, straight legs. Notice how its knee bends backward!

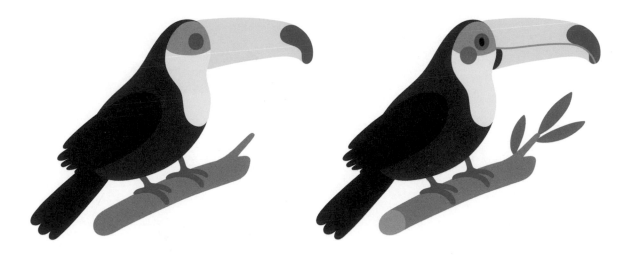

Use lots of colors to accent this tropical bird! Detail the branch with a few leaves.

sloth

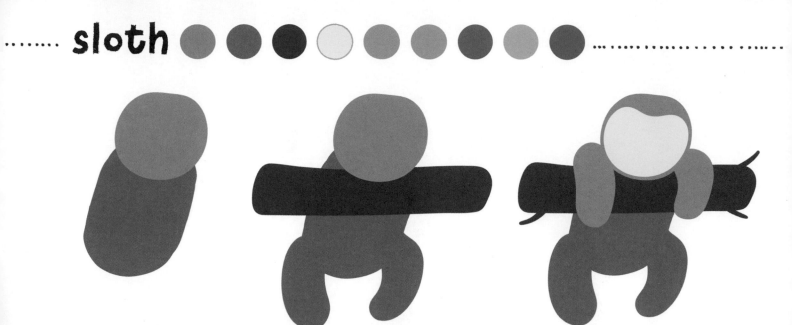

Start with a circle for the head. Its limbs are round and curved like jelly beans!
Paint the thick branch with a long rectangle, and add the light shape of the face.

panda

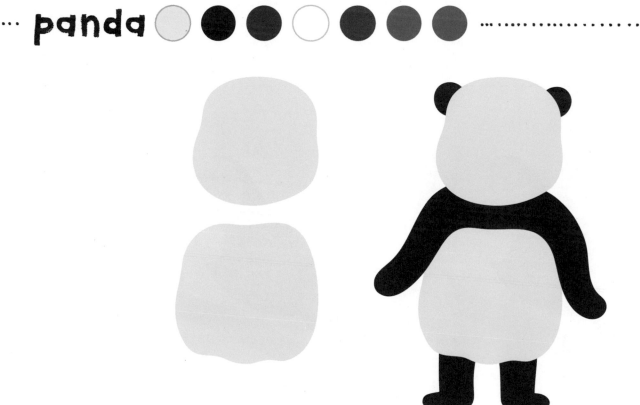

Start by drawing the panda's large, round head and body.
Add half-circle ears, curved arms, and boot-like legs and feet!

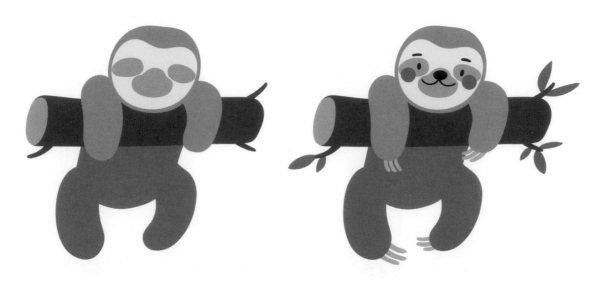

Paint darker face markings and add long claws with thin strokes.
Add color and detail to the branch with twigs and leaves!

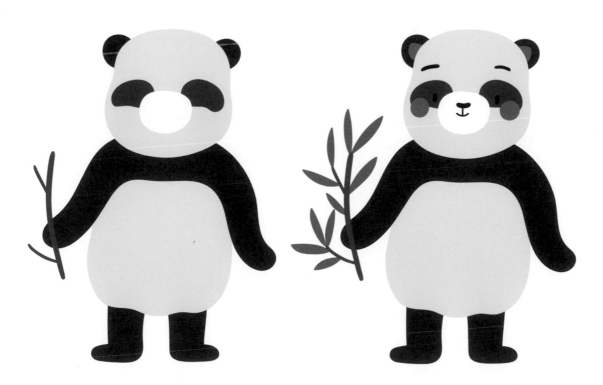

Paint eye markings and a circle in the middle of the face.
Add bamboo shoots and leaves for detail!

koala

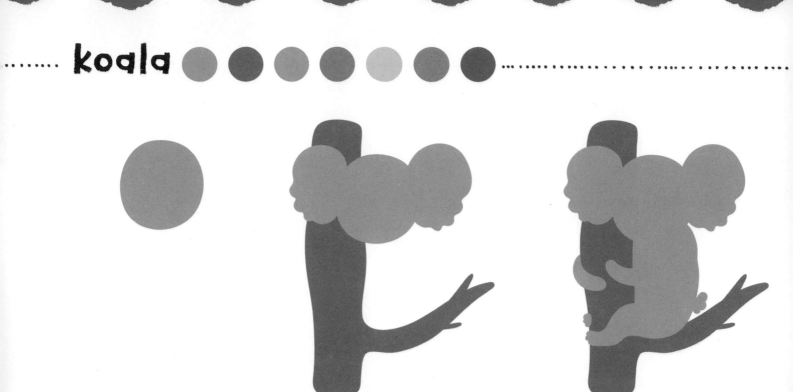

Start with a circle for the head and add ears with bumpy edges. Paint the body around the tree trunk.

llama

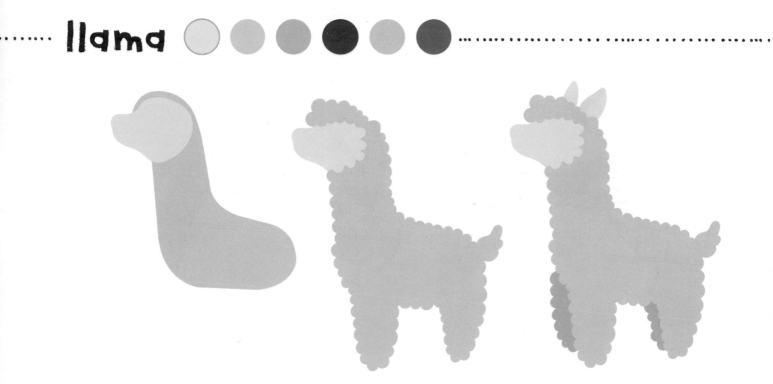

The llama has a very tall neck! Paint bumpy edges for a curly coat of hair. The ears are triangles.

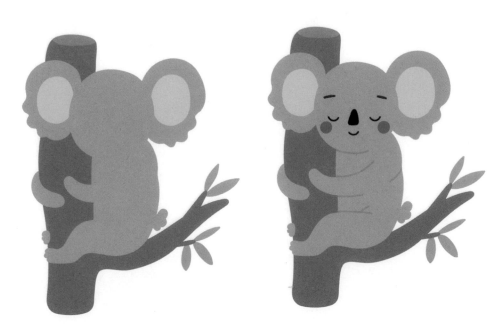

Paint ovals for the insides of the ears, and define the limbs and chin with thin lines.

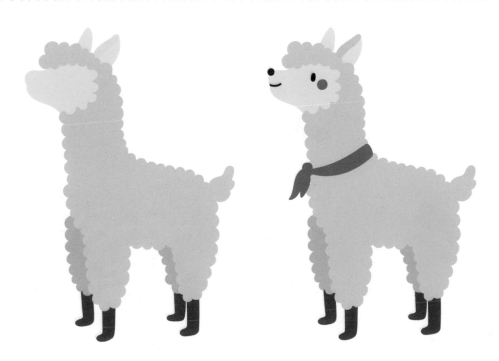

Add four small feet and tie a decorative bandana around the neck!

zebra

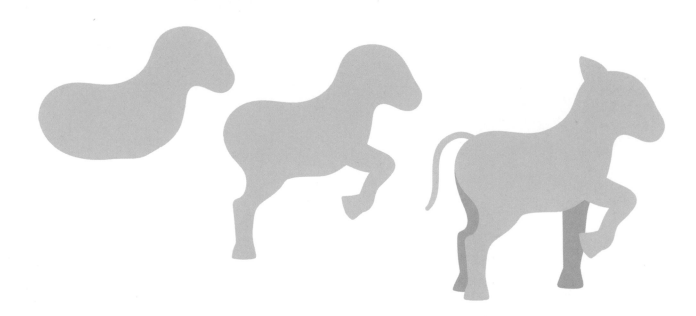

The zebra has a rounded head and body. Paint one leg up in the air! Add an ear and a skinny tail.

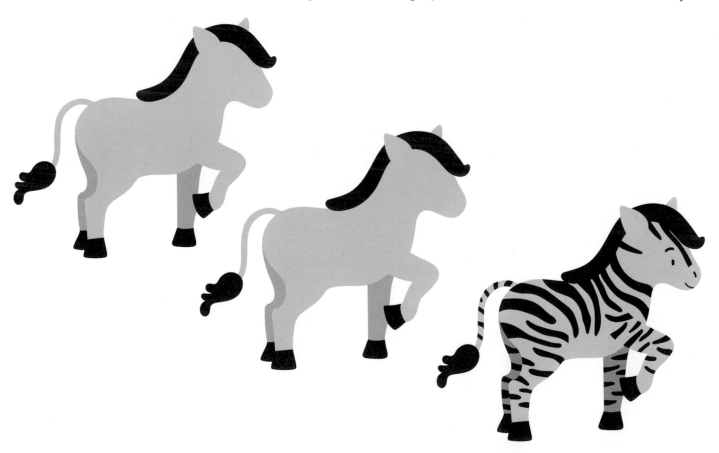

The hooves are large and wide at the bottom.
Paint a flowing mane, tuft of hair on the tail, and stripes all over!

lion

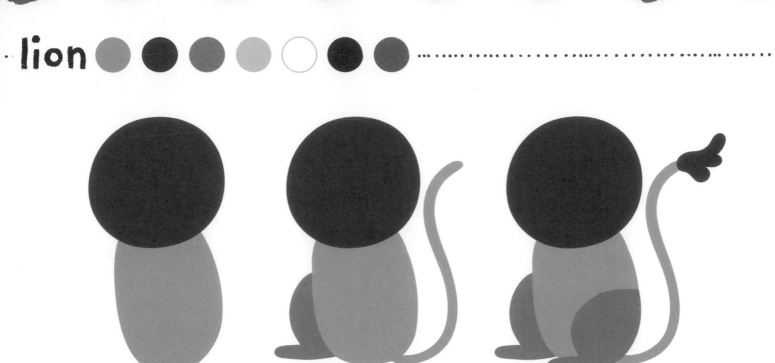

Paint a tall oval for the body and a big circle for the mane. The S-shaped tail is long and skinny.

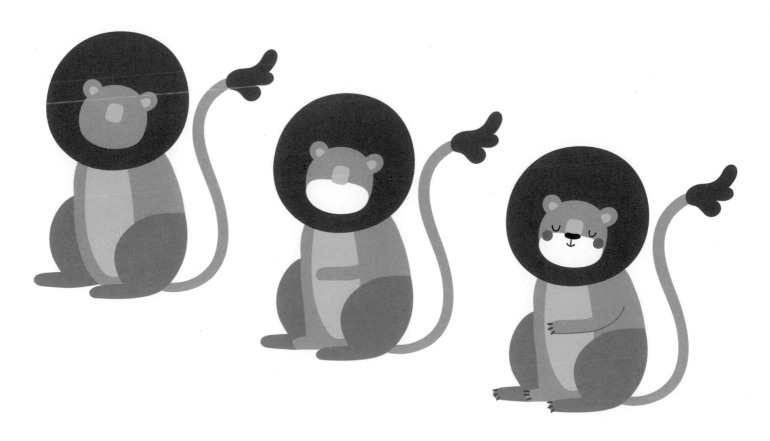

Build the head, nose, and ears with round shapes. Add the remaining limbs and claws.

elephant

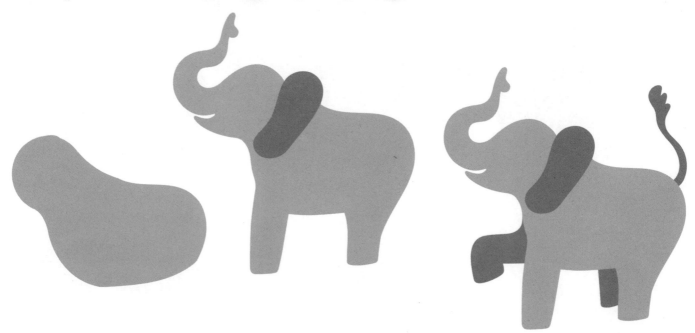

The elephant has a thick torso and rectangular legs. Use a jelly bean shape for the ear and the tip of the snake-like trunk!

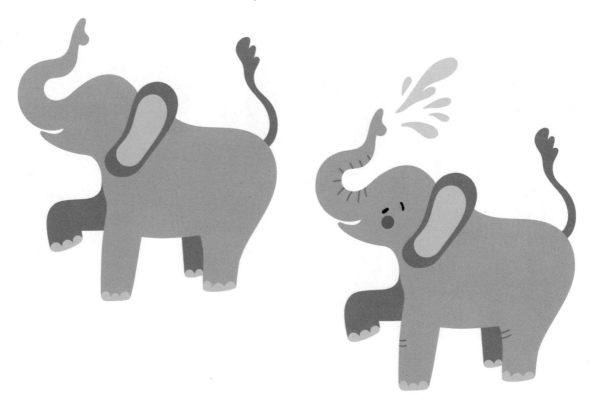

Paint short, thin lines to show wrinkles on the knees and trunk.
Use teardrop shapes to add a splash of water!

tiger

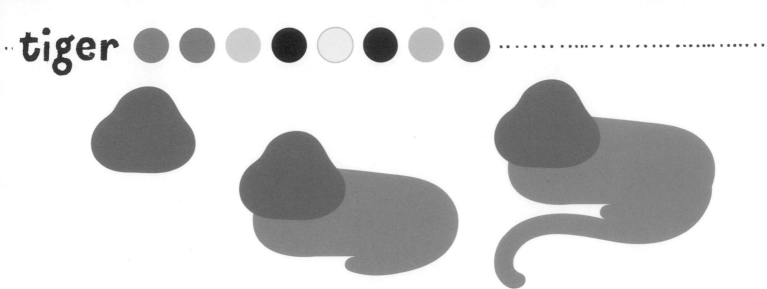

The tiger's head is a rounded triangle. Add a long, curving tail.

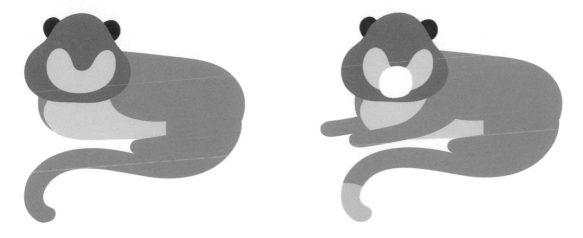

Paint half-circle ears and light markings. Add a circle on the middle of the face.

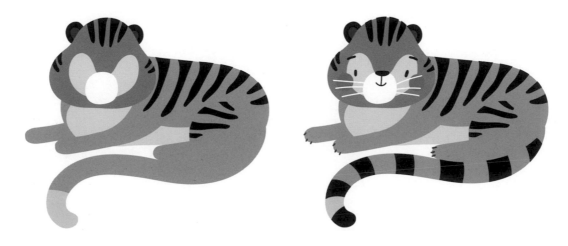

Use thin, black lines for the stripes and claws. Detail the face with a nose and whiskers!

giraffe

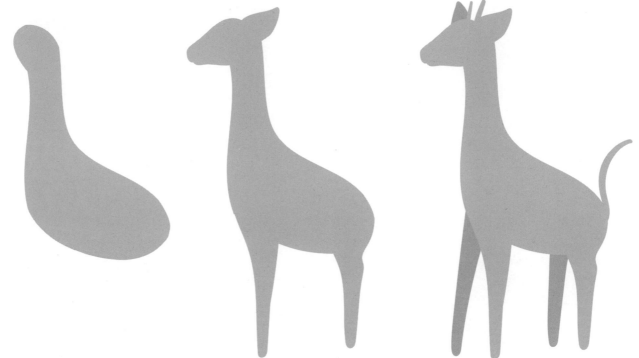

The giraffe has a long neck, skinny tail, and tall legs. Use triangle shapes for the pointy face and ears.

crocodile

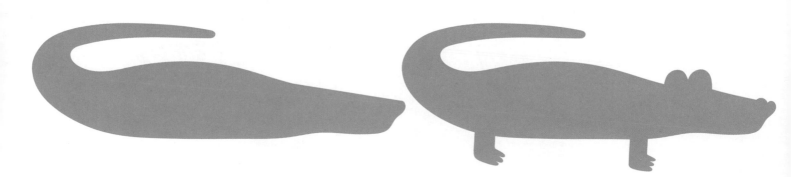

The croc has a long body and tail. The head is rectangular with round eyes on top!

Add the horn-like ossacles using lines topped with circles.
Then paint spots, hooves, a tuft of tail hair, and the inside of the ear!

Paint the underbelly and add triangles for spikes along its back.
Dot on a pair of nostrils and draw a wide mouth!

people

faces

Start with an oval and add half circles for ears. Top with three curved strokes of hair.

Painting people gives you a chance to experiment with so many fun things, such as hairstyles, hair colors, jewelry, glasses, mustaches, beards, and clothing. Follow these step-by-step examples, and then make as many of your own characters as you can!

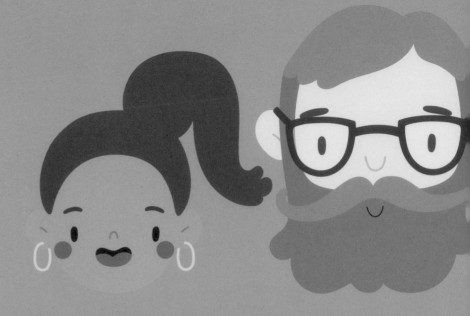

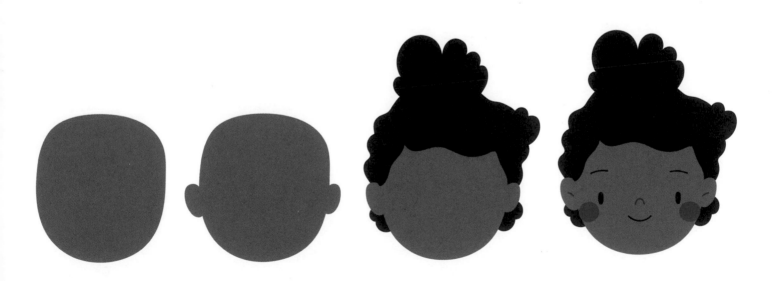

Give this cutie a high, curly bun!

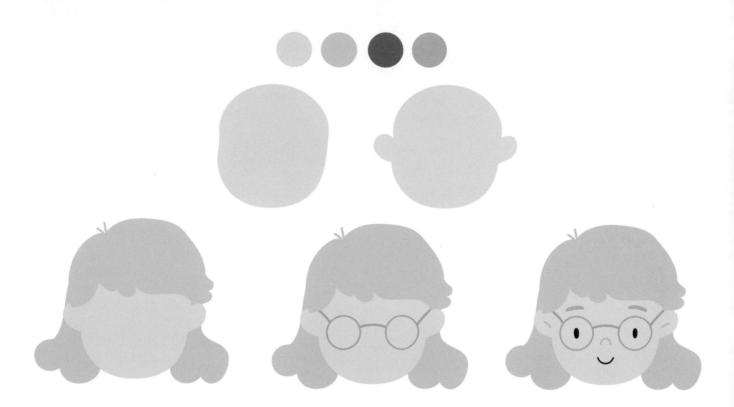

The hair is smooth on top and curly on the bottom. Add circles for glasses!

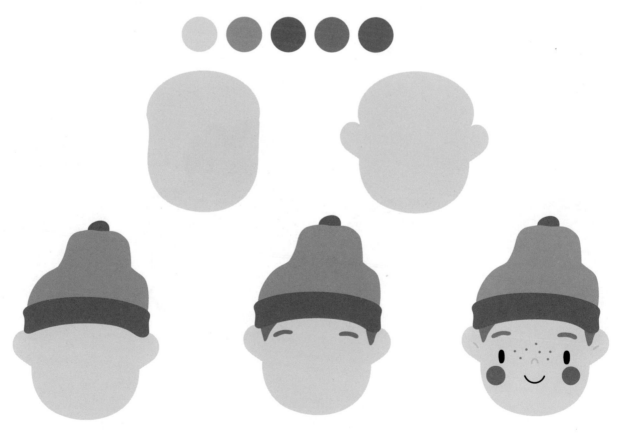

This kid's beanie curves with the forehead. Add dots for freckles!

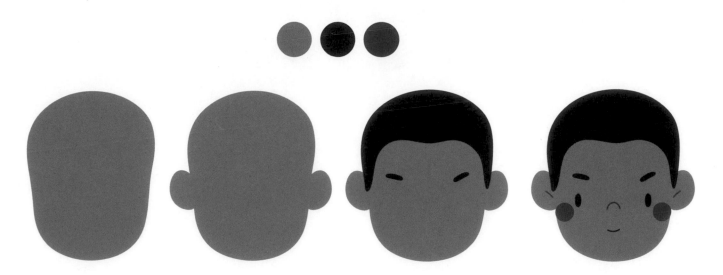

Start with an oval that's slightly wider on top. The eyebrows and mouth are short!

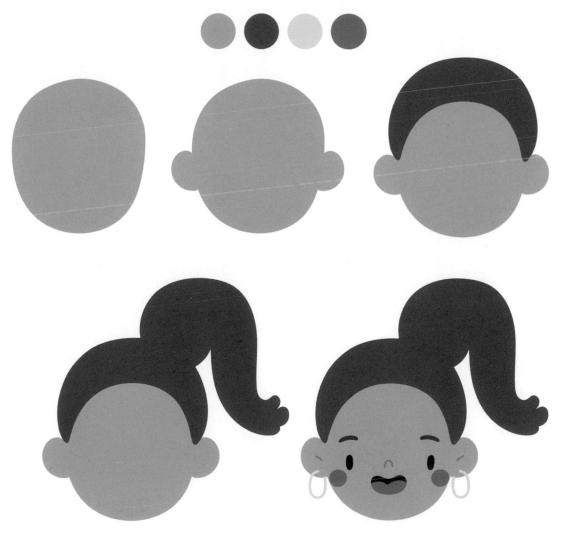

Paint a high, curving ponytail and a big smile. Use circles for hoop earrings!

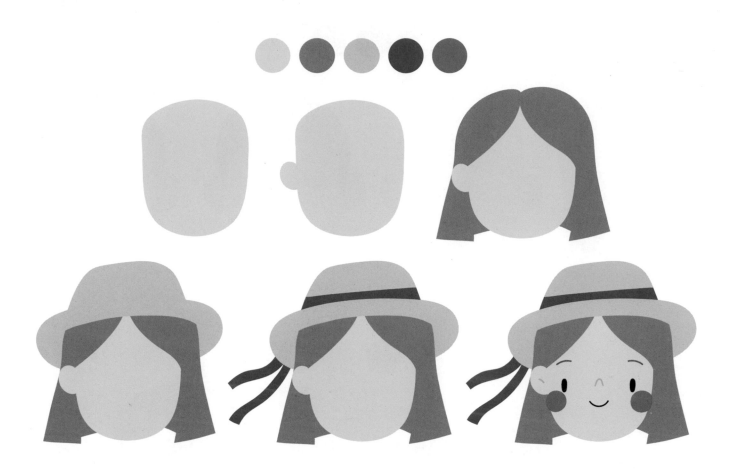

This girl's hair parts in the center and is straight across the bottom.
The brim of the hat makes an oval around her head!

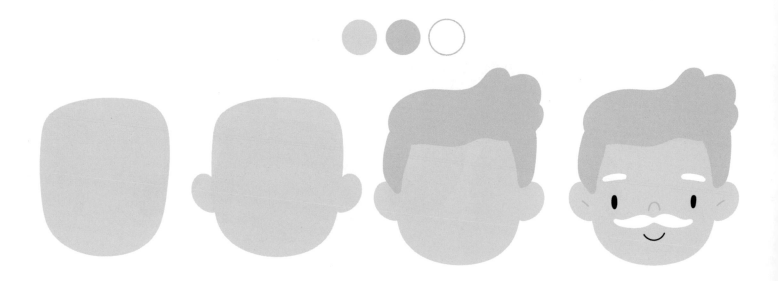

This old man's gray hair is wavy on top. Use two teardrop shapes for the mustache!

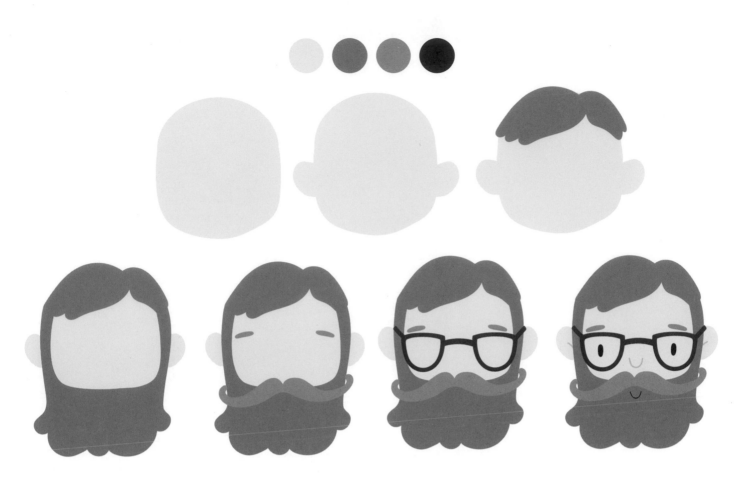

This man's mustache is curvy and his beard is curly! Paint the glasses using thin lines.

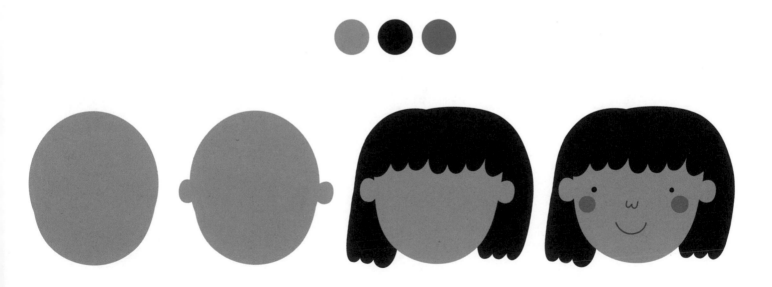

Paint hair that is flat on top with scalloped edges along the bottom.

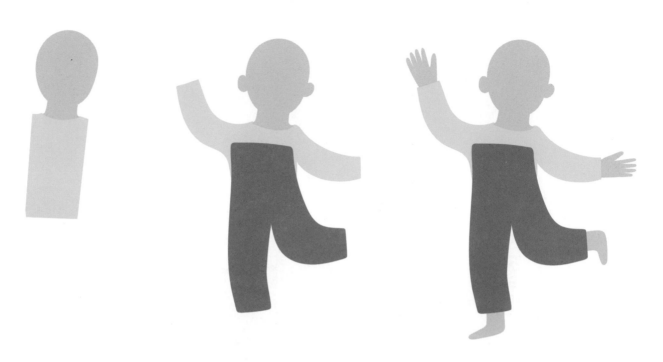

The outstretched arms, leg in the air, and flowing hair show a playful attitude!

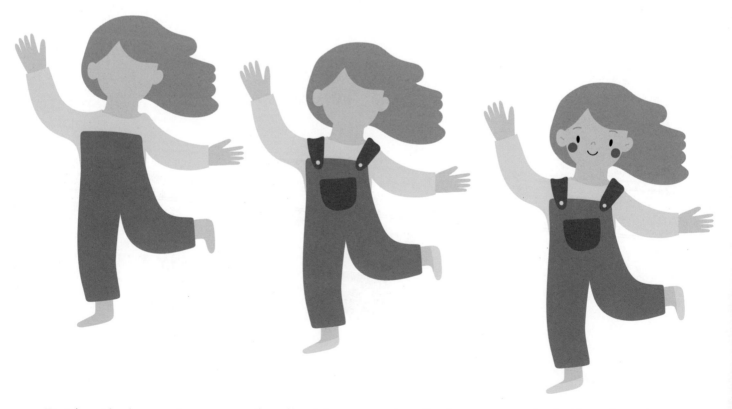

Finish with shoes, straps over the shoulders, two dots for buttons, and a half-oval pocket.

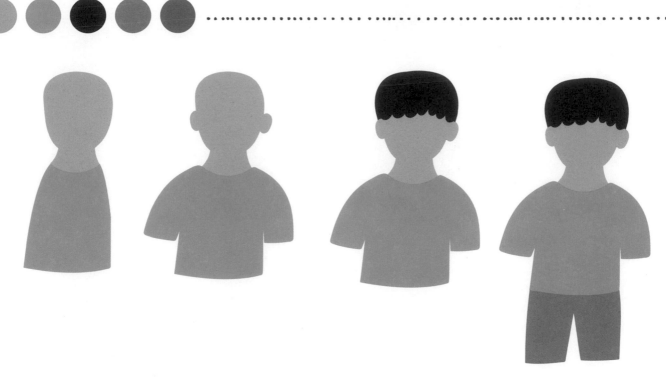

This kid's shirt has rounded shoulders, and the shorts are two rectangles.
The hair is flat on top with a scalloped bottom.

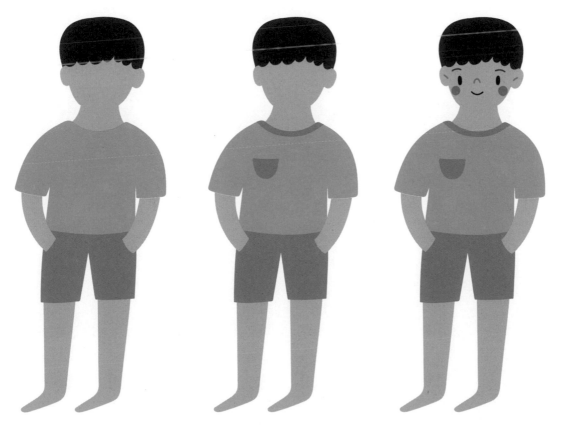

Paint arms and legs. Then outline the scoop of the neck and add a half-circle shirt pocket.

The dress has a V-shaped neckline and puffy sleeves. The bottom is a tall bell shape!

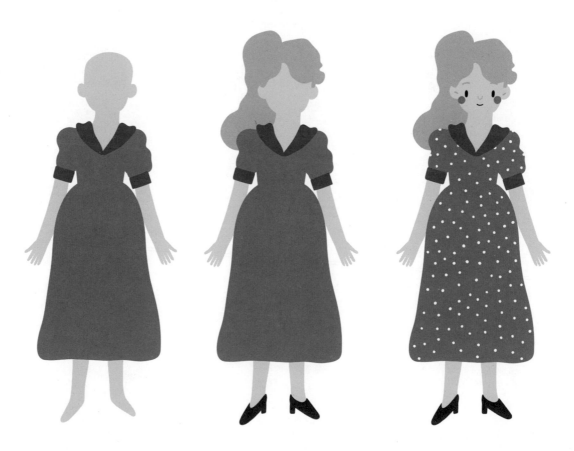

Add a curly side ponytail, pointy shoes with heels, and polka dots over the dress!

Start with a bean-shaped head, and then add the neck, ear, and sweater.

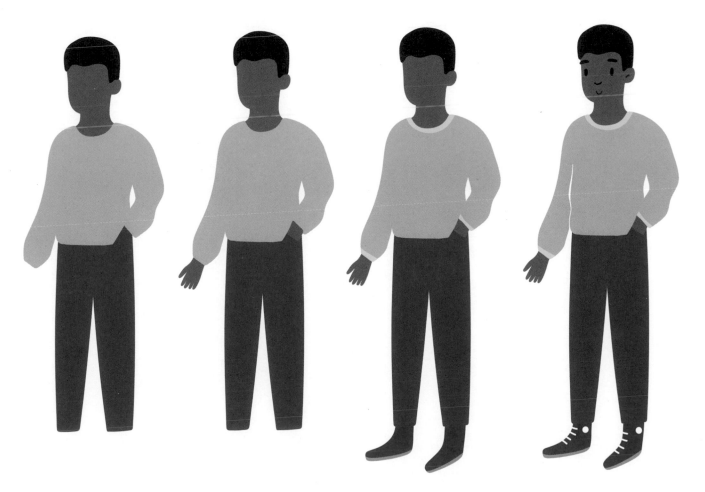

Use long rectangles for the legs. Put one hand in the pants pocket and add cool shoes!

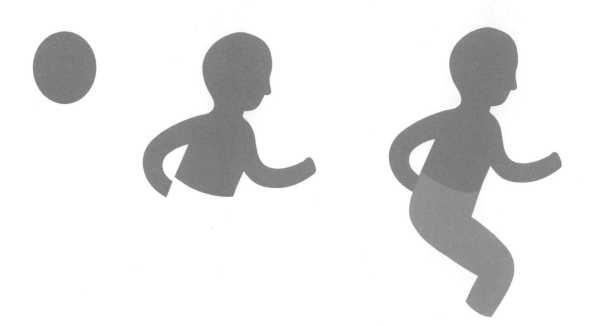

Paint an oval for the head and add a torso and curved arms. The front leg is bent at the knee.

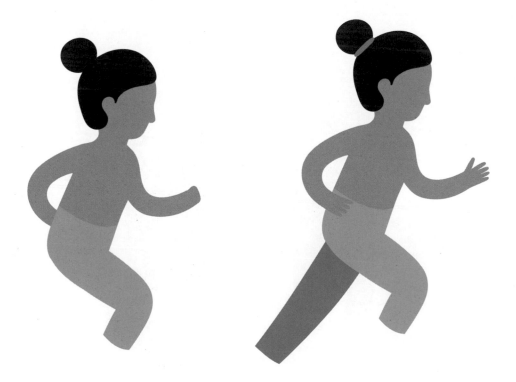

Use a circle for the bun, and paint a line for the pink hair tie! Make the back leg long and slanted.

Now add hands and L-shaped feet. Paint a top that matches the running shoes!

superhero

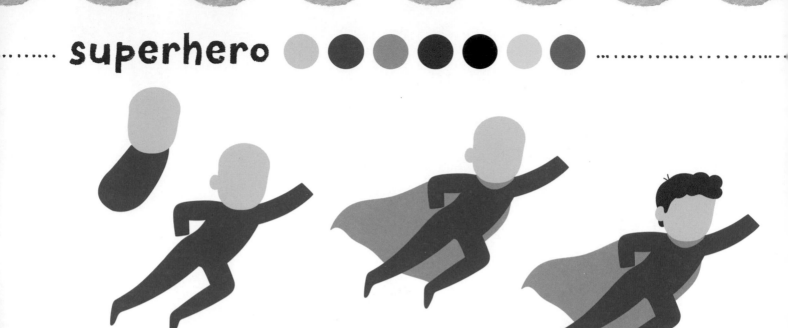

Start with an oval head and a bean-shaped torso, and then add the limbs. One hand is on the hip, and one leg is bent! Think of the cape as a wavy triangle shape behind the body. Add hair!

ballet dancer

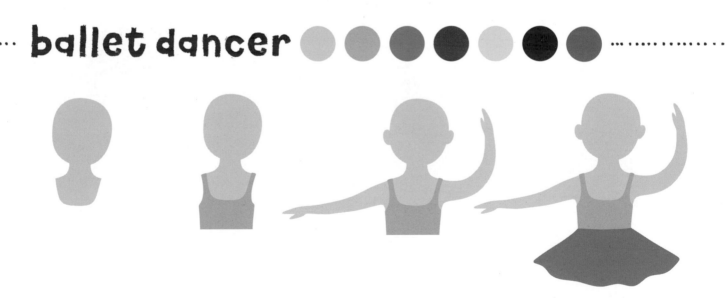

Start by painting an oval for the head and a small top with thin straps. One arm is outstretched, and the other curves upward. The tutu is short and wide with a wavy bottom!

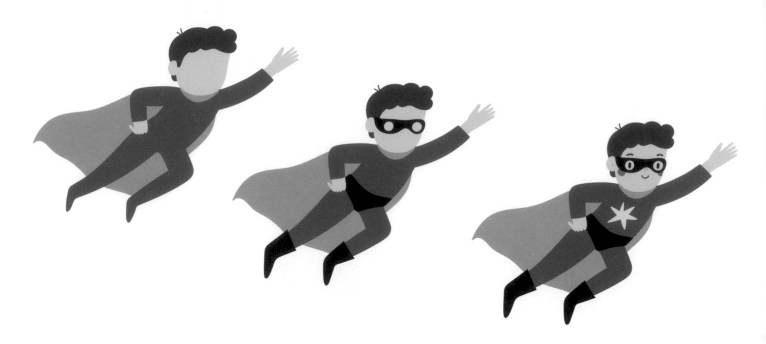

Paint the hands, and then add boots, little pants, and a mask with circular eye holes.
Finish the superhero suit with a gold star on the chest!

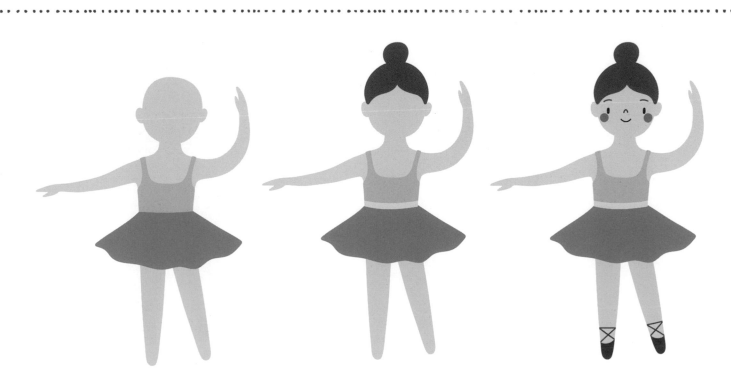

Add long legs with rounded toes. Use a circle for a bun on the top of the head.
Paint an "X" on each foot for shoe straps!

police officer

Paint an oval head, two half-circle ears, and a neck. Add the uniform, shoes, and straight hair.

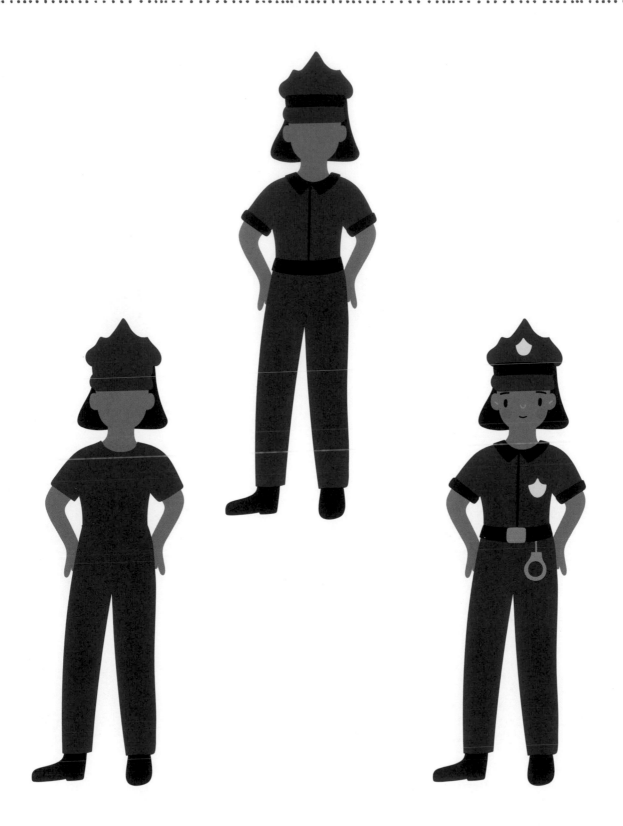

The triangular cap has a pointed top! Detail the cap, collar, sleeves, and waist with black bands. Finish with a belt buckle, handcuffs, and two gold badges!

firefighter

The firefighter has a high collar with a V-shaped dip. Add a hat, and then detail the shirt and pants with buttons and yellow bands.

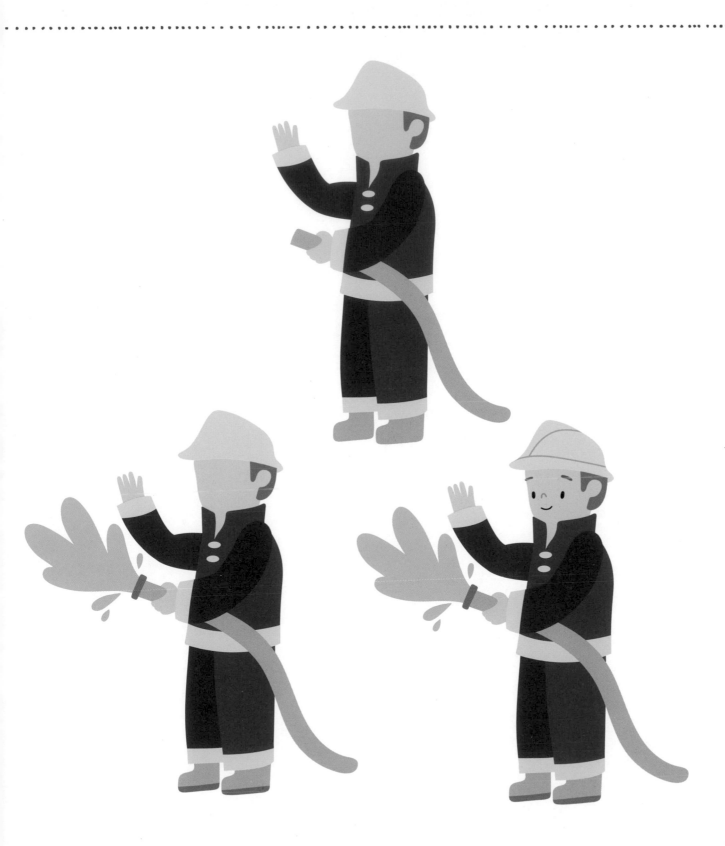

Paint a thick, curving hose with a spray of water. Use teardrop shapes for more water droplets!
Add boots and detail the helmet with thin lines.

magical fairy tale

unicorn ● ● ● ●

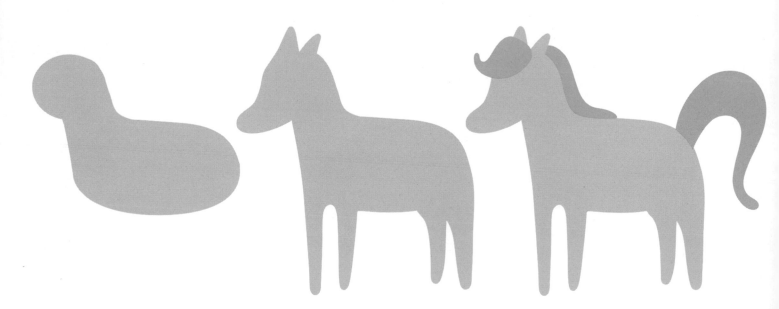

Start this unicorn with a circular head connected to wide, oval body.
The ears are little triangles, and the tail curves like an upside-down "U."

Step into a kingdom of fantasy where you'll learn how to paint a castle, a royal family, and a brave knight. In this enchanted land, unicorns roam the earth, mermaids swim in the seas, and fairies dwell in the forests. Set your imagination free—anything is possible in a fairy-tale world!

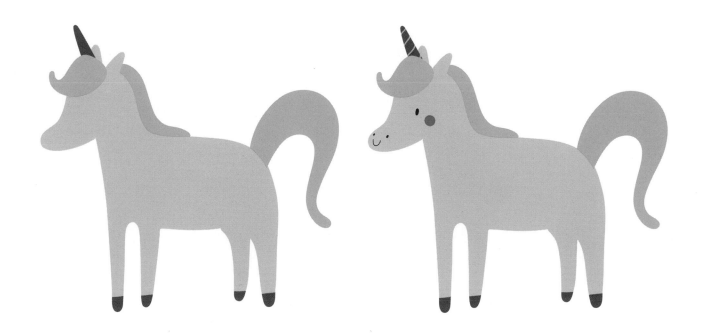

The unicorn's horn is a triangle with diagonal grooves. Add half circles for hooves!

fairy

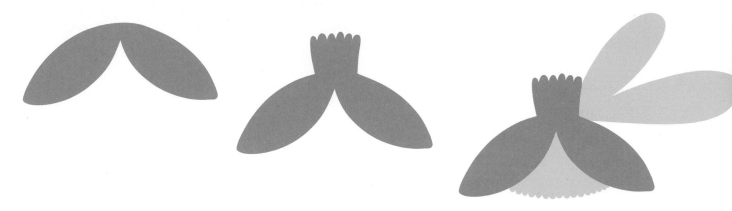

The tips of the dress are pointed like leaves, and the tips of the wings are rounded!

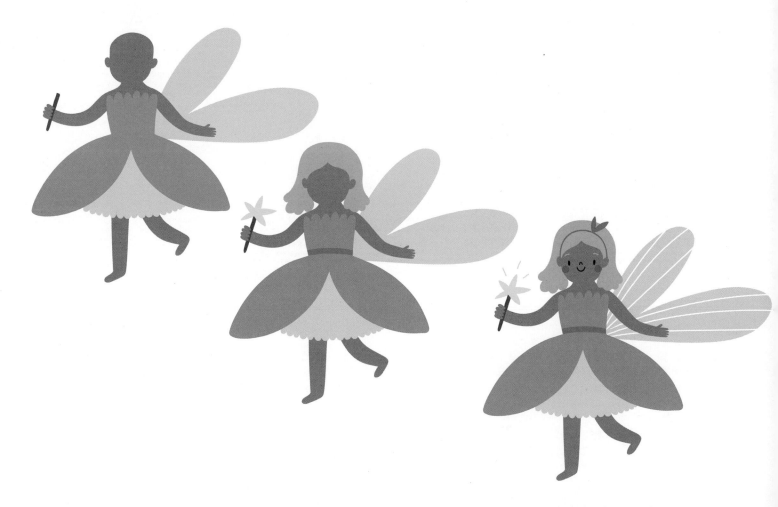

The wand is a line topped with a star. Give the fairy bright hair and a leafy headband.
Detail the wings with long, thin lines!

castle

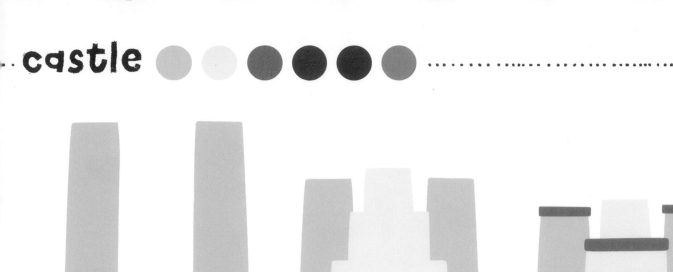

Paint two tall rectangles for towers. Then stack three rectangles for the center.

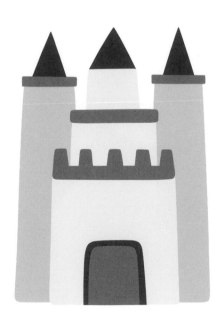
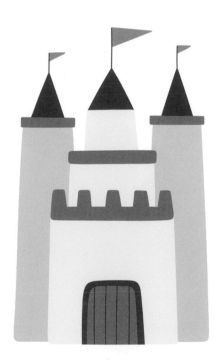

Outline the castle door and paint thin lines to show planks of wood.
Top each tower with a triangle—and use triangles for the flags too!

mermaid

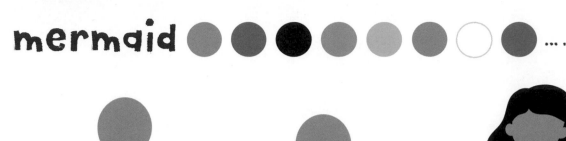

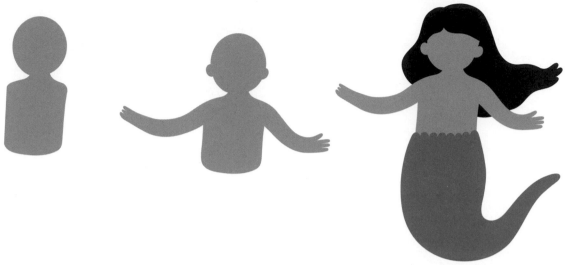

Paint a round head, square torso, and outstretched arms. Her tail is shaped like a pipe!

pirate

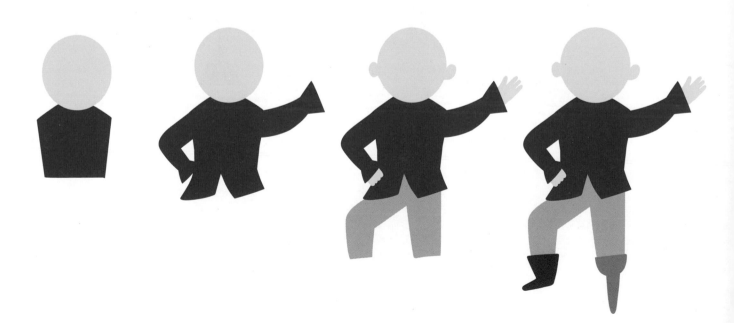

Start with a round head and add the coat, pants, and boot. Use a sharp point for the peg leg!

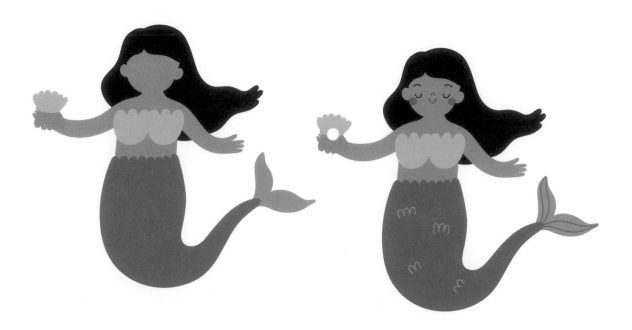

Use scalloped edges to detail her top, waistline, and shell. Add a few curls for scales!

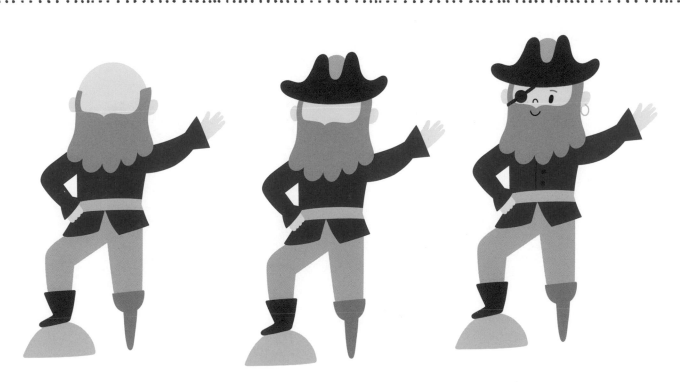

Paint his beard with a scalloped bottom. Add a belt, buttons, an eye patch, and a hoop earring.
The top of the hat is shaped like an "M"!

princess

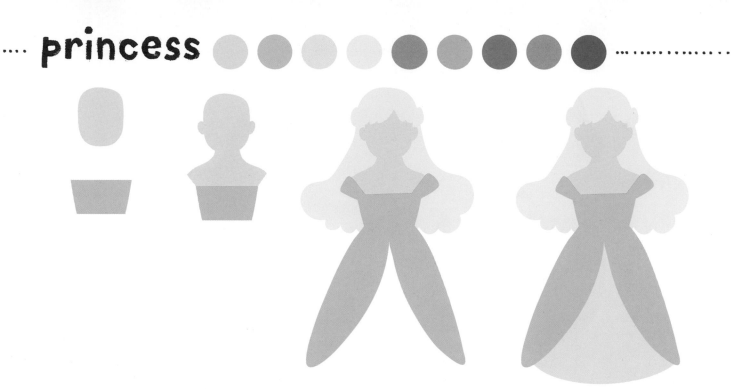

Start with an oval head and a rectangle for the top of the dress.
Her hair is wide and curly at the bottom.

prince

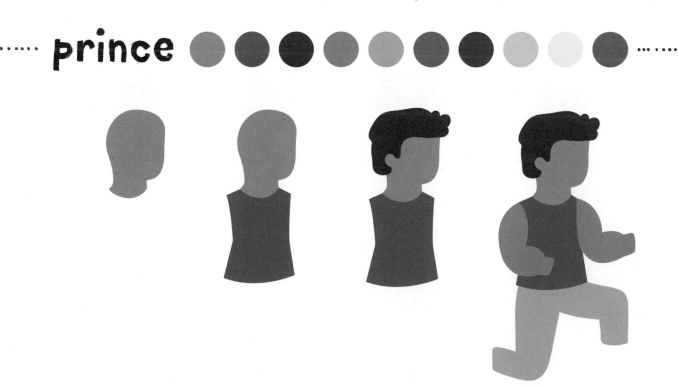

Paint his shirt with a scooped neck and puffy sleeves. Add legs with bent knees.

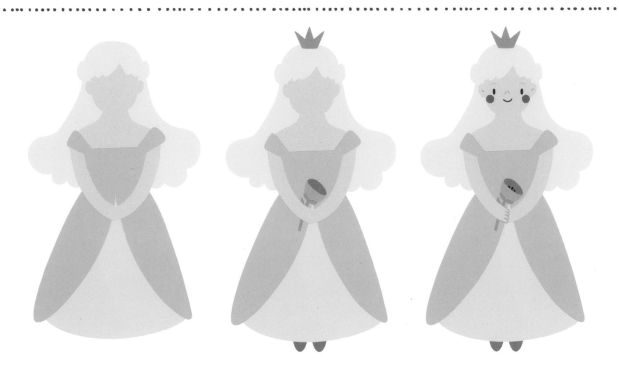

Paint the arms with curved strokes. Give her a rose, a pointy crown, and tiny shoes!

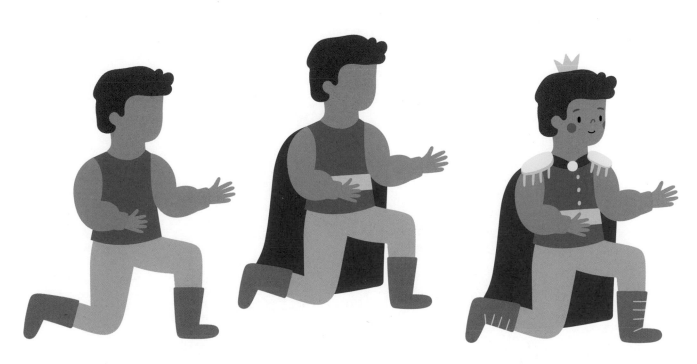

Paint L-shaped boots and a cape. A crown, collar, and shoulder frills finish his royal look!

queen

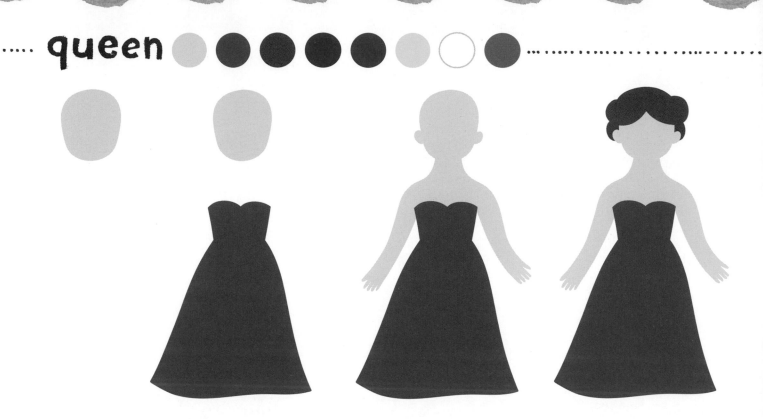

Paint an oval head and then build the dress. It has an "m" shape at the top and a wavy bottom.

king

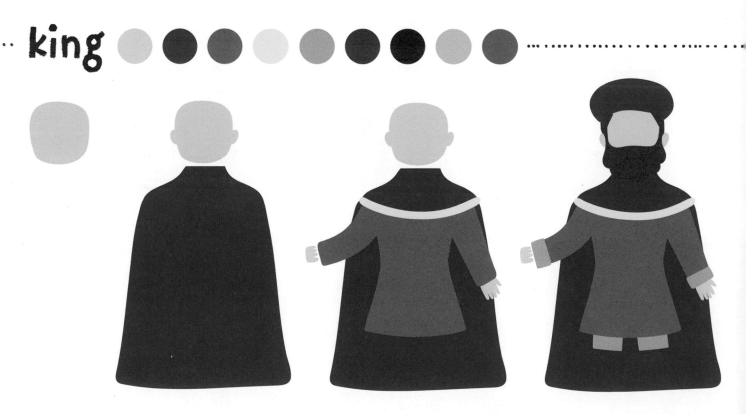

Paint a round head and a bell shape for the cape. The fur lining is a scoop between the shoulders.

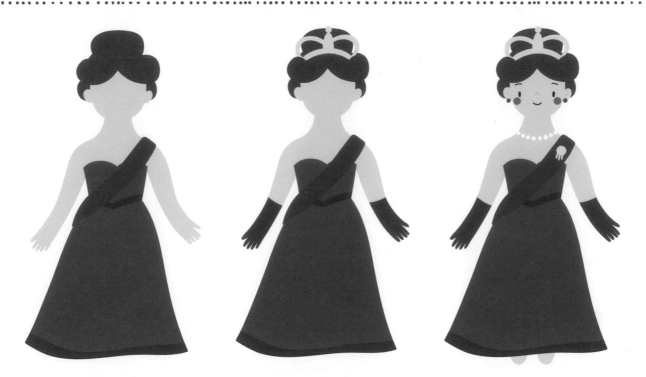

Use a thick, diagonal stroke to paint the sash. Add the crown, gloves, and shoes.
Paint a pearl necklace using a row of dots!

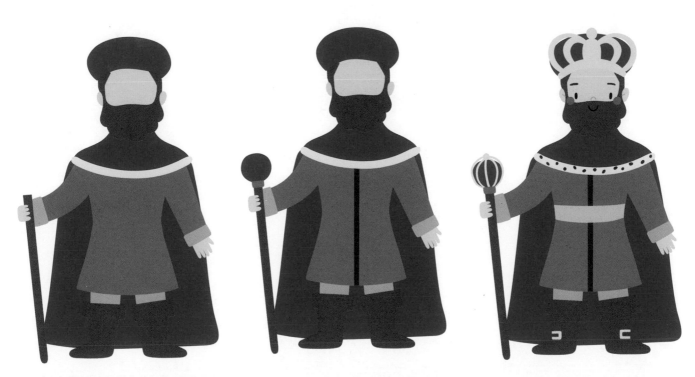

The scepter is a long line topped with a circle. Add dots to the fur and detail the king with gold!

knight

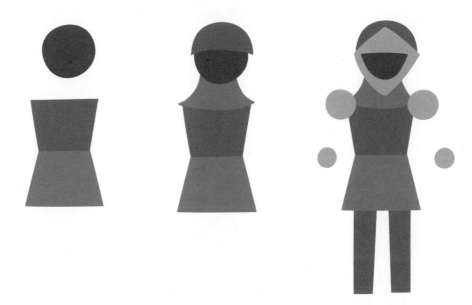

Build a suit of armor! Use circles for joints, rectangles for legs, and a diamond for the face mask.

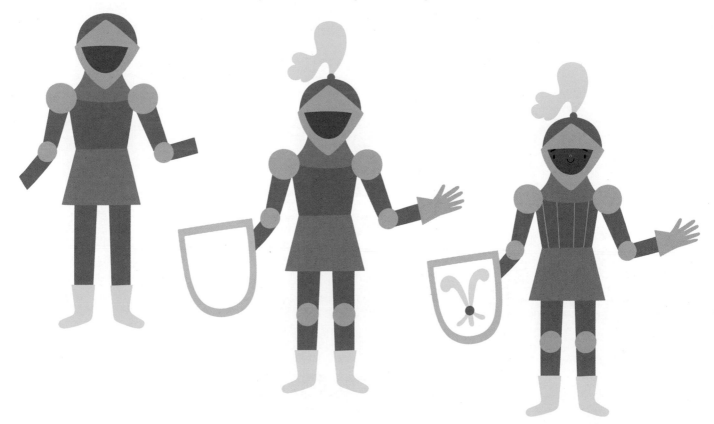

The shield is an upside-down arch. Finish with boots, a helmet feather, and a shield design.

dragon

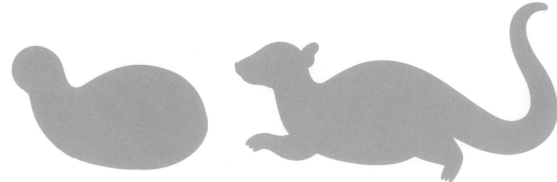

Connect a circle to an oval for the head and body. Add the face, limbs, and thick, S-shaped tail.

Paint the underbelly and add wings with curly ends. Give the tail a triangular tip!

Add pointed horns, a spine of spikes, dots on the skin, and ridges on the underbelly.

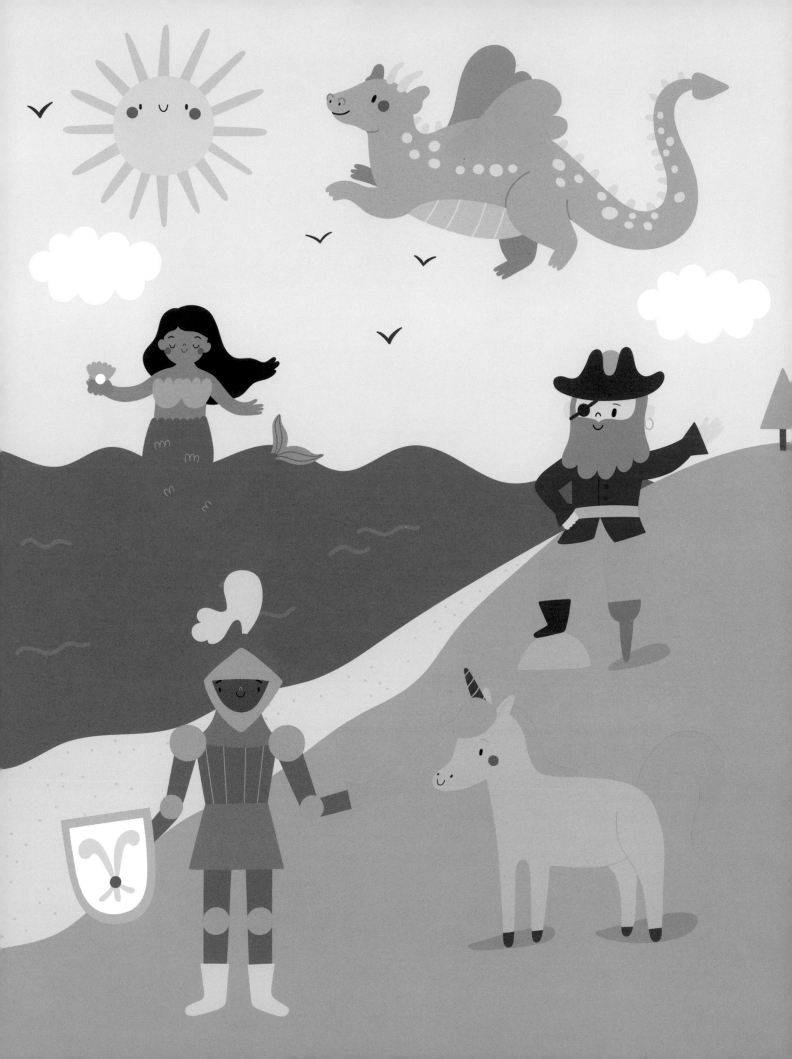

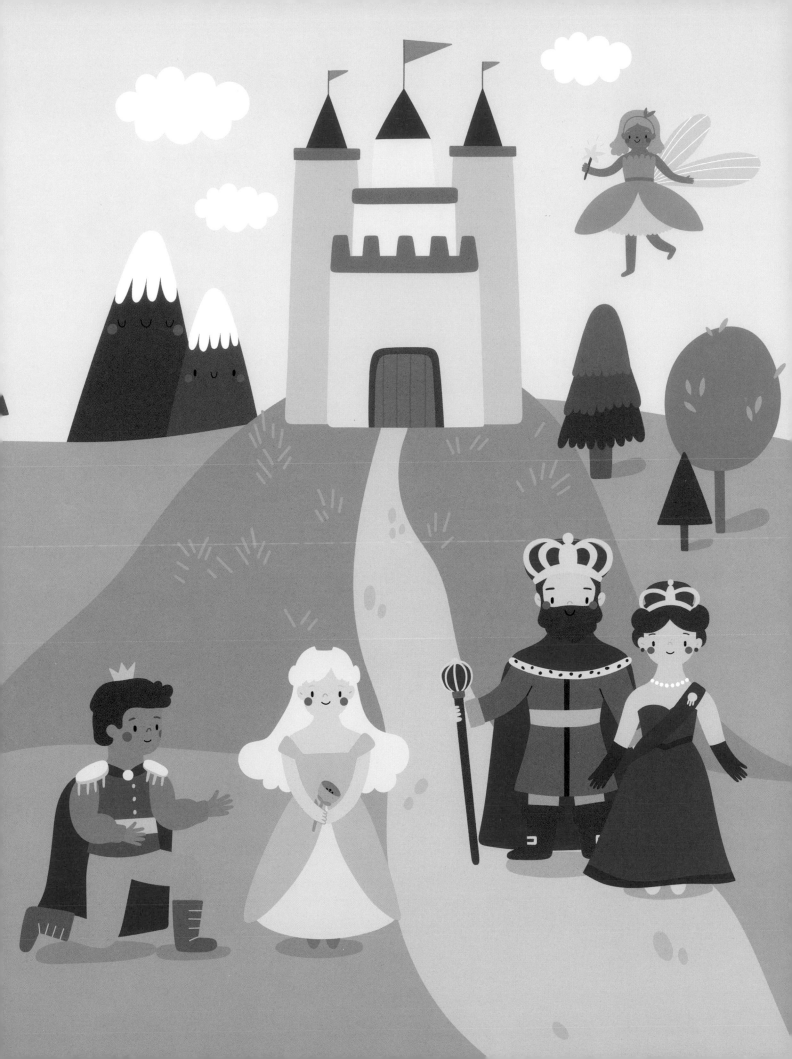

objects

···· teapot ● ● ● ● ● ● ···

This teapot is wider on the bottom than it is on the top.
The spout curves like a backward "S," and the handle looks like half of a heart shape!

When looking for something fun to paint, you don't really have to go anywhere! Just look around your house, and you'll find fun shapes, lines, and colors in objects you see every day. Follow the step-by-step projects to paint a light bulb, a clock, a globe, a pair of glasses, and more!

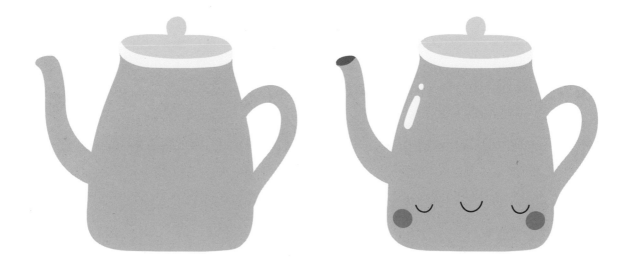

The lid is an oval with a circle on top. Add an oval shadow in the spout and highlights for shine!

t-shirt

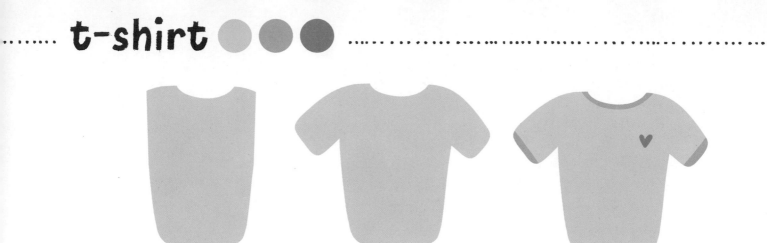

Paint a tall rectangle with a scoop for the neck. Add rectangles for sleeves and detail a few edges!

lamp

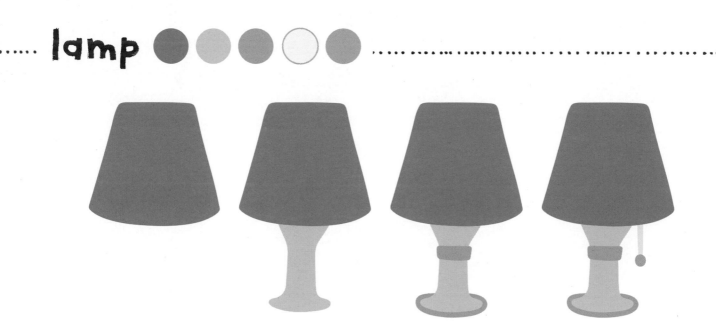

This lampshade is shaped like a skirt! Give it a sturdy base, and use a line and circle for the pull chain.

pencil

Start with a long, thin rectangle. Add a half circle for the eraser and a triangle for the tip.

light bulb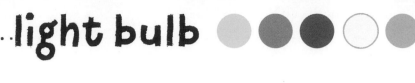

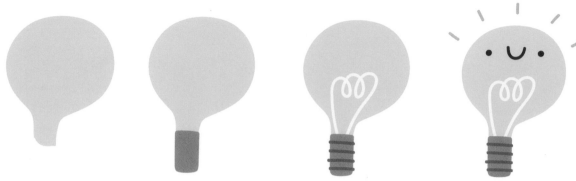

Paint a circle and add a rectangular base with horizontal lines. Detail with a curly coil and rays of light!

envelope

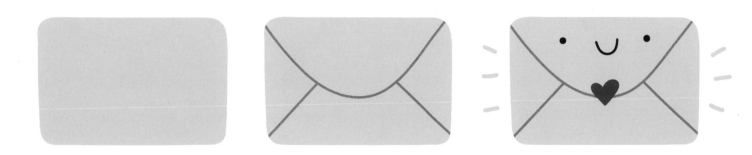

Start with a rectangle and add lines to detail the folded paper. Seal it with a heart!

Paint lines along the pencil's barrel. Detail the tip and eraser with black!

trophy

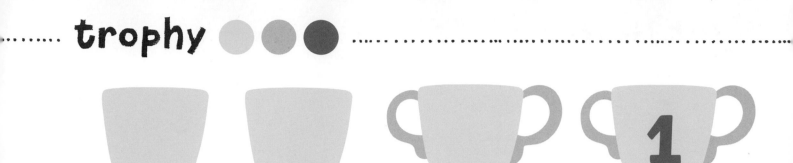

Start with a square shape that's wider on the top than the bottom. Add a rectangular stem and an oval base. The handles are shaped like question marks!

globe

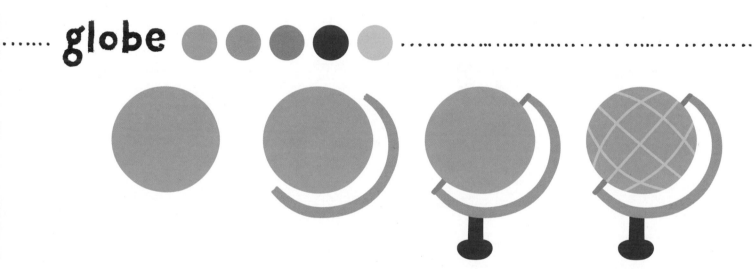

Start with a solid circle and add a half-circle around it. Add the base and detail the globe with grid lines!

backpack

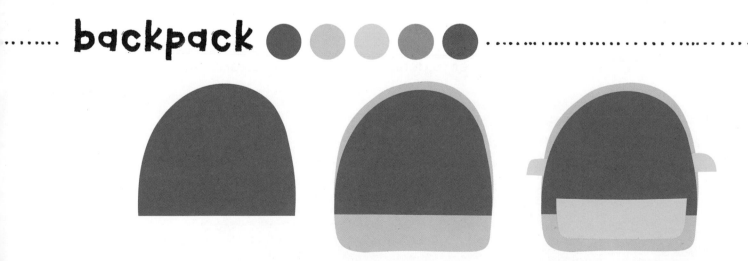

Paint a solid arch shape. The bottom of the backpack and pockets are rectangular.

potted plant

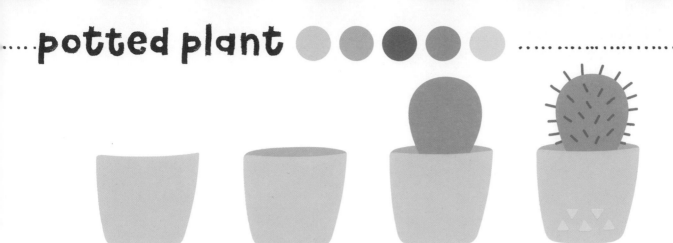

The pot is a square shape with a skinny oval across the top.
Give your cactus thin, prickly spines, and detail the pot with triangles!

mug

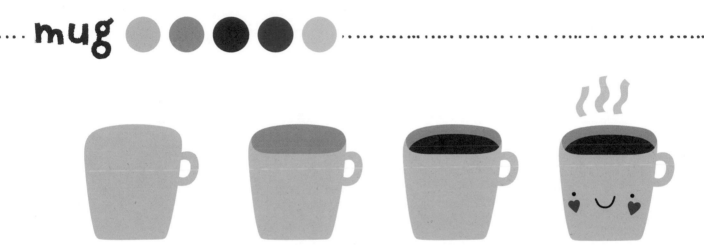

Start with a rectangle and add a backward "C" shape for the handle. Add an oval at the top
for the inside of the mug, and another oval for the liquid inside! Paint wavy lines for steam.

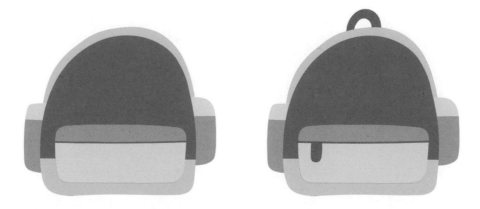

Paint more rectangles to finish the pockets. Add a handle, a zipper, and a half-circle hook for detail!

clock

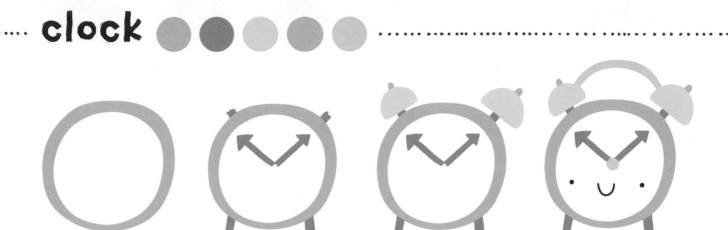

Start with a circle and add the clock's two "hands."
The alarm bells are half circles connected with an arch!

eyeglasses

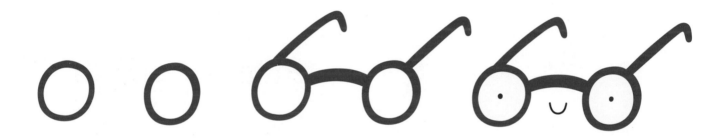

Connect two circles with a curved line. Then add two hooks.

journal

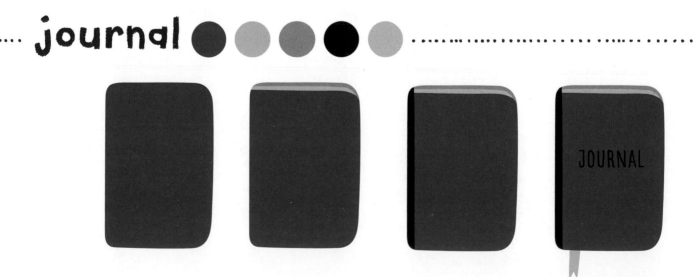

Paint a tall rectangle with rounded corners. Don't forget a ribbon bookmark!

calculator

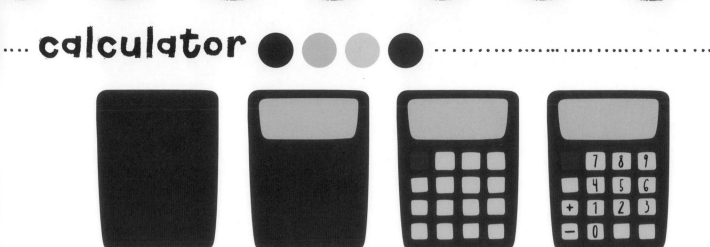

Start with a rectangle, and then paint a wide screen and square buttons. Add numbers for detail!

computer

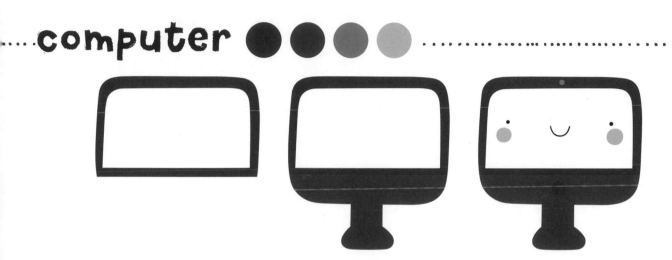

The computer is wide rectangle with rounded corners. Use circles to add button details!

phone

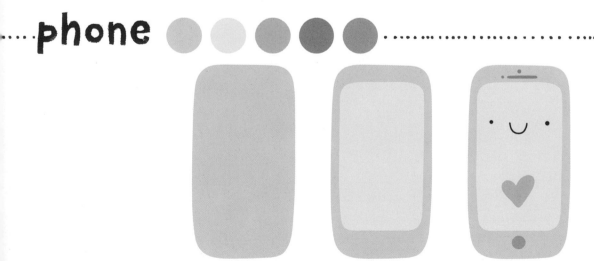

Use two rectangles to paint the phone and its screen. Add a circle button and details up top!

matryoshka doll

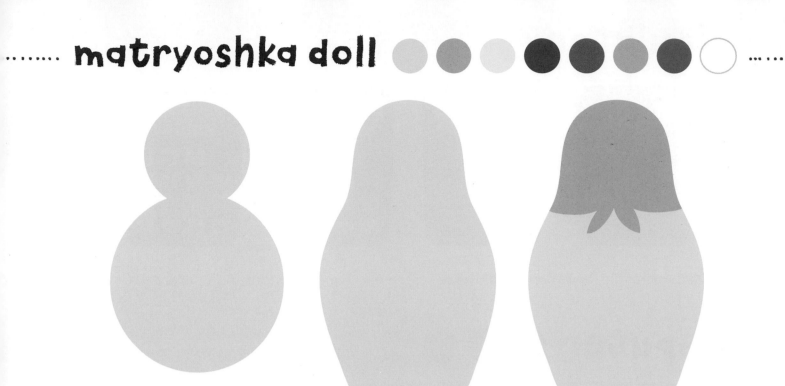

Create the doll's shape using two overlapping circles Then add a handkerchief with two points.

balloon

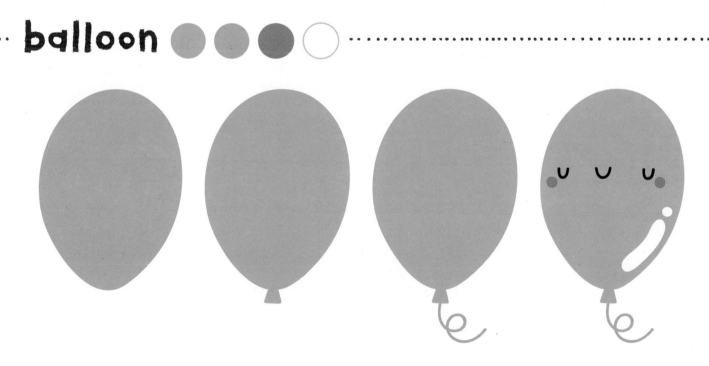

Balloons look like upside-down egg shapes. Paint a triangle for the tie at the bottom, and attach a curl of string. Add white highlights for shine!

Paint a circle for the face, and use ovals to build the flower. Add thin leaves, a face, and dots for detail!

sugar skull

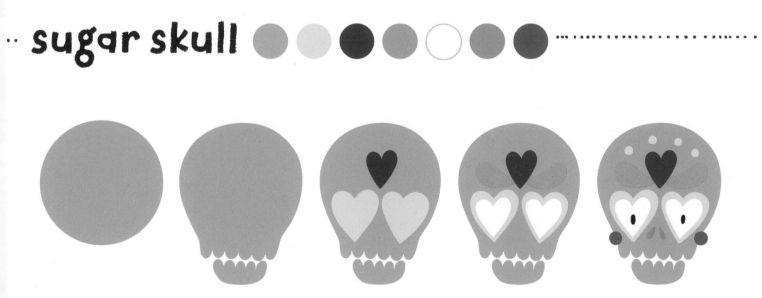

Build on a circle to create a skull with two rows of scalloped teeth. Detail with hearts and dots. Use two small teardrop shapes for the nose, plus two more heart shapes for the eyes!

things in nature

flowers

Use heart-shaped petals for this flower. Paint a line for a stem, rounded leaves, and a wavy center!

The natural world is full of beautiful scenes and colorful critters. Learn how to draw all sorts of outdoor subjects in this chapter, from big things (like sunsets and rain clouds) to little things (like flowers and bugs). You can even try painting outside for extra inspiration!

This flower is made up of skinny ovals. Paint a long, thin stem and add a circle for the center.

flowers

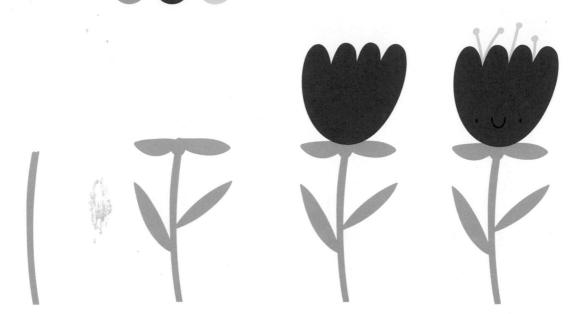

A tulip looks like half an egg shape with a scalloped top.
Use thin yellow lines and dots at the top for the stamen!

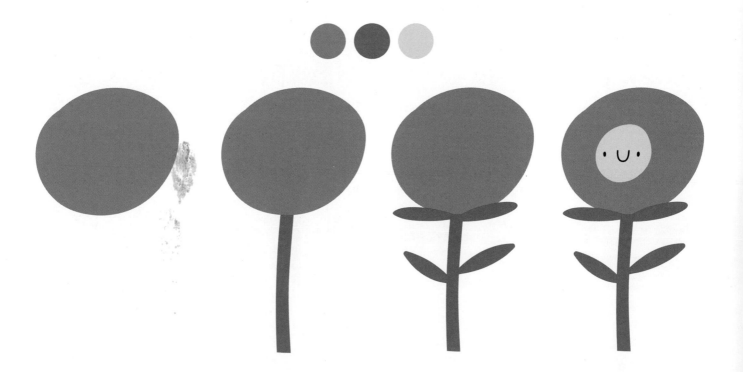

This simple flower is a circle inside of a circle. Paint a line for the stem and add pointed leaves!

butterflies

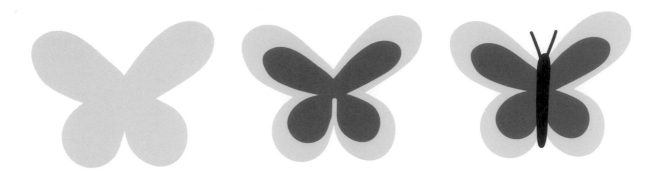

These curvy wings make an "X" shape. Paint a thick line for the body and thin lines for antennae.

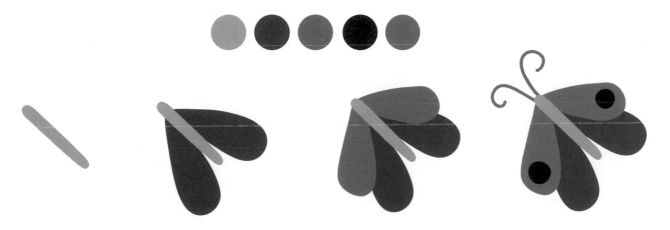

Paint two layers of pink wings using teardrop shapes. Detail with two circles and curling antennae.

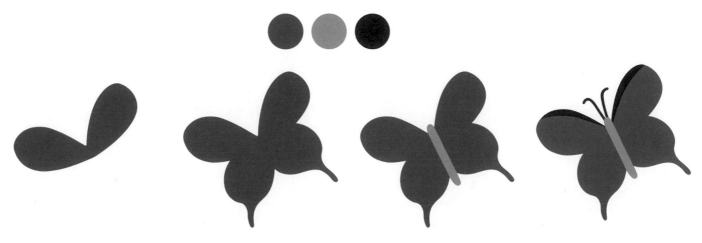

Use two teardrop shapes and two ovals for the wings. Add points on the bottoms for detail!

birds

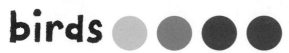

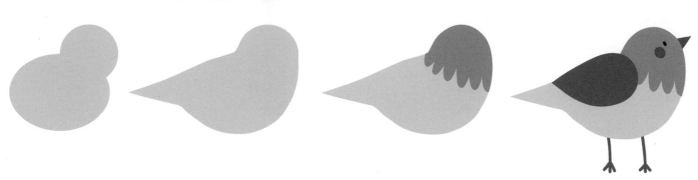

Start with two circles for the body and a triangle for the tail. The wing is a teardrop shape.

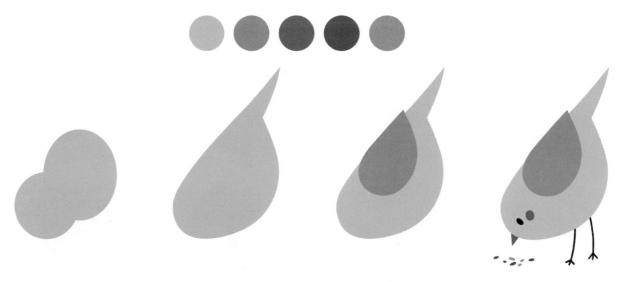

This bird's tail points up into the air. The beak is a triangle. Paint small dots for seeds on the ground!

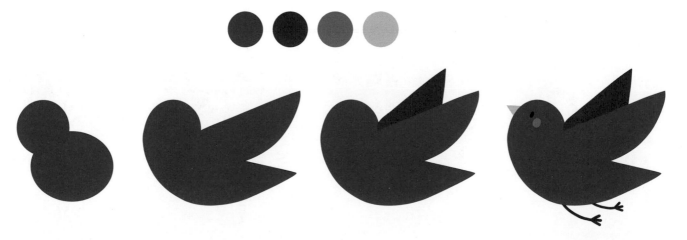

Use two circles for the body and a triangle for the tail. Paint the first wing using half an oval, and add the second using a darker triangle. Give it a triangular beak and curved lines for legs.

Try painting more birds with different shapes and colors!

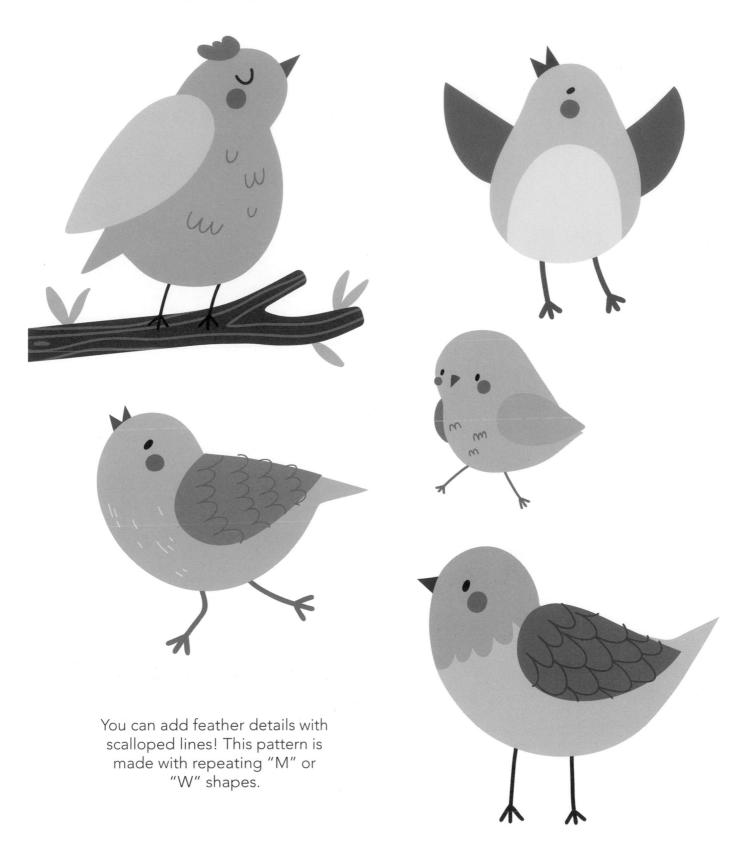

You can add feather details with scalloped lines! This pattern is made with repeating "M" or "W" shapes.

caterpillar

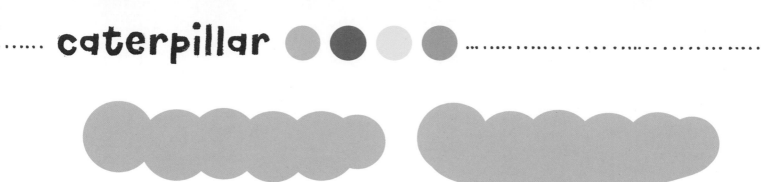

Paint a row of overlapping circles for the body. Smooth out the bottom with a long, straight stroke.

snail

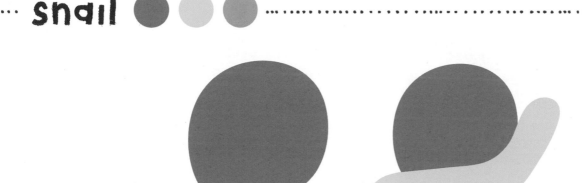

Paint a round shape for the snail's shell. The body is like an "L" on its side with a squiggly bottom!

bee

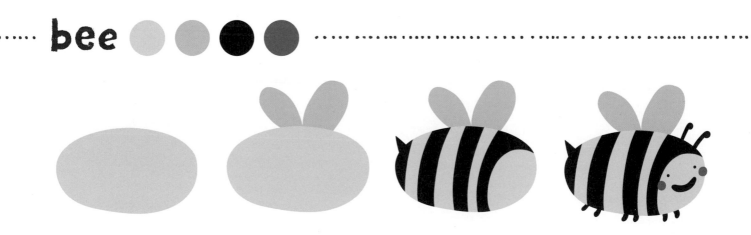

Begin with an oval and use thick black lines to add stripes.
The stinger is a tiny triangle, and the wings are like ovals!

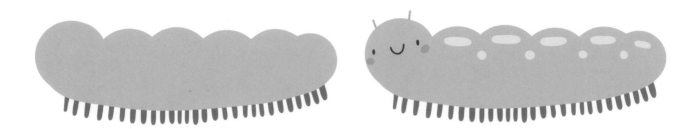

Paint lots of little feet with short lines. Use dashes and dots to detail the body. Add the antennae!

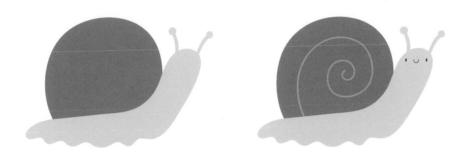

Use a line and a dot for each antenna. Then paint a thin, curving line for the shell's spiral.

ladybug

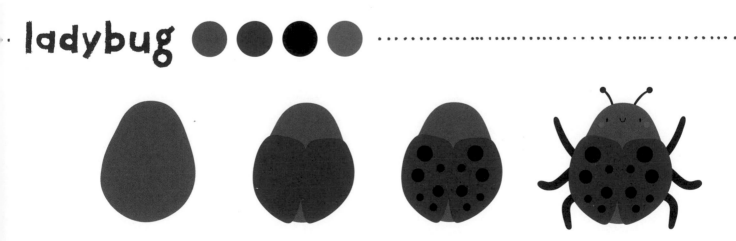

Start with a gray egg shape and paint two teardrop-shaped wings. The black spots are simple circles.

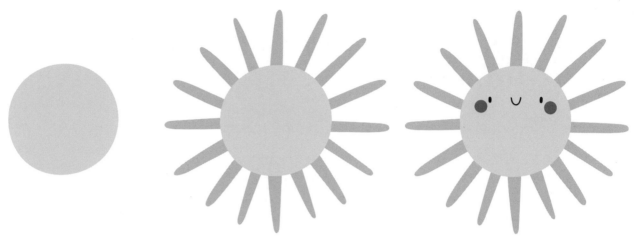

Paint a solid circle. Add thin, pointed lines to surround it with sunrays!

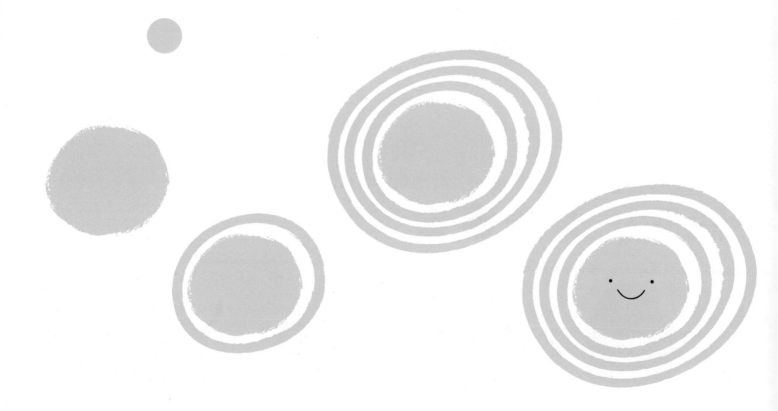

Start with a solid circle. Paint three thin rings around it, leaving rings of white in between.

You can paint the sun in many different ways. Try these variations!

rainbow

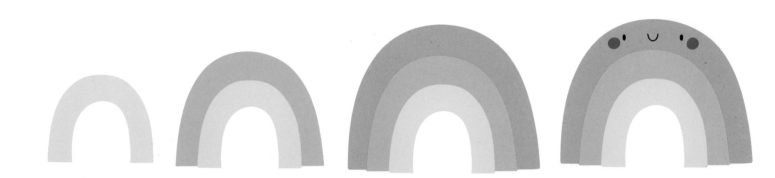

This rainbow is made of upside-down "U" shapes. Start with a small "U" and add the rest on top!

sunrise

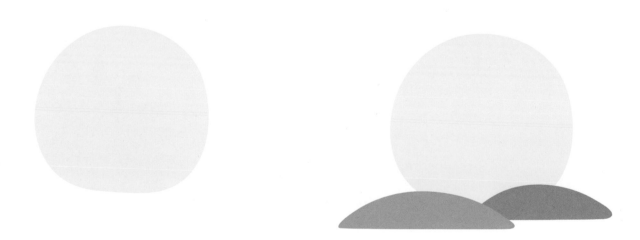

Begin with a solid circle. For the hills, paint two shapes with curved tops and flat bottoms.

rain cloud ● ● ●

Paint a solid cloud with curly edges. Use small teardrop shapes for the rain!

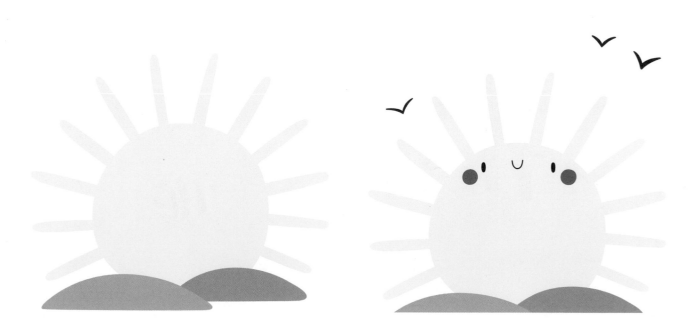

Paint lines for sunrays, and add a few V-shaped birds. Finish with a "good morning" smile!

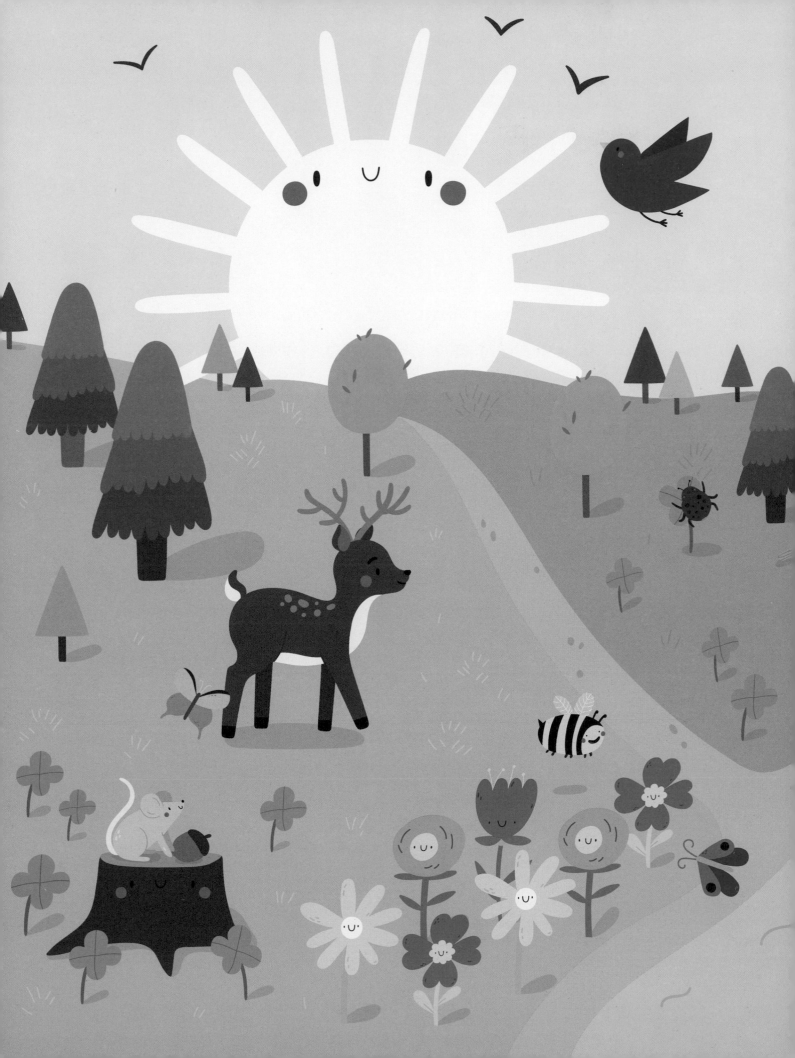

trees

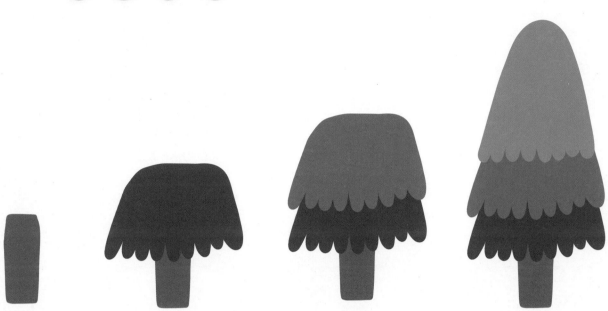

Paint a rectangle for the trunk. Add layers of leaves with bumpy bottoms. The lightest goes on top!

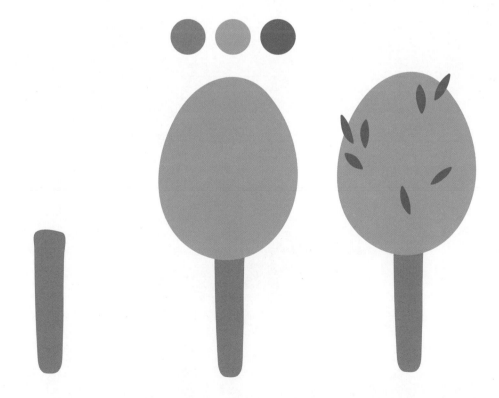

Paint a tall, rectangular trunk and top it with an egg shape. Add detail with a few darker leaves!

162

leaves

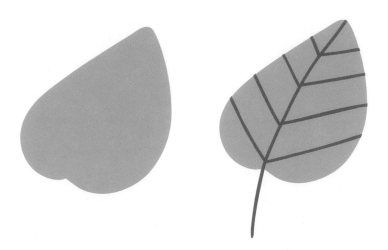

Start with an upside-down heart shape. Then paint thin lines for a stem and veins!

Try painting these other leaves too!

clover

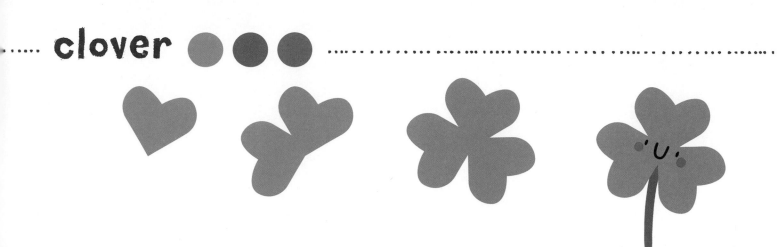

Each leaf of this clover is a heart shape. Paint a line for the stem, and make it smile!

acorn

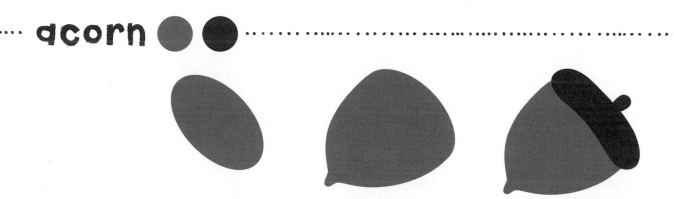

Create the acorn from an oval, and give the bottom a point. The "cap" is shaped like a jelly bean!

twig

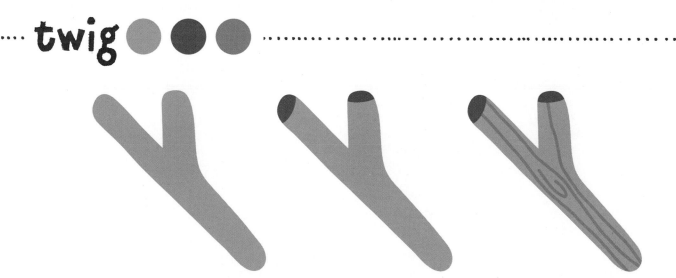

Paint a "Y" shape and add dark ovals on the ends. Detail it with long, thin groove lines.

mountain

Paint two overlapping triangles with rounded points. They're shaped like candy corns!

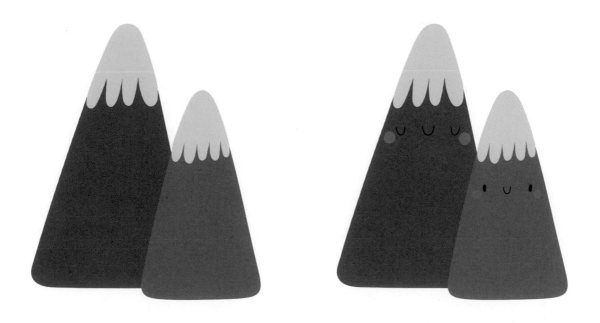

The snow caps have a bumpy bottom. Finish the mountains with friendly faces!

sunset ●●●●

Paint a half circle with a wavy bottom. Use short lines to add sunrays along the curve.

shooting star ●●●

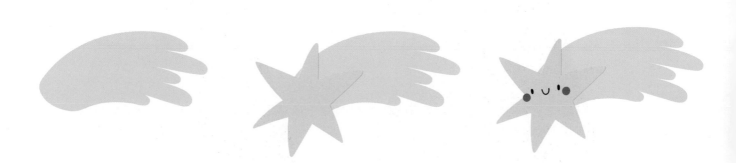

Paint a few curved strokes to make the star's path. This star is made up of six triangles!

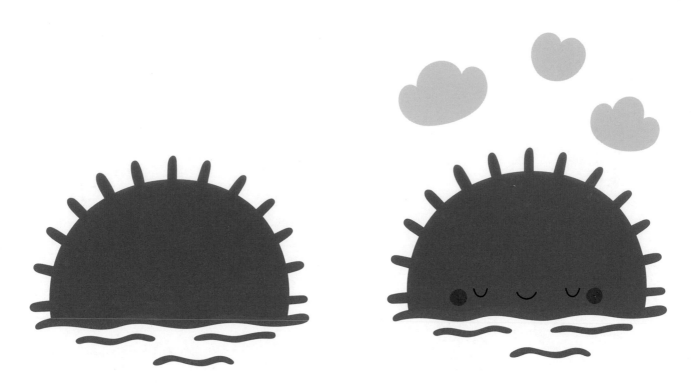

Now add wavy lines for the ocean. Finish with a few curly clouds and a sleepy face!

moon

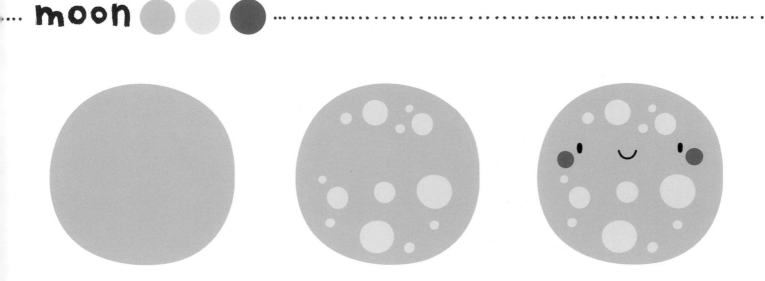

Start with a solid circle. Then paint smaller, lighter circles on top for craters!

things to eat

tomato

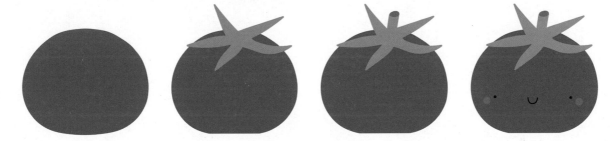

This tomato is a circle with a flattened bottom. Use long, thin triangles for the leaf-like sepals on top!

broccoli

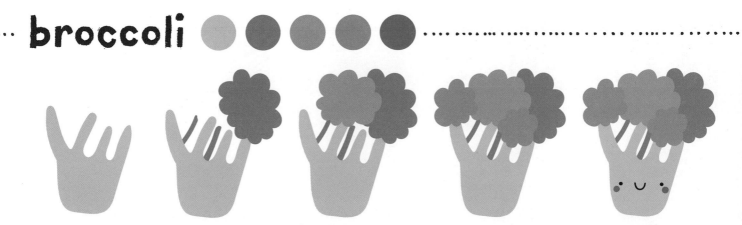

Use a square and thick lines to paint the stalk. Add curly cloud shapes for the head!

Calling all food lovers! Whether you're hungry for a healthy snack from the garden or a delicious dessert, you'll find a ton of treats to satisfy your artistic appetite. Paint an apple, a watermelon, a cookie, ice cream, and more. Want a sushi lunch? You can paint that too!

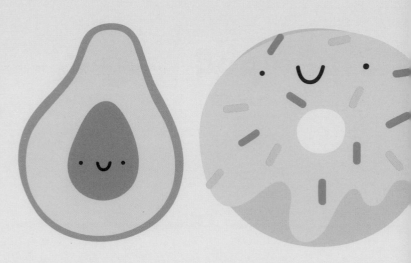

carrot

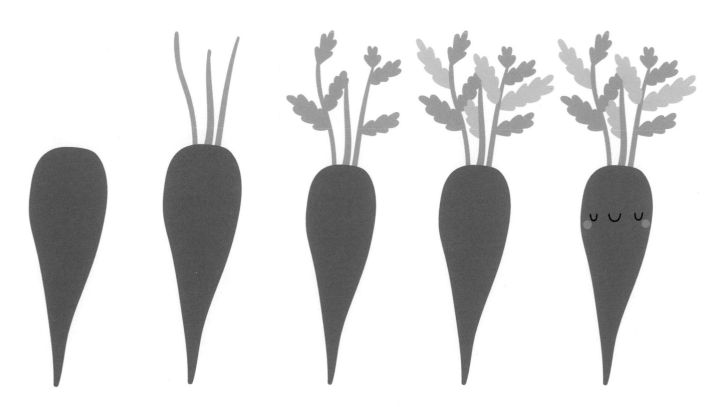

A carrot is tall with a round top and a pointed bottom. Its leaves have lots of curly edges!

pea pod

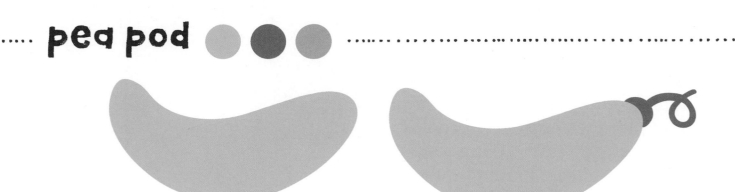

A pea pod is a thick "U" shape with rounded ends. Use a curling stroke for the stem.

onion

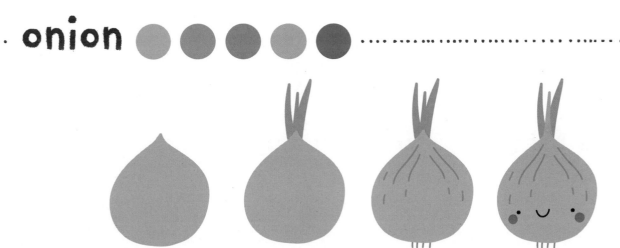

Start with a circle and paint a triangular point at the top. Add thick sprouts and thin roots.

avocado

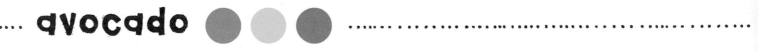

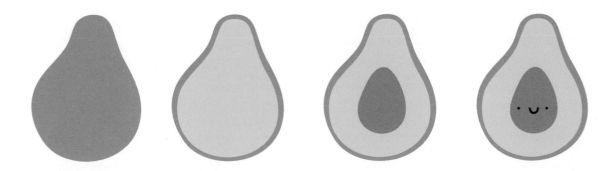

An avocado is shaped like a circle with a bulge at the top. The pit is an egg shape!

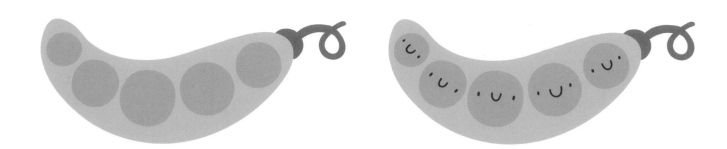

Paint a row of circles inside the pod, following the curve. The biggest peas are in the middle!

potato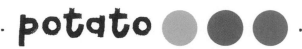

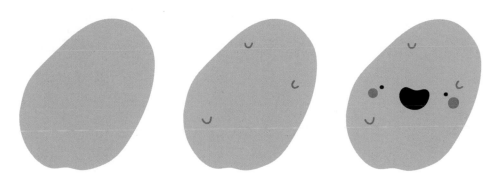

Potatoes are usually ovals, but their edges can be bumpy! Add "U" shapes for even more bumps.

beet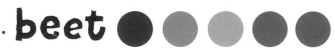

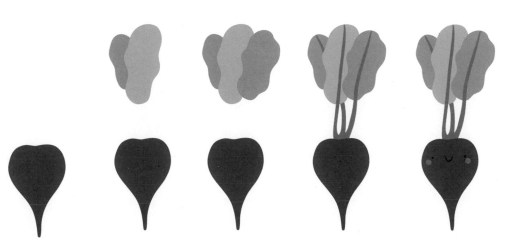

A beet looks like a heart with a long tip. Use wavy shapes for leaves and long strokes for stems!

mushroom

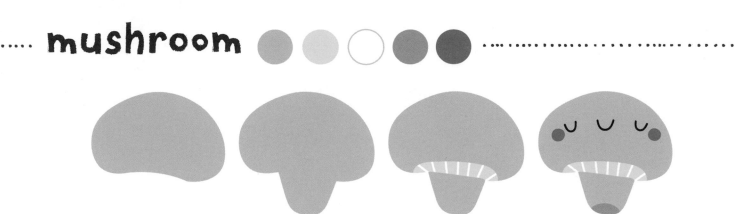

The top of a mushroom is shaped like a jelly bean. Don't forget tiny white lines for the gills.

eggplant

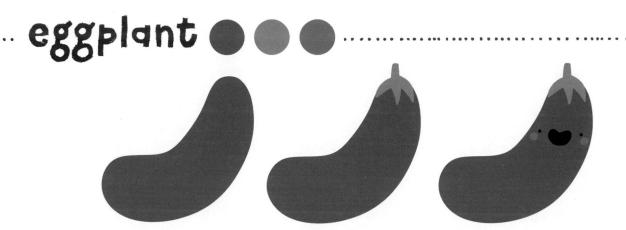

This eggplant is shaped like a thick "J." Use a short line for the stem and triangles for the sepals!

radish

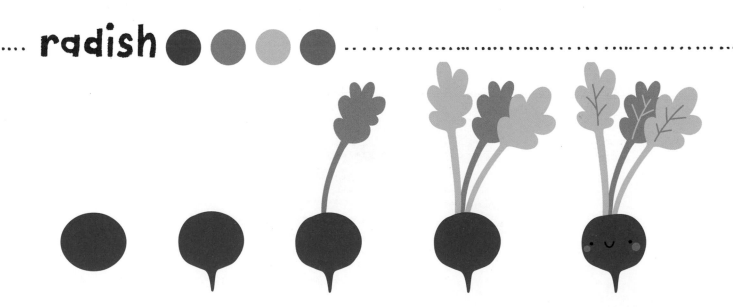

Start with a circle and add a sharp point at the bottom. Paint long stems and bushy leaves!

Try painting more healthy foods from the garden!

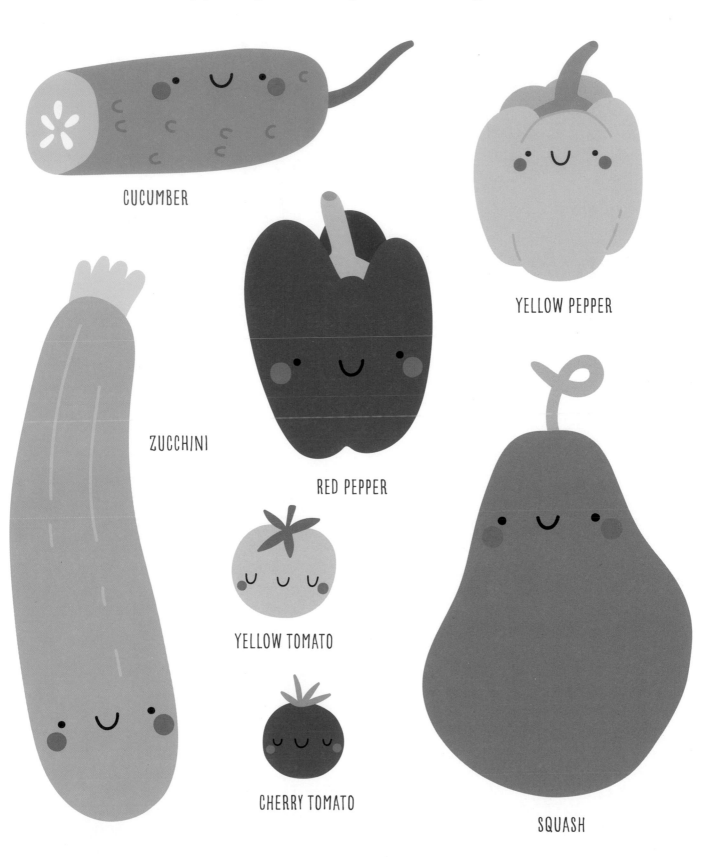

CUCUMBER

YELLOW PEPPER

ZUCCHINI

RED PEPPER

YELLOW TOMATO

CHERRY TOMATO

SQUASH

apple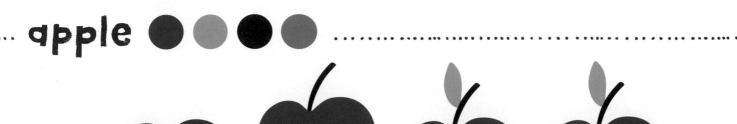

Build the apple's shape using two overlapping ovals. The leaf is an oval with pointed tips.

lemon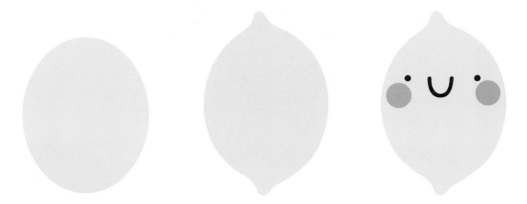

Start with a tall oval and add a rounded tip on the top and bottom.

pear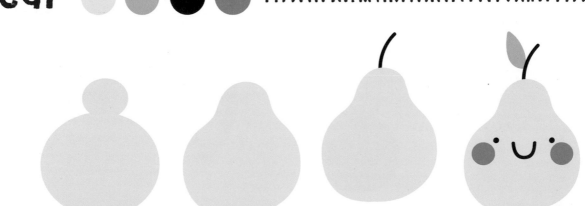

Build the pear using a large circle on the bottom and a small circle on top. Smooth out the edges.

banana

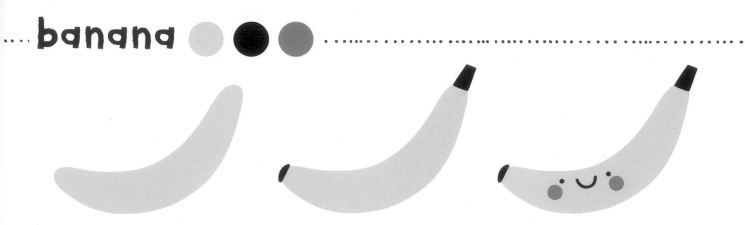

A banana is shaped like a "J." Use rectangles to detail the ends.

orange

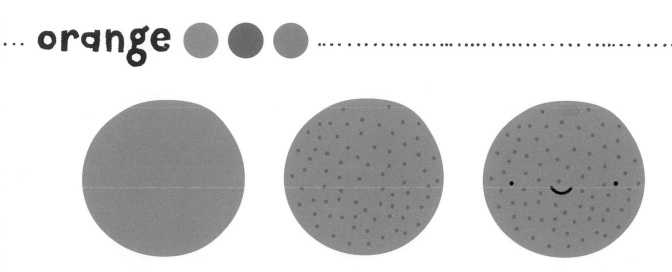

Begin with a circle and add small dots to show the texture of the orange peel.

cherries

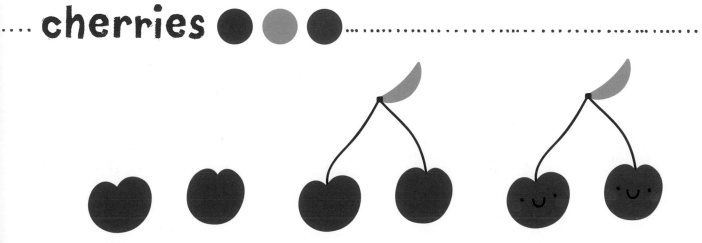

A cherry is a circle with a dip at the top. Paint thin lines for stems and a moon shape for the leaf!

strawberry

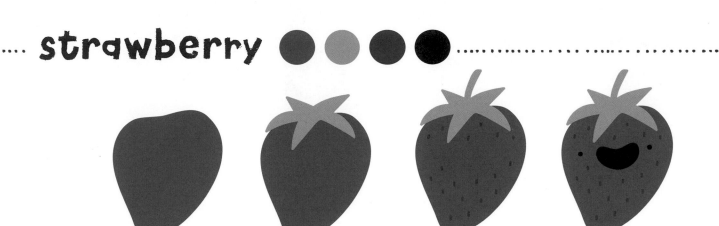

A strawberry is shaped like a heart. Use thin triangles for the sepals, and use dots for the seeds!

pineapple

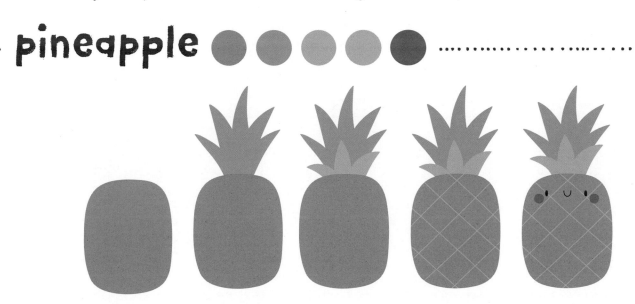

Paint a rectangle with rounded corners. Add tall, pointed leaves and a diagonal grid pattern.

watermelon

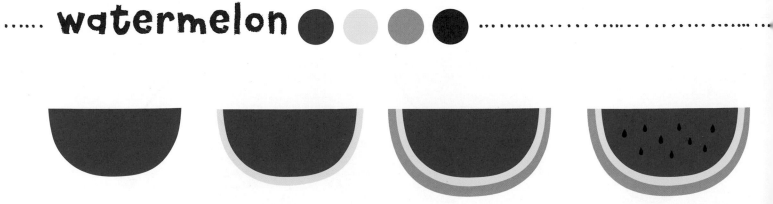

Start with a solid half circle and paint arches around the curve. Add teardrop-shaped seeds!

eggs

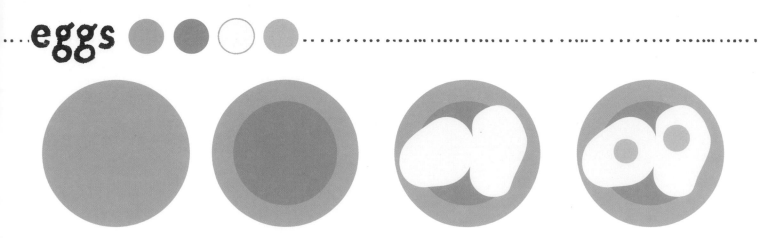

The plate is a circle inside of a circle. The egg yolks are circles too!

cereal

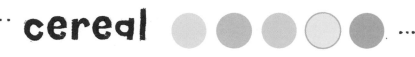

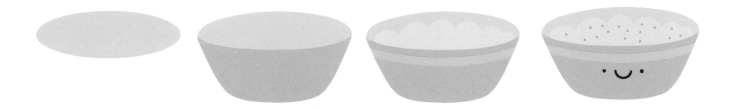

Start with an oval for the inside of the bowl. The cereal has a curly top edge and dots for texture!

muffin

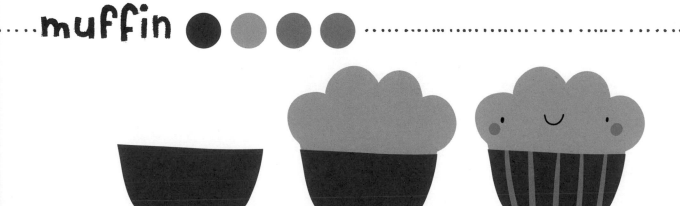

Use a rectangle shape with vertical lines for the muffin liner. The top is puffy like a cloud!

donut

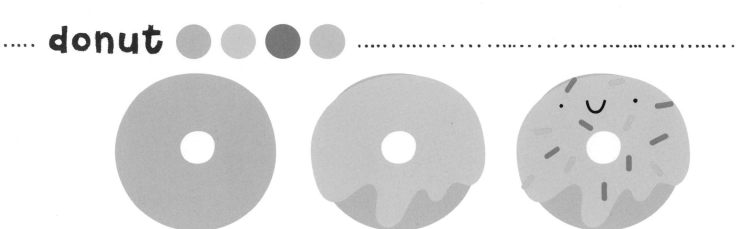

Paint a circle with a hole in the center. Add drippy frosting and finish with short lines for sprinkles!

cookie

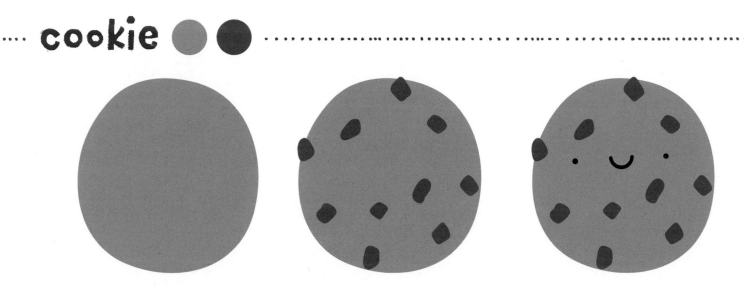

Start with a round shape. It doesn't have to be a perfect circle! Then dab on chunks of chocolate.

biscuit

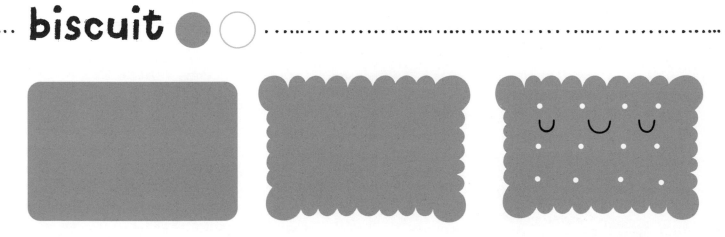

Start with a rectangle. Round out the corners and paint scalloped edges. Add white dots for holes!

pretzel

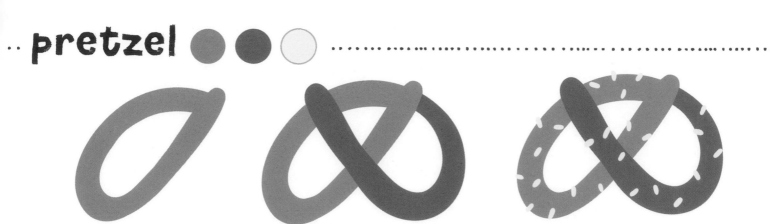

Paint the pretzel with thick lines, starting with a loop. See how the shapes make an "X" in the middle.

cupcake

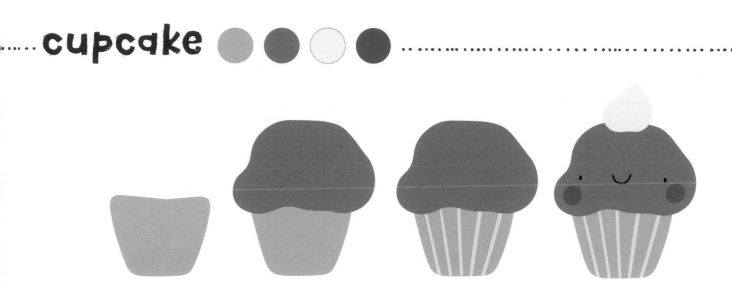

The cupcake liner is widest on top. Add folds with thin lines. Top it with a rounded dollop of frosting!

pie

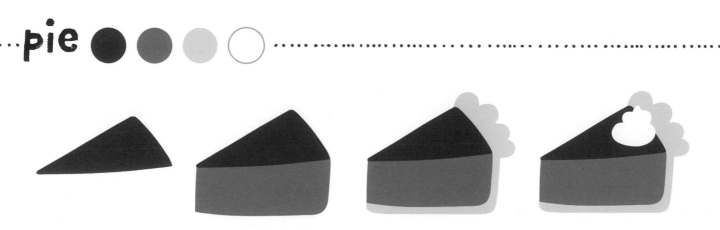

This piece of pie is a triangle on top of a rectangle. Add crust with thin lines and a curly edge.

ice cream cone

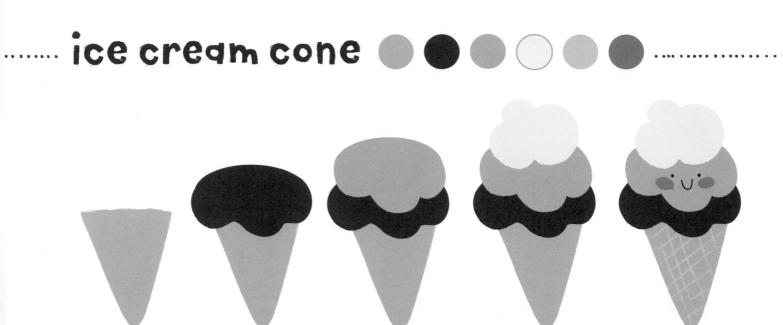

Start with a triangle for the cone. Add layers of ice cream using cloud shapes!

popsicle

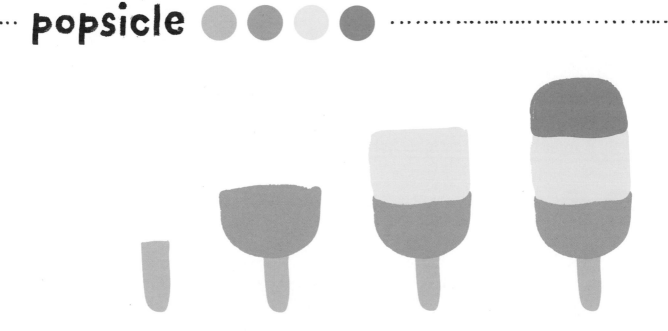

Paint a tall rectangle for the stick. Add a half circle for the bottom flavor,
a square for the middle, and another half circle for the top!

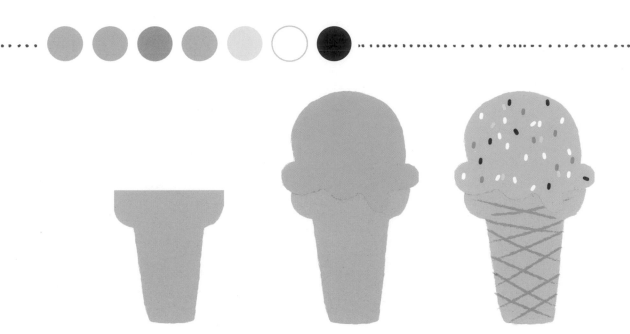

This cone is made of two rectangular shapes. Use thin lines for a criss-cross texture. The ice cream has a round top and a wavy bottom to show drips. Add dots for sprinkles!

Still have a sweet tooth? Try painting more popsicles and ice cream bars!

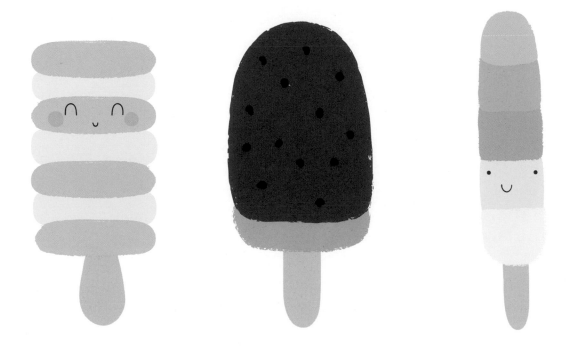

ice cream sundae

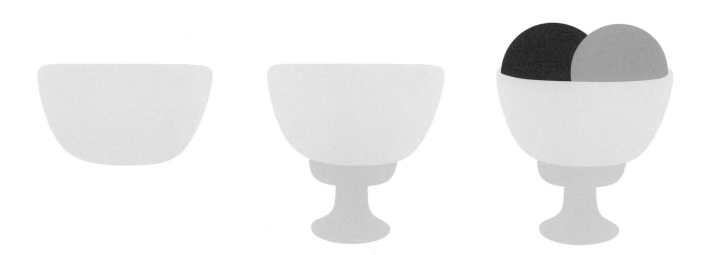

Paint the bowl using a half circle with a flat bottom. The scoops of ice cream are half circles too!

waffle

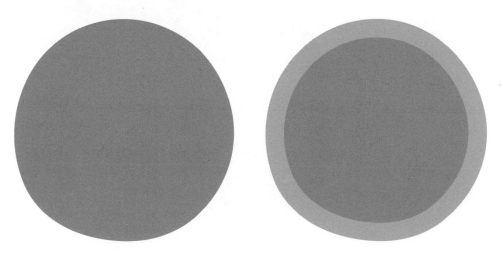

Start with a solid circle, and then paint a lighter circle around it.

The cherry is a small circle with a dip in the top. Each wafer is a long rectangle with an oval on the end.

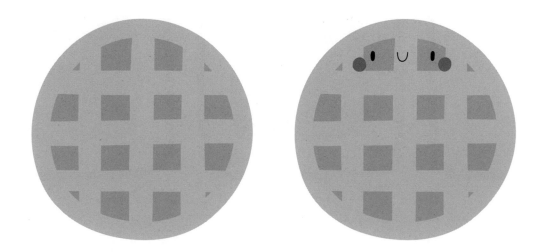

Now paint three thick lines across and three thick lines down to make a grid pattern.

pizza

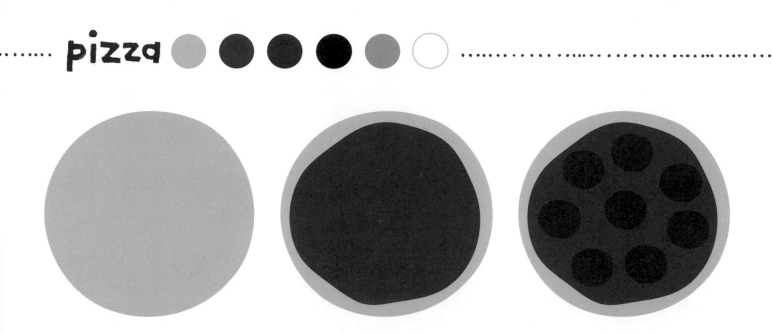

Paint a solid circle for the crust. Add a round shape inside for the sauce, plus circles for pepperoni.

sushi roll

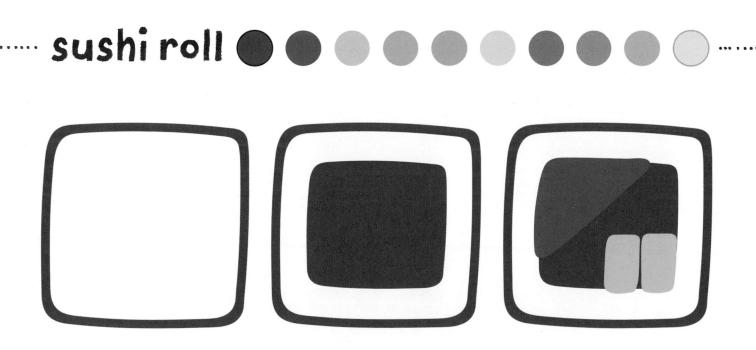

Start by painting a square within a square! Add a triangle and two rectangles for the different foods inside.

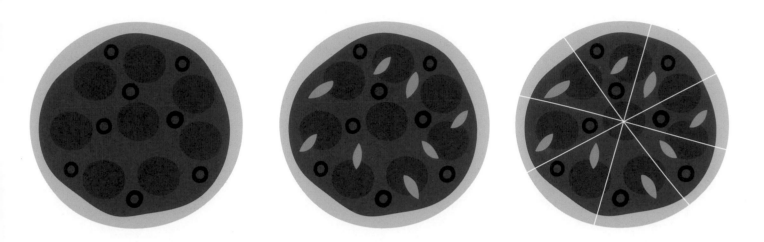

Add "O" shapes for olives, plus a few basil leaves. "Cut" your pizza with thin white lines!

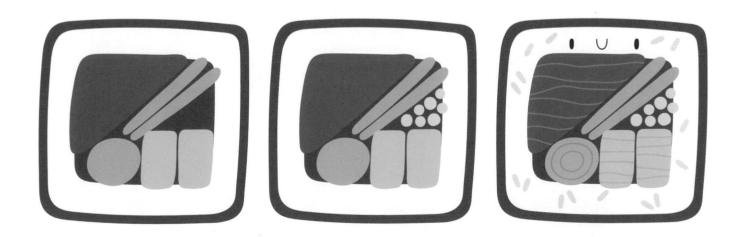

Fill in the empty spaces with circles and a pair of long strokes. Add texture to the different foods with thin, wavy lines. Detail the rice with small, light ovals!

taco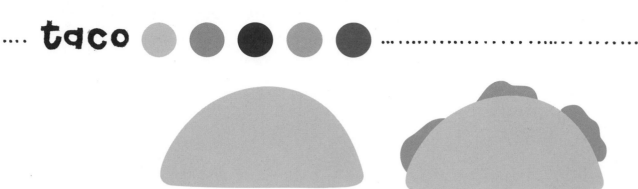

Start with a half circle for the shell. Use wavy shapes along the curved edge for lettuce.

fries

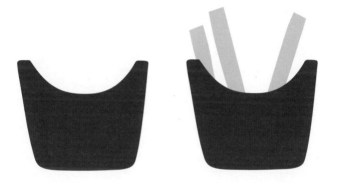

The fry holder is shaped like a square with a scoop out of the top. Use long rectangles for fries.

popcorn

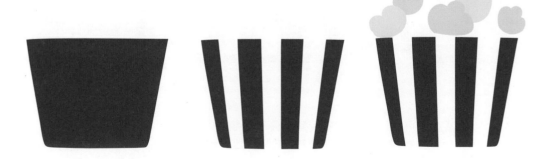

This bucket is widest at the top. Paint thick lines for stripes! Add popcorn using round, curly shapes.

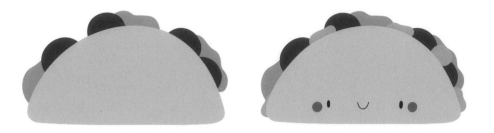

Paint half circles for tomatoes. Add any other fillings you'd like!

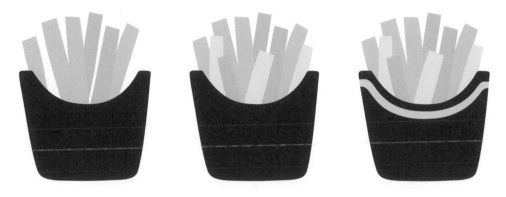

Paint light and dark fries to keep the shapes separate. Detail the holder with a thin line along the top!

Paint more popcorn, using lighter and darker colors to keep the shapes separate.

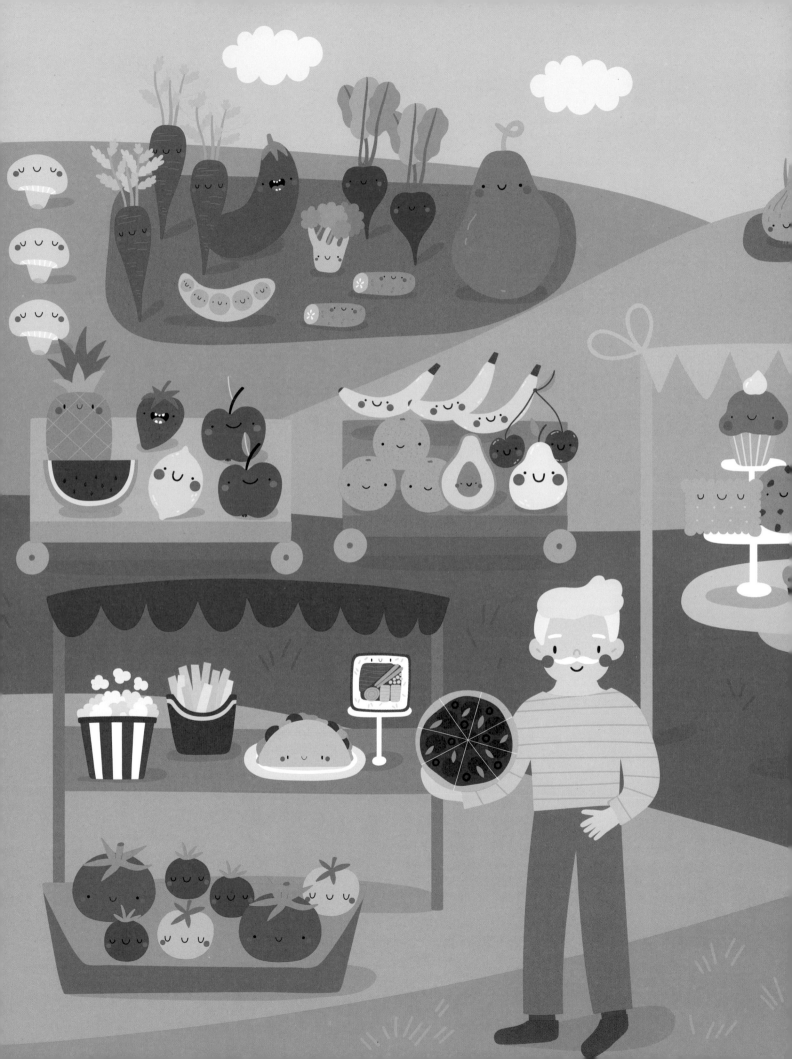

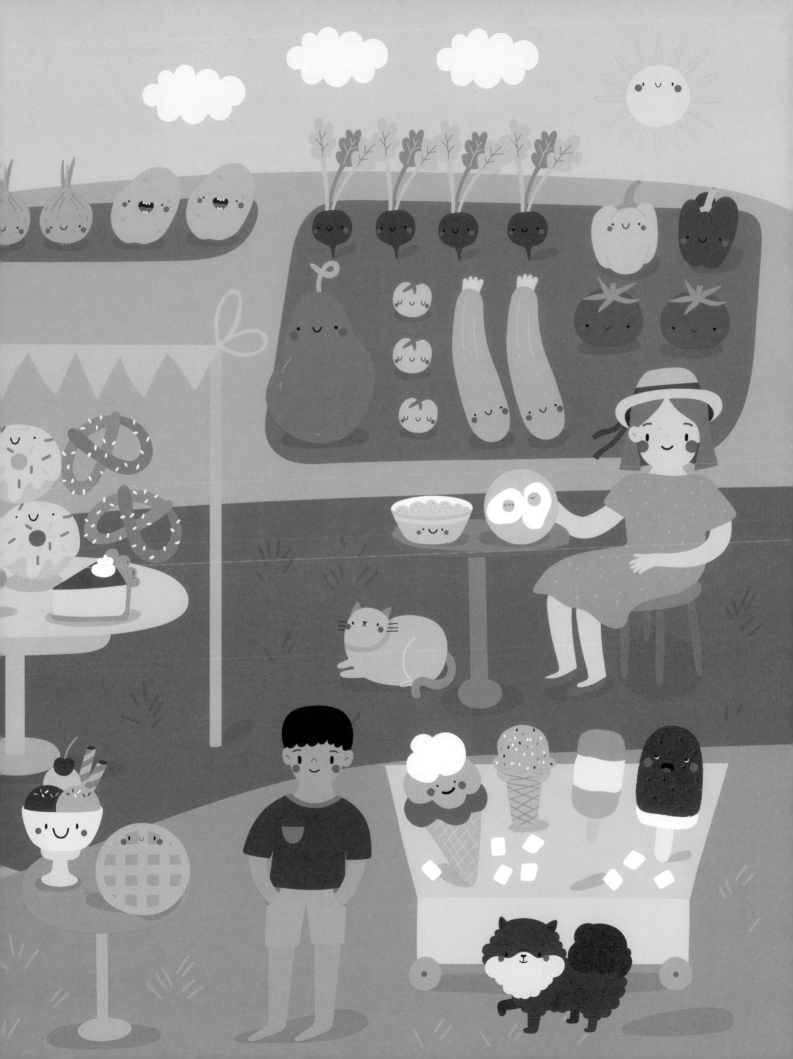

vehicles & buildings

skyscraper

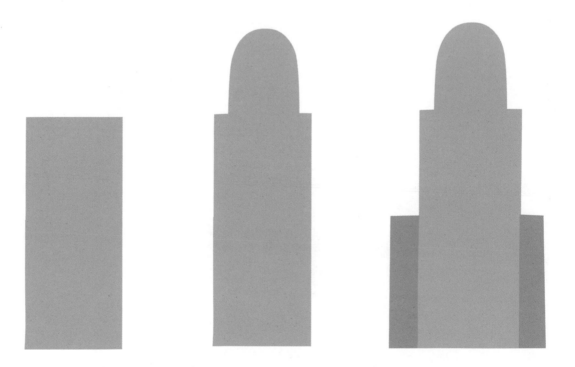

Start with a tall rectangle and add a rounded top. Paint a smaller rectangle on each side.

Cars, trucks, tractors, and buildings are all big subjects, but they're easy to paint if you use basic shapes and simple lines! These subjects are great for drawing city scenes and busy streets. For a calm, breezy adventure instead, you'll also find a sailboat and a hot air balloon.

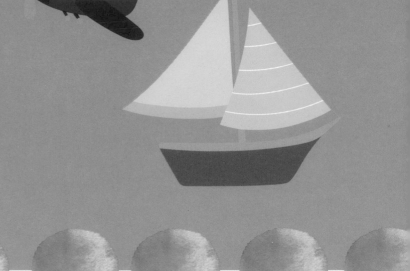

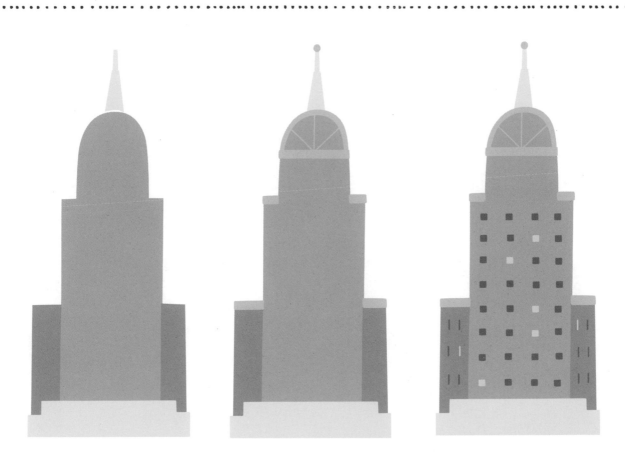

Top it with a skinny triangle and a circle. Then add windows and roof details!

circus tent

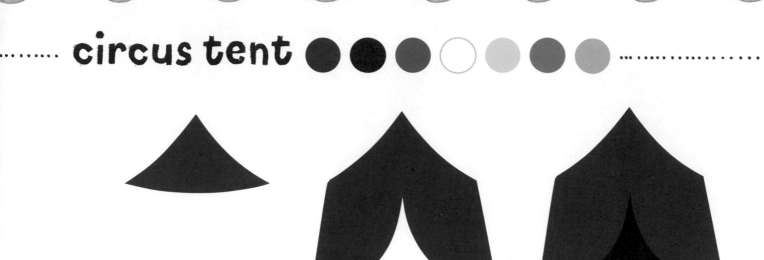

The top of the tent is a triangle with curved edges. The opening of the tent is a similar shape!

igloo

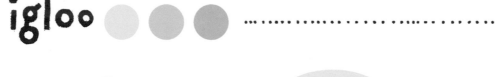

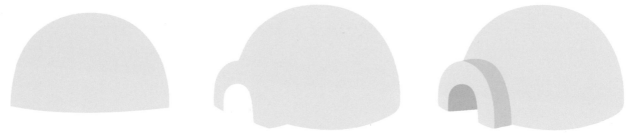

Start by painting a half circle. The opening arch is shaped like an upside-down "U."

pagoda

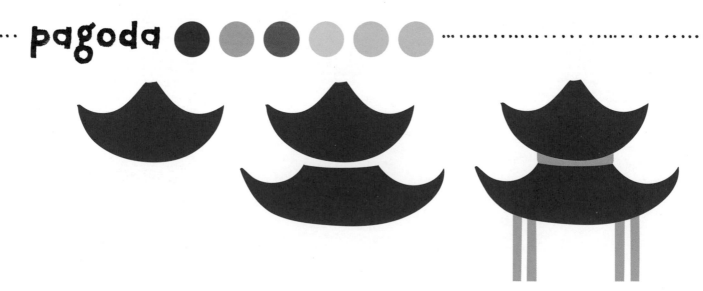

The pagoda roofs are shaped like skirts! Use long rectangles to add beams.

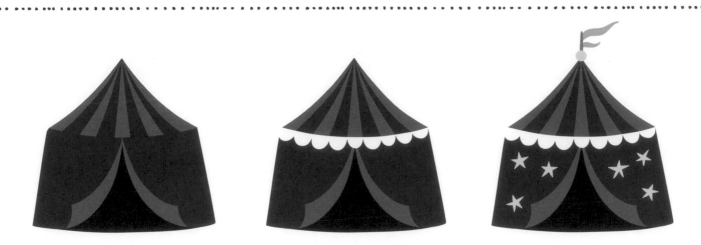

Detail the tent with stripes, a scalloped edge, and stars. Top it with a circle, line, and wavy flags!

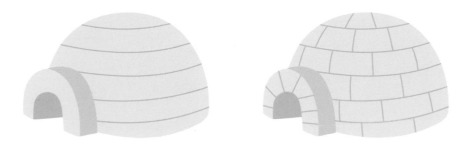

Paint thin, curving lines to create the bricks.

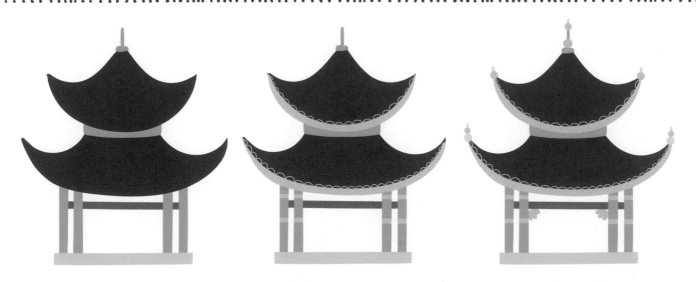

Add a post and circles to the roof's points. Detail the roof edges with "m"-shaped strokes.

police car

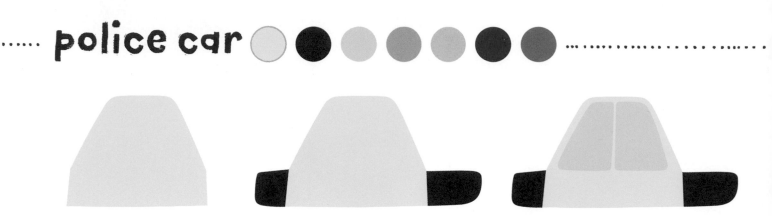

The center of this car is similar to a triangle with a flat top.
Add a rectangle to each end and paint tall windows.

fire truck

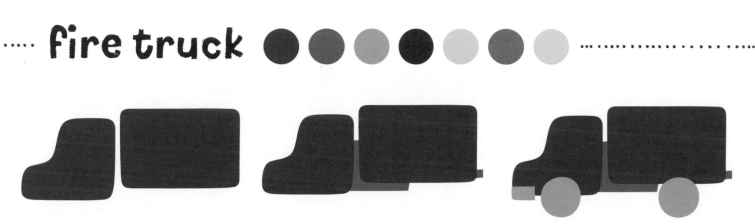

The front of the truck is shaped like a boot.
Use a rectangle for the back and circles for wheels.

train

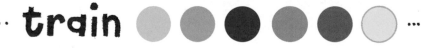

Start with a long rectangle topped with a scooped rectangle.
Use simple shapes to build the rest, including circles for wheels and triangles to the front.

Add circles for wheels, a square tail pipe, and a cone for the headlight.
Detail the car with a gold star on the door and oval lights on top!

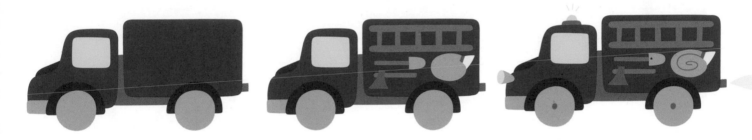

Paint a square window and add half-circle strokes over the tires.
Fire trucks include lots of fun details, including a ladder, shovel, axe, hose, and lights!

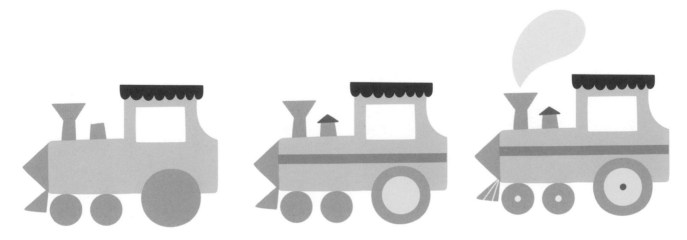

Top the train with a scalloped edge.
Add all the details, including a puff of steam!

car

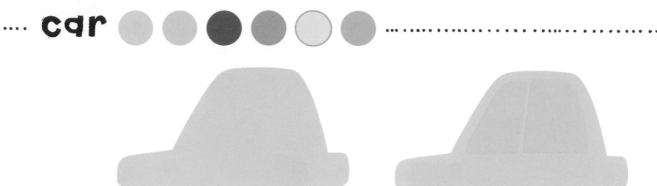

This car is shaped like a wide traffic cone! Paint tall windows.

motorcycle

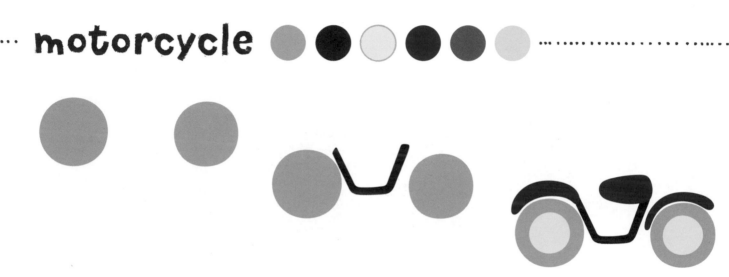

Start with two circles for wheels. Build a sturdy frame with thick, angled lines. Add curves over the tires.

ice cream truck

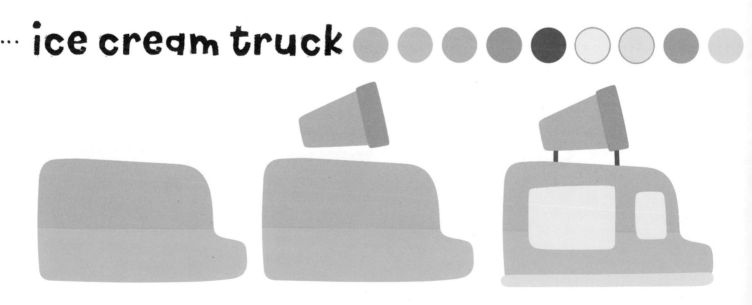

This truck is rectangular with a small bulge at the front. The cone on top gives it a fun touch!

Add wheels, the door handle, the headlight, and the tailpipe.
Finish with a steering wheel and a puff of exhaust!

Paint the handlebars, seat, and pipes with thick strokes. The headlight is shaped like a cone!

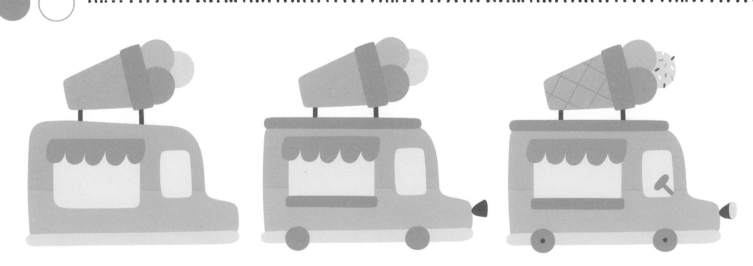

Paint a scalloped overhang along the back window.
The ice cream scoops look like overlapping circles. Add the final details.

school bus

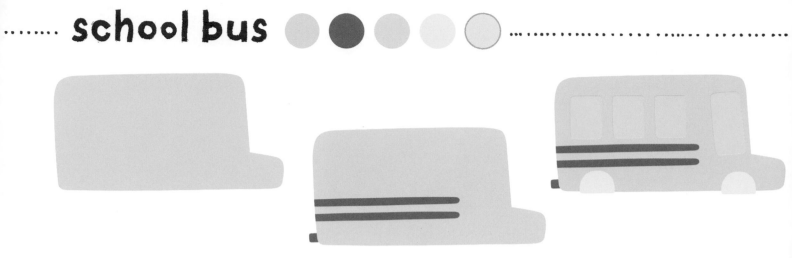

Start with a rectangle and add a small square for the front. Paint two parallel lines under the windows.

race car

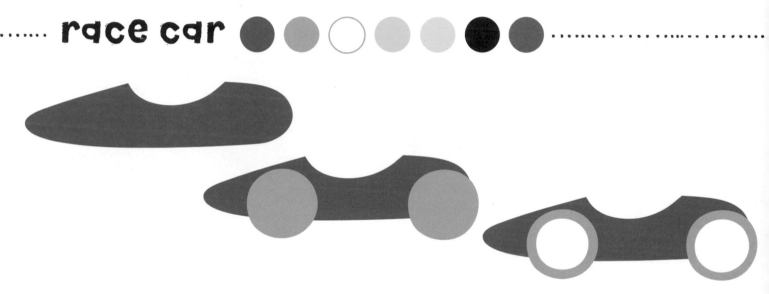

This speedy vehicle has large wheels, a pointed front, and a big dip in the middle.

convertible car

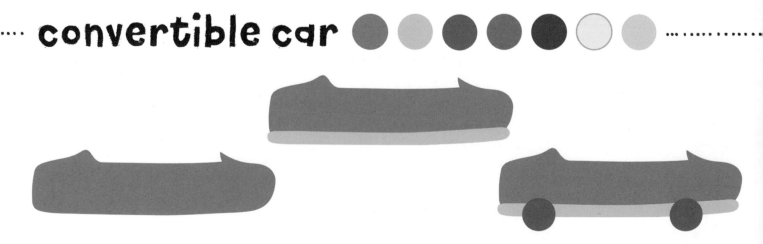

This topless car is shaped like a hot dog! Paint a stripe along the bottom and add circles for wheels.

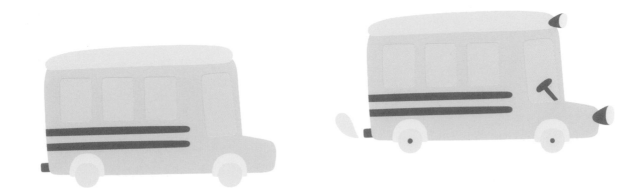

Add circular tires and a thick, rounded top. Finish with lights and other details!

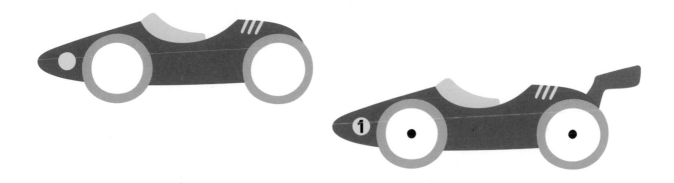

Paint the windshield with a curved stroke and the spoiler with an angled shape.
Detail the race car with stripes and a number!

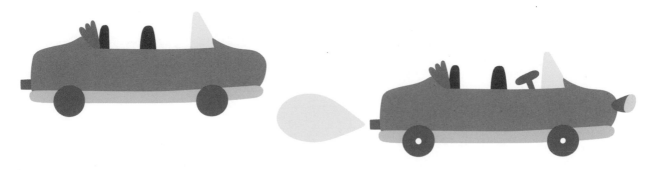

Paint a triangle for the windshield and tall arches for seats. Add the headlight and other final details!

barn

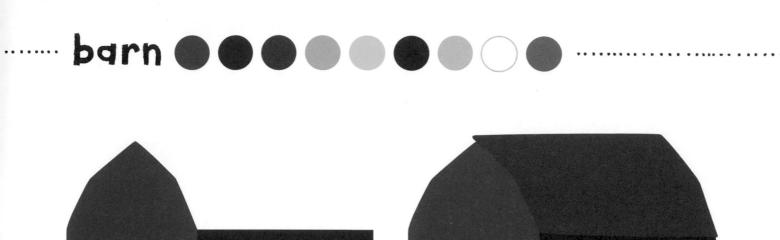

Start with a long rectangle for the side and a rounded triangle for the front. Then paint a roof!

house

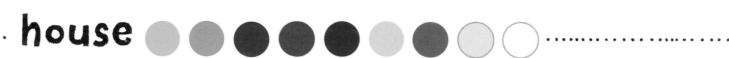

This tall house is a triangle on top of a rectangle. Use a diamond shape for the roof.

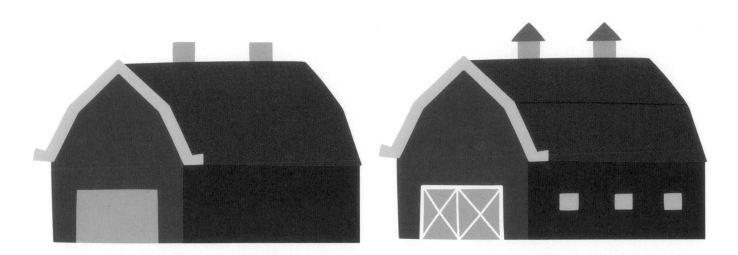

Add details to the roof and windows. Paint thin lines to add an "X" over each door!

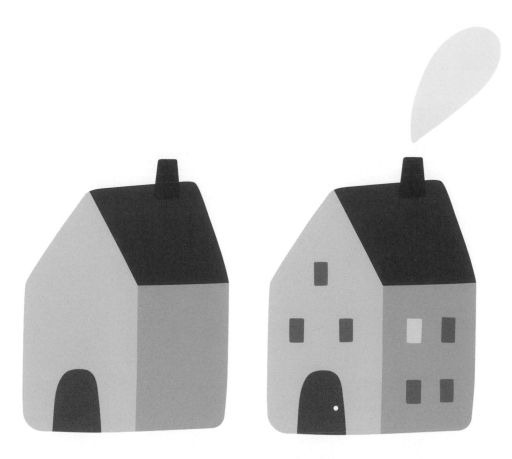

Add an arch for the door and rectangles for the chimney and windows. Don't forget the smoke!

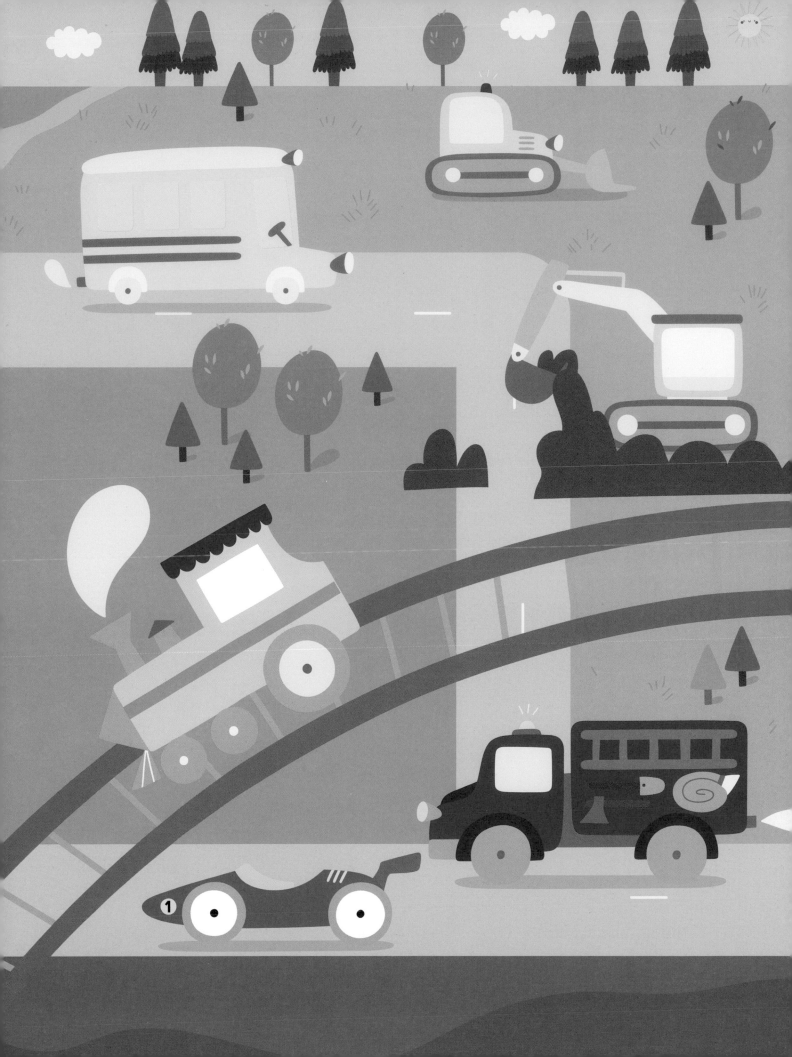

excavator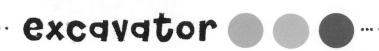

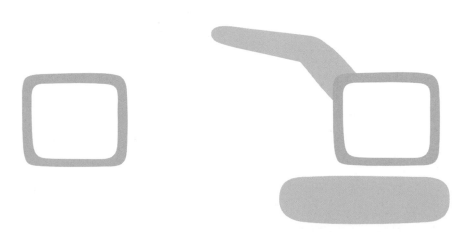

Start with a square for the cab. Add an angled arm and a rounded rectangle for the track.

bulldozer

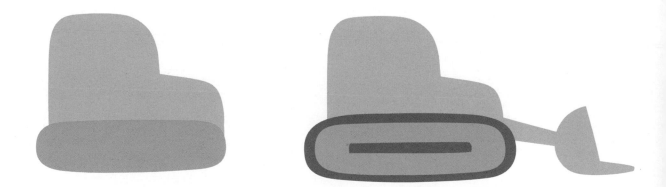

The cab and track make a boot shape. The blade is a half circle with a triangular point!

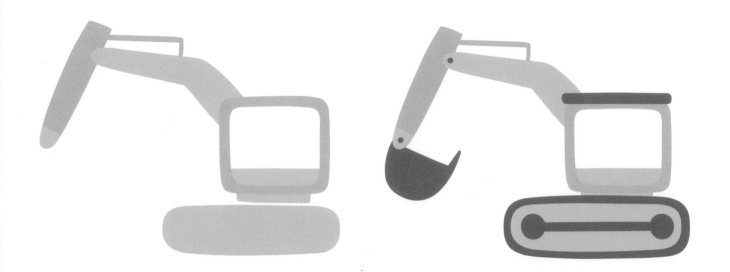

Finish the arm and half-circle bucket. Connect two circles with a line for the inside of the track.

Paint an arched window and details inside the track. Add lights and a few parallel lines to finish!

tractor

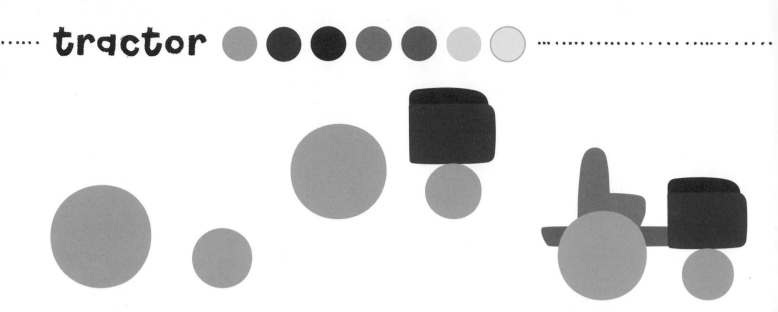

Start with a big circle for the back tire and a small circle for the front tire. Add a square over the front tire and an L-shaped seat over the back tire.

hot-air balloon

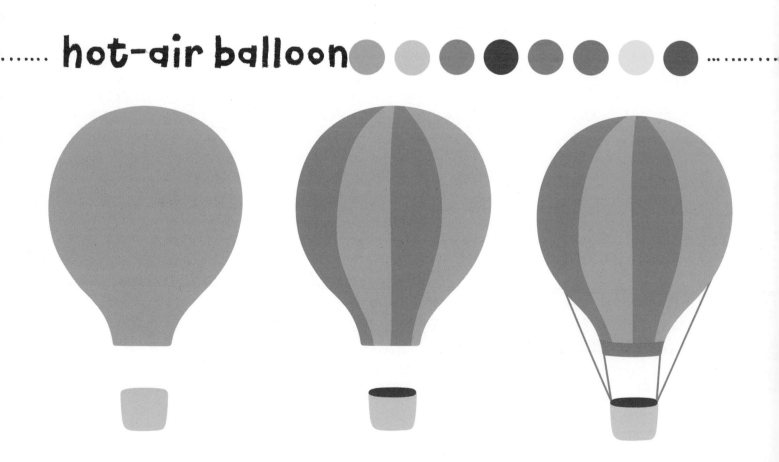

The balloon is a circle with a flat opening at the bottom! Add a square with an oval on top for the basket. Connect the balloon and basket with thin lines.

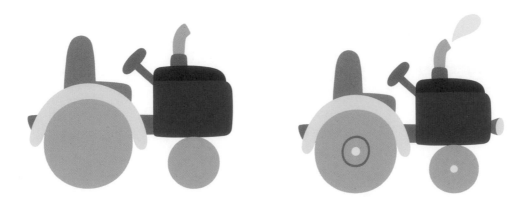

Paint a half circle around the top of the back tire. Add a curved exhaust pipe on the front. Finish with a headlight, steering wheel, and a few tire details!

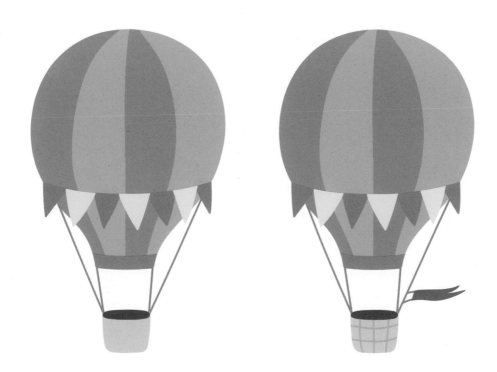

Decorate the balloon with flags using a row of triangles!
Detail the basket with a grid pattern, and finish by adding one more waving flag.

sailboat

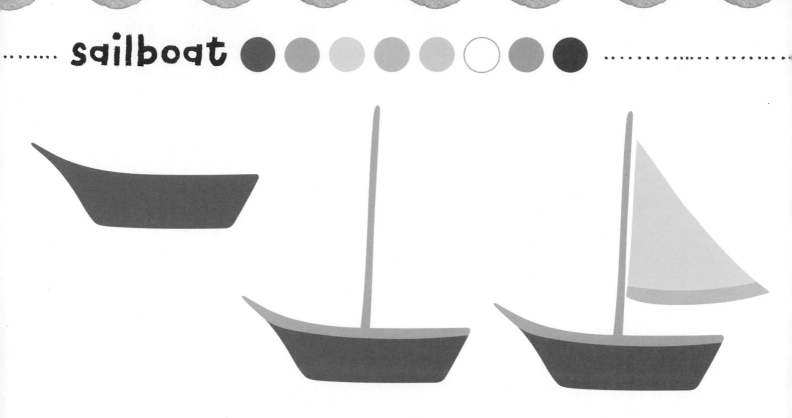

The front of the boat has a sharp point.
Add the mast using a tall, straight line in the center.

lighthouse

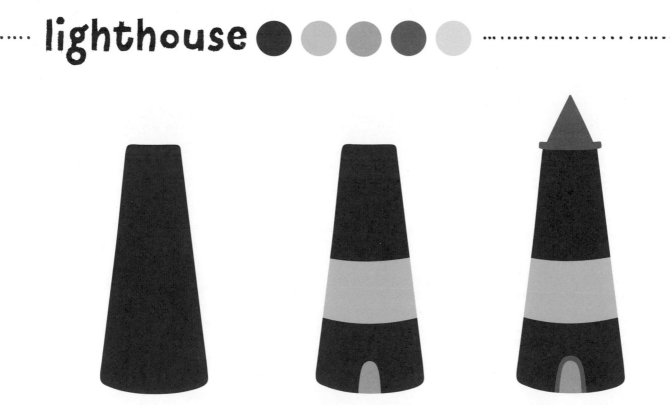

Paint a tall cone shape with a flat top and a curved bottom. Paint a light band across the shape. Now add an arch for the door and a triangle for the top!

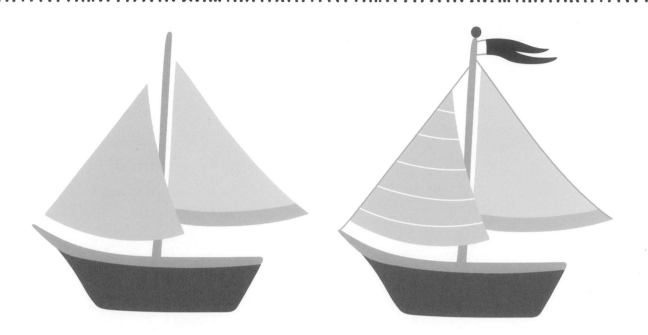

The sails are triangles with curved bottoms. Connect them to the mast with thin lines. Top the mast with a circle and a waving flag!

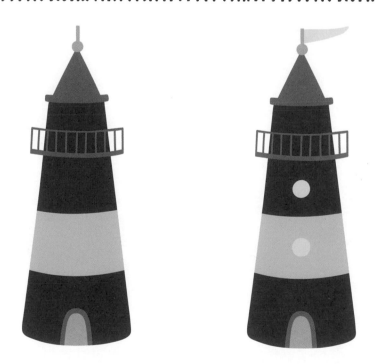

Add circles for windows and paint the railing with thin lines. Finish by adding a circle and a flag on top!

submarine

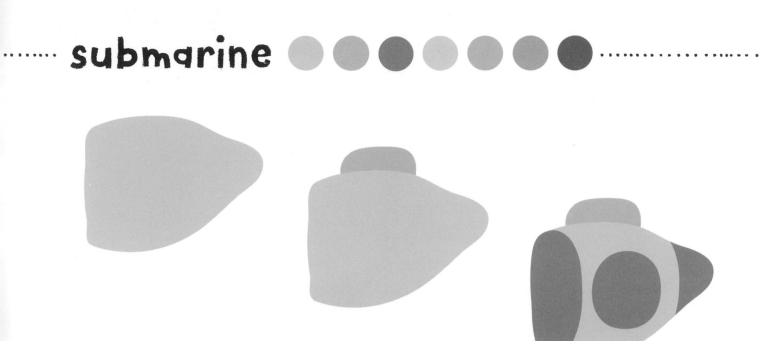

Start with a shape that looks like half a lemon! Add a bean shape to the top.
Then use a circle and an oval to mark the windows, and paint the back tip.

airplane

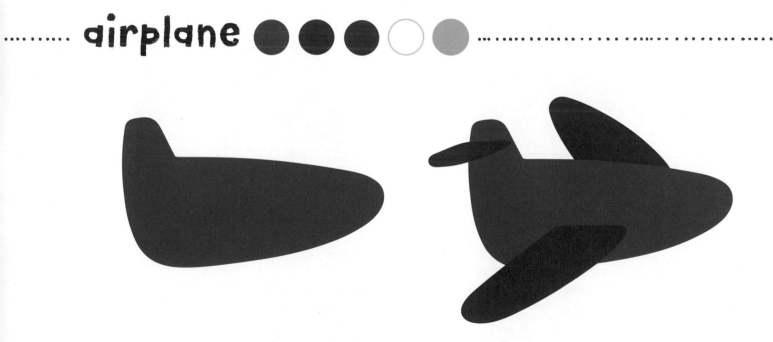

Begin by painting the airplane's body and tail fin.
The nose and wings have rounded tips.

Finish painting the windows, and add a thick hook shape to the top for a periscope. The propeller is made up of two teardrop shapes connected by a circle!

Darken the nose and stroke a thick line across the body. Paint the propeller using teardrop shapes and a circle. The landing gear is made up of two short lines and circles for wheels!

space

rocket ship

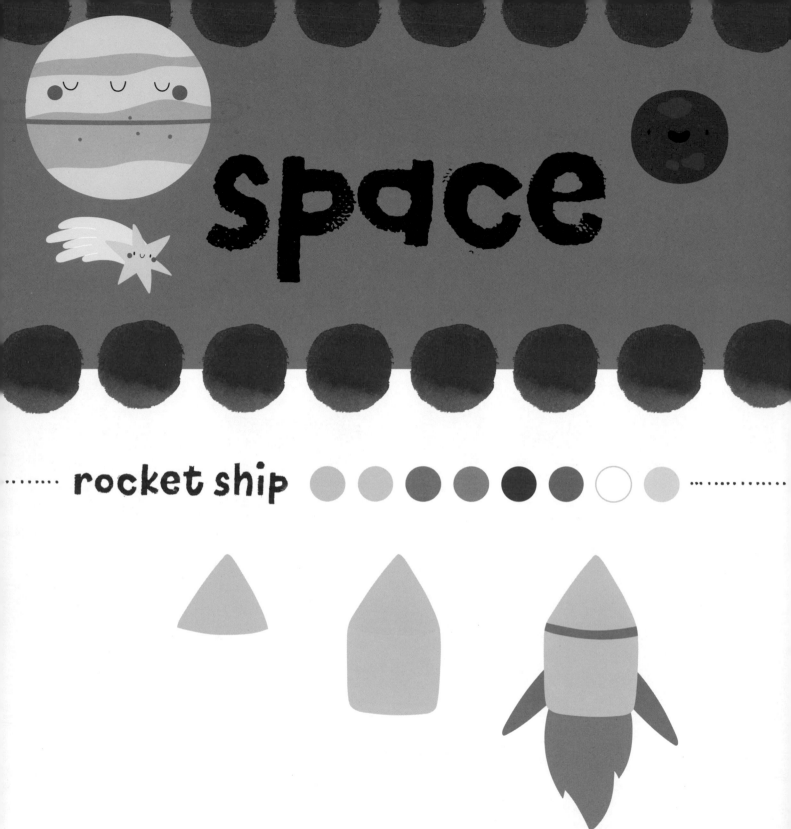

Start the ship with a triangle on top of a square. The fins are shaped like wide triangles.

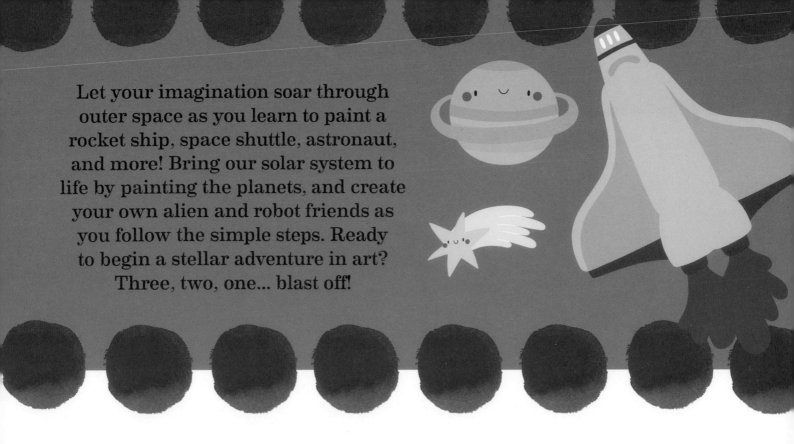

Let your imagination soar through outer space as you learn to paint a rocket ship, space shuttle, astronaut, and more! Bring our solar system to life by painting the planets, and create your own alien and robot friends as you follow the simple steps. Ready to begin a stellar adventure in art? Three, two, one... blast off!

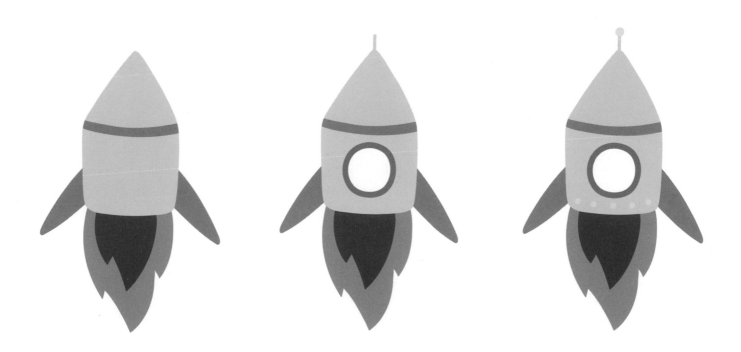

Paint shapes that point downward for the fire. Add a circle for the window and dots for lights!

space shuttle

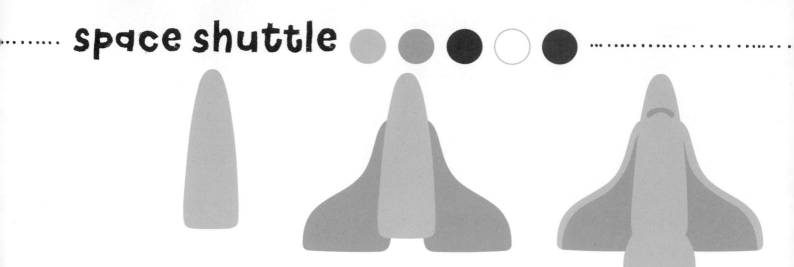

Paint a tall triangle with rounded corners. Add two curved wings with flat bottoms.

astronaut

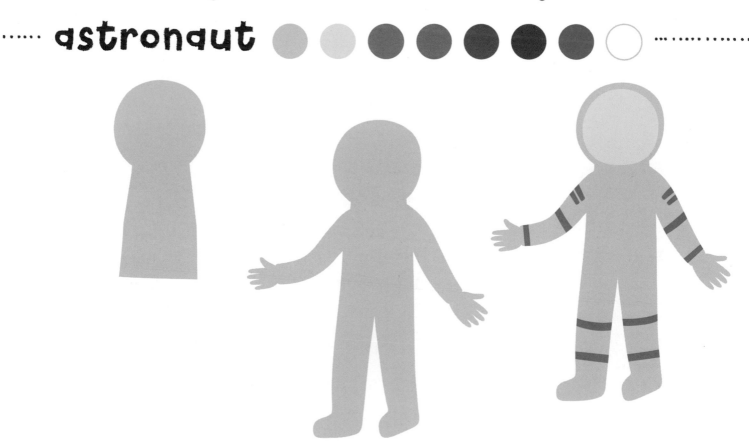

Use a circle and a rectangle to start the helmet and body. The legs and feet are rectangles too!
Paint lines to create bands on the arms and legs.

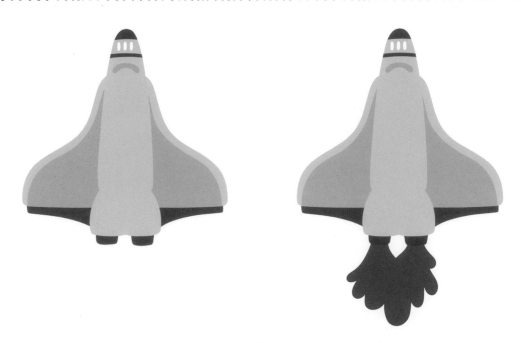

Use thin lines to detail the nose and wings. Add a curly cloud of fire coming out of the engine!

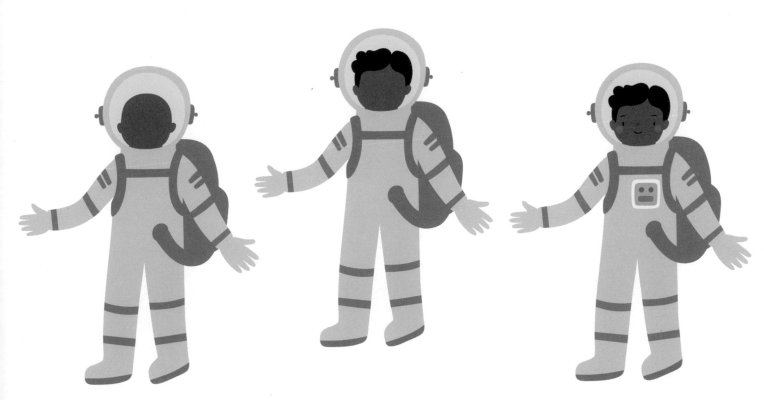

The straps of the backpack make an "H" shape. Paint a round head with two half circles for ears. Add hair with wavy strokes, and then detail the feet, helmet, and suit with thin lines.

alien

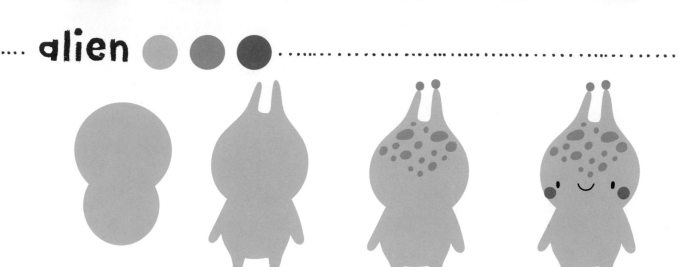

Start with a circle for the head and a smaller circle for the body. Paint different sizes of skin spots!

u.f.o.

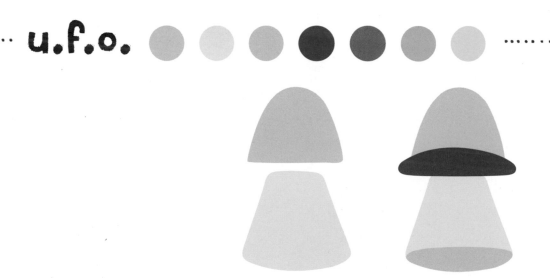

Paint a bell shape for the ship and a skirt shape for the spotlight. Add an oval at the bottom of each.

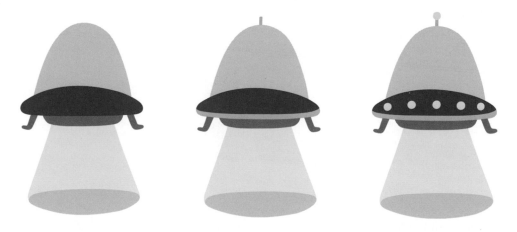

Use thin lines to create the bottom of the ship. Add detail with a row of circles for lights!

robot

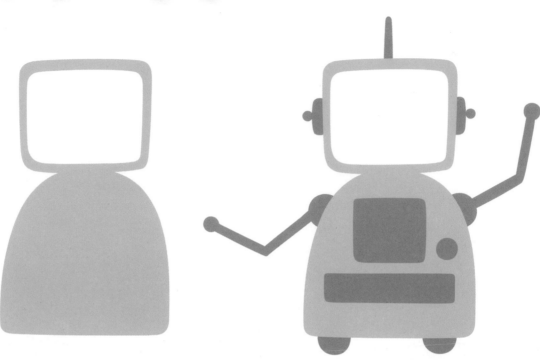

Start with a rectangle for the head and a solid arch for the body. The arms and antenna are straight lines.

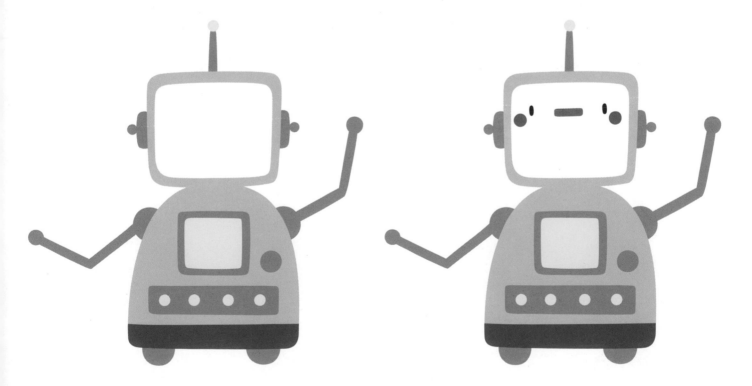

Paint a rectangle along the base, and add circles for lights—including one on top of the antenna!

uranus

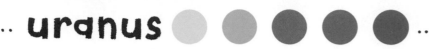

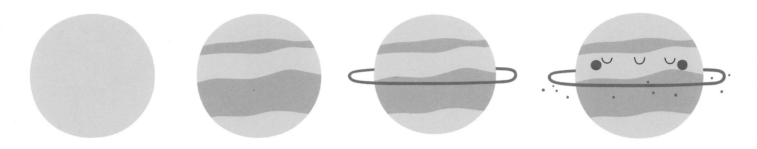

Paint a circle and add wide, wavy bands. Stroke a thin, oval ring around the middle.
Then add tiny dots for moons!

mars

Paint a solid circle. Add lighter splotches and splatters before adding a smile!

earth

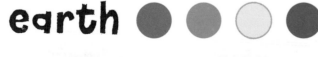

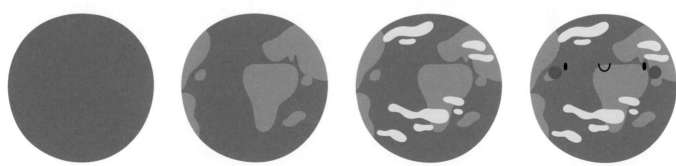

Begin with a circle, and paint land using irregular shapes. Finish with a few wiggly strokes for clouds!

Now try painting the rest of the planets in our solar system, plus the moon!

JUPITER

SATURN

NEPTUNE

MOON

VENUS

MERCURY

225

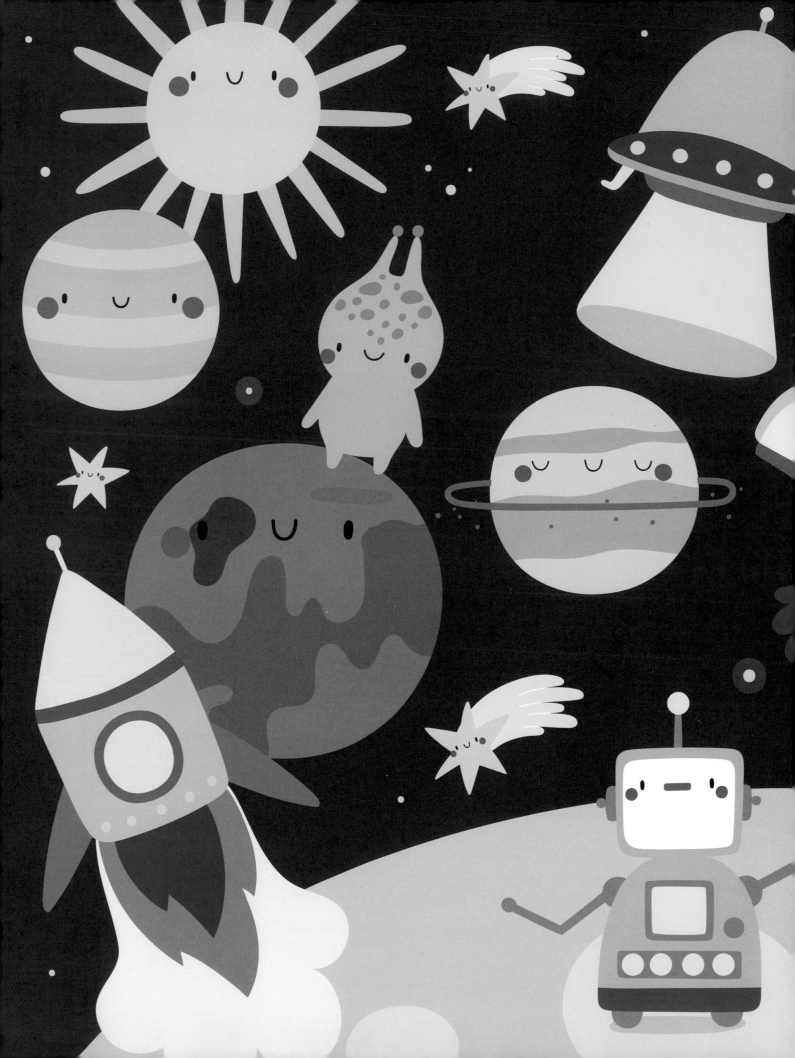

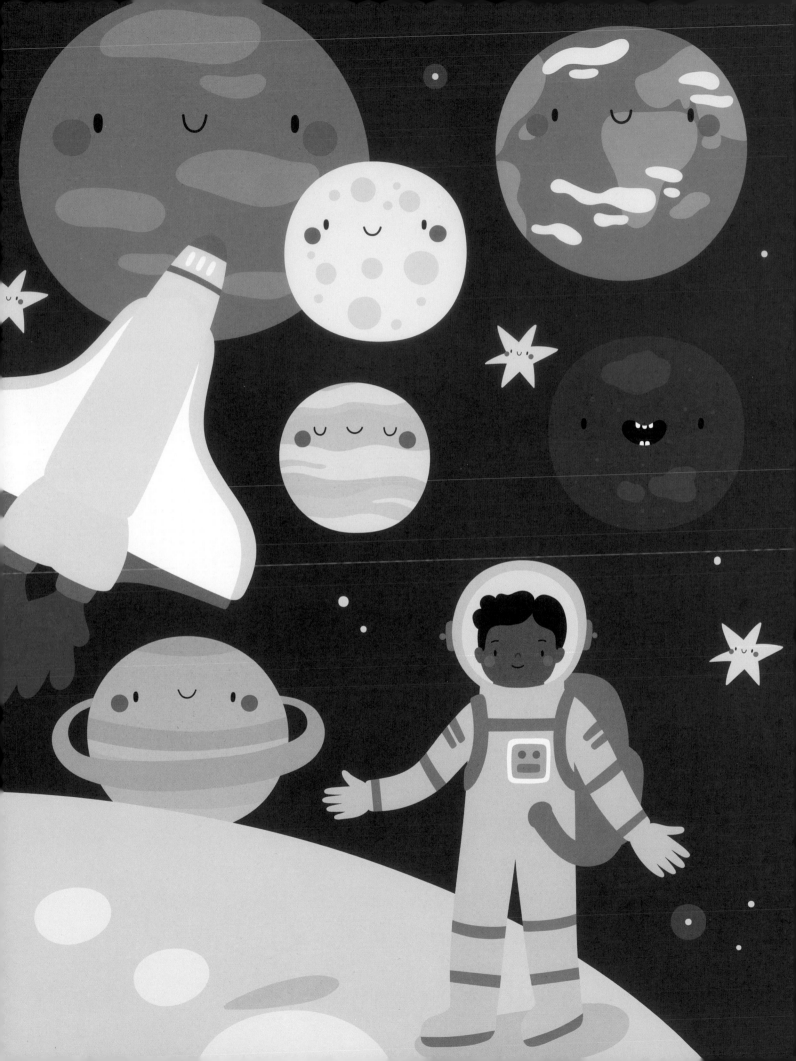

dinosaurs

t-rex

This fierce dino has an upright body made of rounded shapes. It has a large mouth and a thick tail!

Dinosaurs came in lots of fun shapes and sizes. They could be huge, tiny, short, tall, winged, or spiny, but all of them are fun to paint! In this chapter, practice painting long necks, curving tails, spikes, horns, wings, and even an active volcano. Nobody knows what colors dinosaurs were, so feel free to play with plenty of paints!

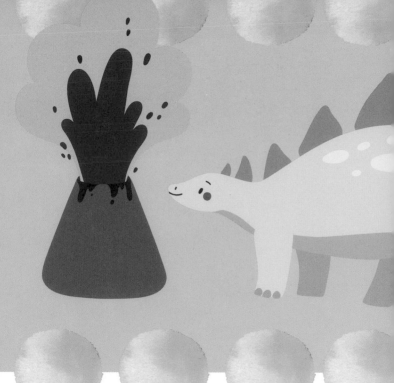

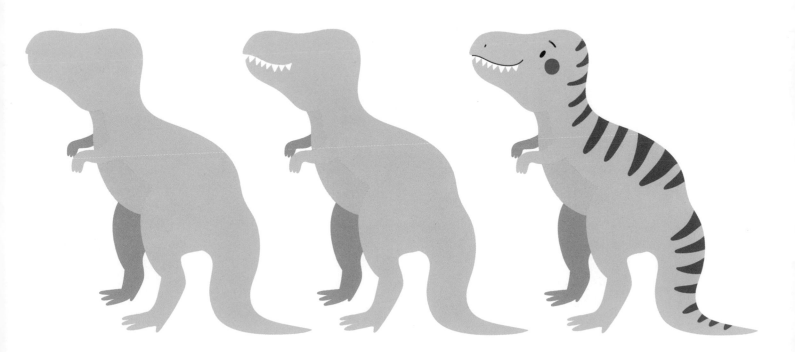

Use small triangles for the teeth and long triangles for the stripes across its back.

triceratops

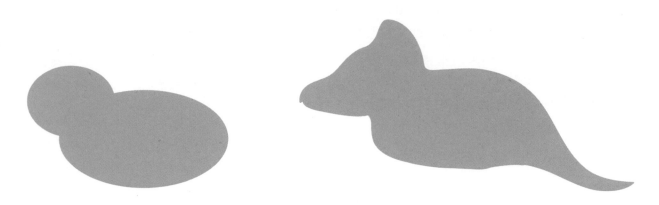

Start with two overlapping ovals. Then add a curved, pointed tail and a triangular head.

Now paint along the underbelly and add two thick, sturdy legs!

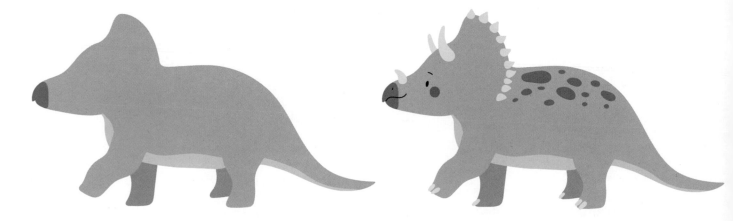

Add two more legs and darken the mouth. Now paint three curved triangles for the horns.
Finish with oval spots, toes, and other details!

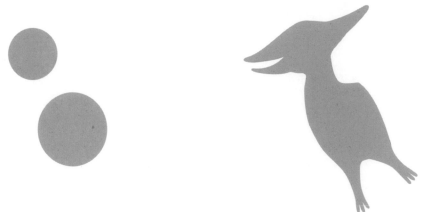

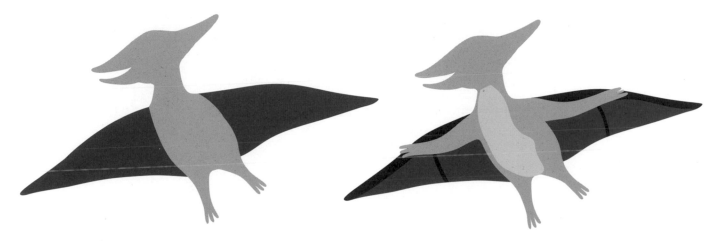

The pterodactyl has a pointed beak, a triangular head, and tiny feet.

The wings look like wide triangles. Add thin arms and an underbelly!

Paint dark lines along the wings for detail. Now paint the beak and add the face!

brachiosaurus

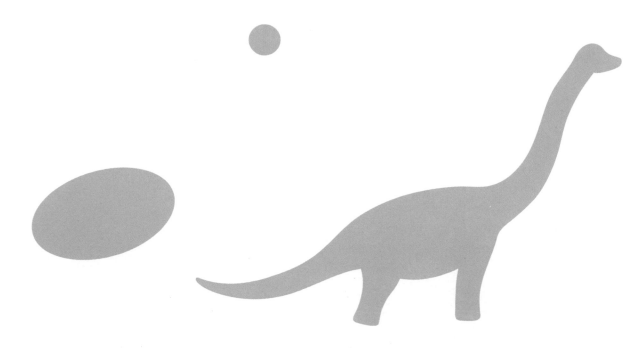

Start with an oval and a circle high above that.
Add a curved tail, an S-shaped neck, and rectangular legs.

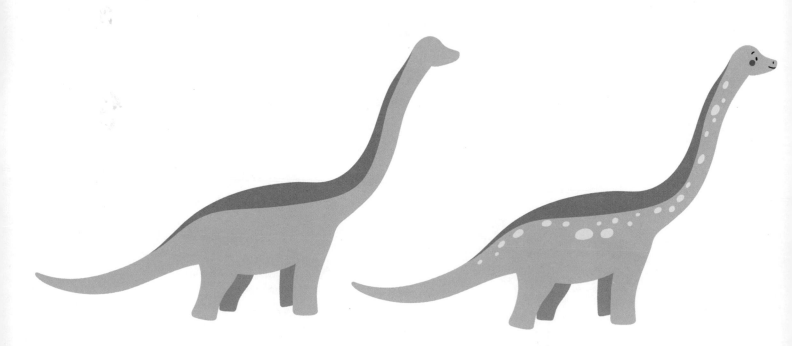

Paint two more rectangular legs and darken the back.
Add ovals for spots along the neck and body!

stegosaurus

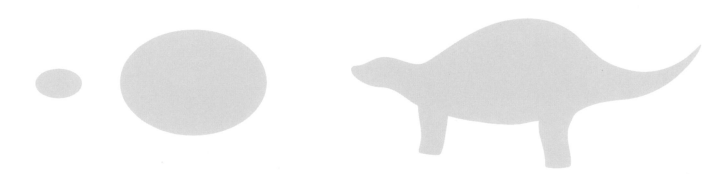

This dinosaur has a small head, a round body, rectangular legs, and a pointed tail.

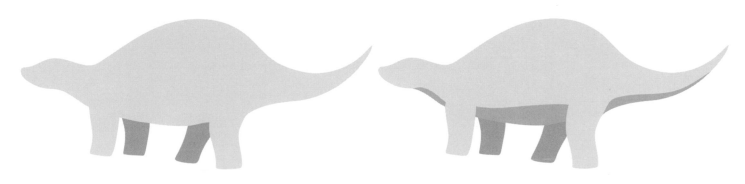

Add two more rectangular legs and paint the underbelly.

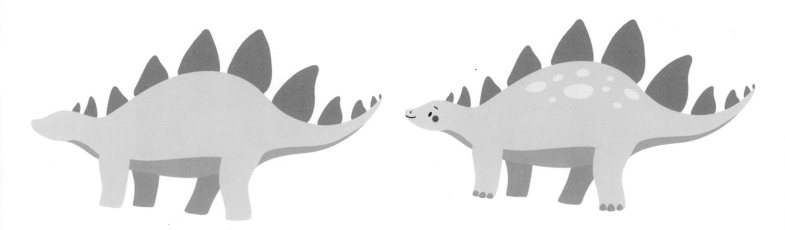

Now add the triangular body plates along its spine, dots on its feet, and oval spots on its back!

diplodocus

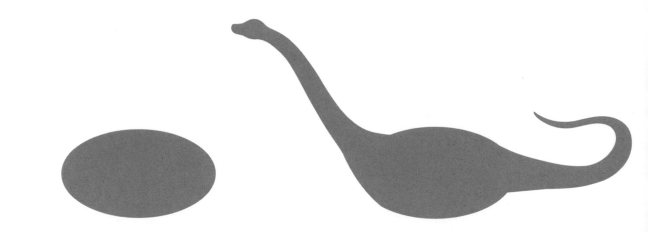

Start with a small circle for the head and an oval for the body.
Then add a long, skinny neck and a tail that looks like a whip!

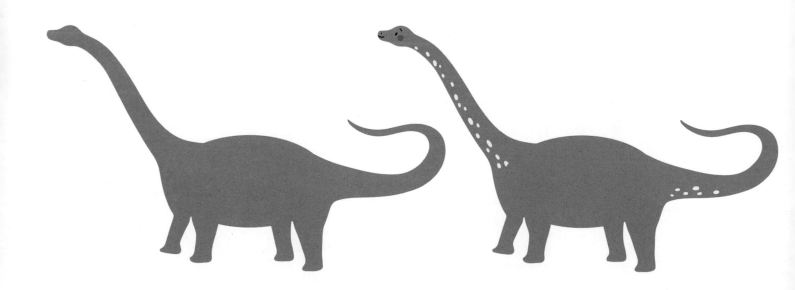

Use rectangles for the legs. Paint white ovals for spots, and finish with the face!

anklyosaurus

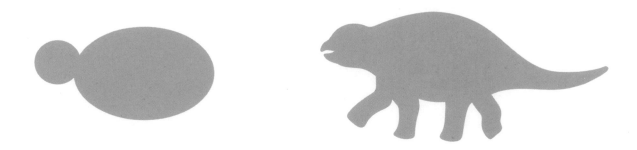

Start with a circle next to an oval for the head and body. Add a small beak, tail, and rectangular legs.

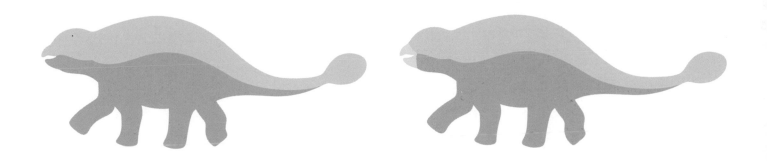

Lighten the top of the dinosaur, and add an oval to the end of the tail.

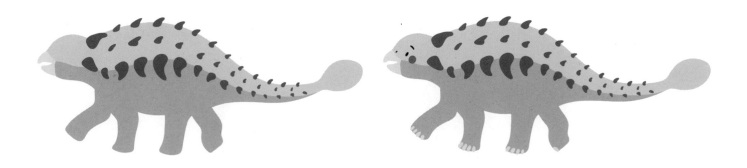

The rows of spikes down the back are made up of curved triangles. Use dots on the feet!

hatchling

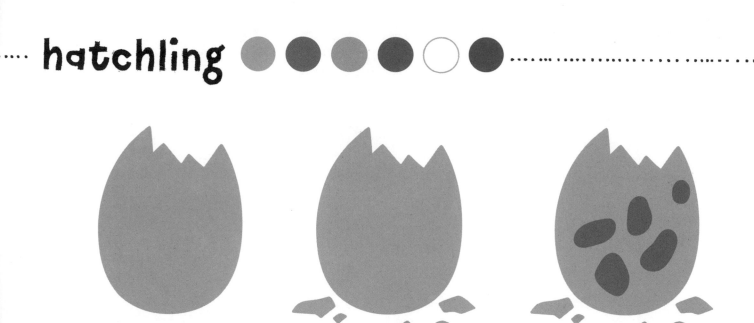

Paint an oval with a jagged top and add sharp pieces of shell on the ground.
The dark spots on the egg are shaped like jelly beans!

volcano

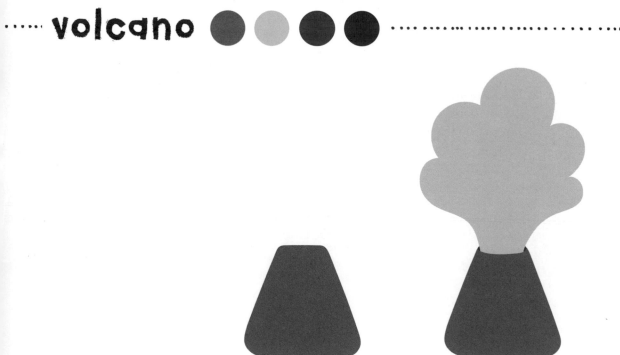

The volcano's shape is a triangle with a missing top. Use wavy lines for the cloud of volcanic gas!

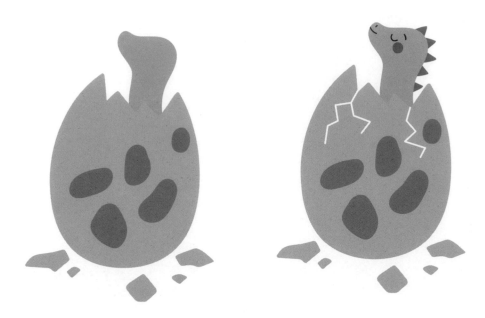

This baby dino has a rounded nose and triangular spikes.
Add thin white zigzags on the shell for cracks!

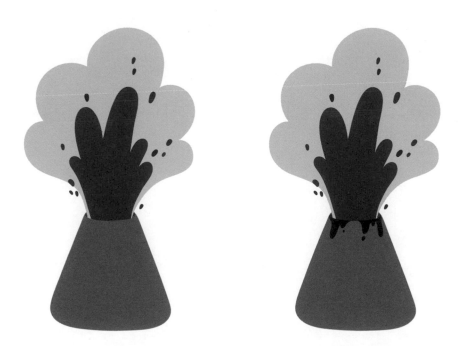

Paint lava spouting out of the top. To make it look like an explosion, splatter some paint!

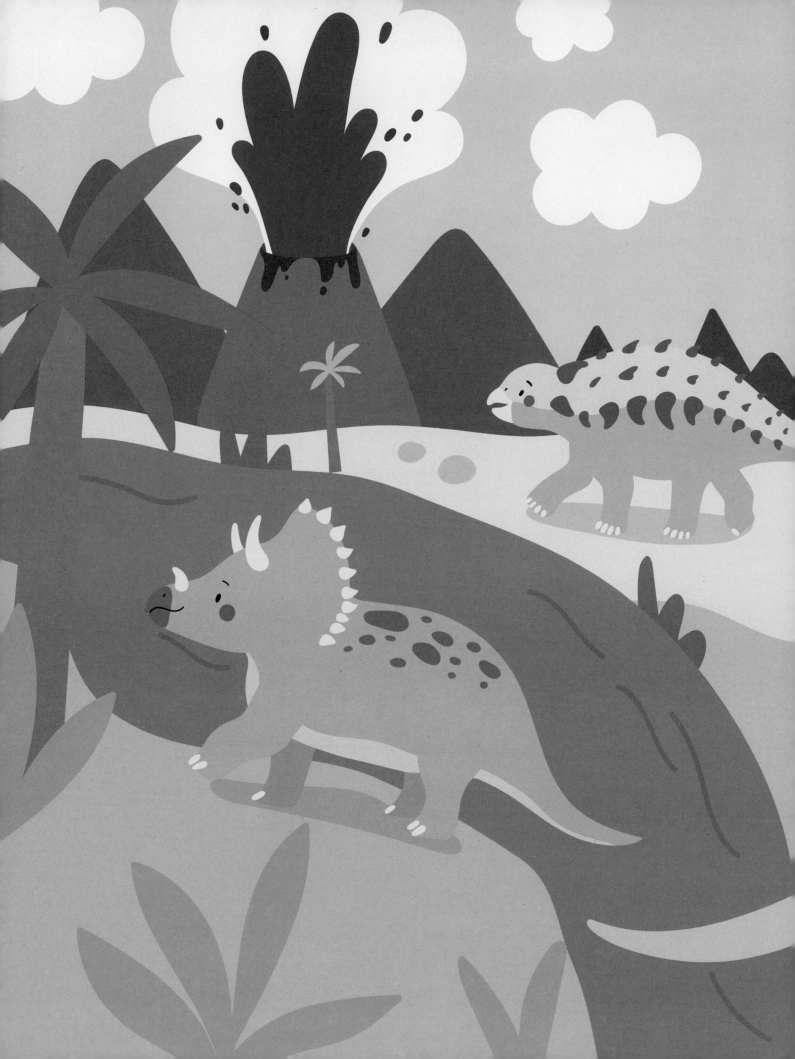

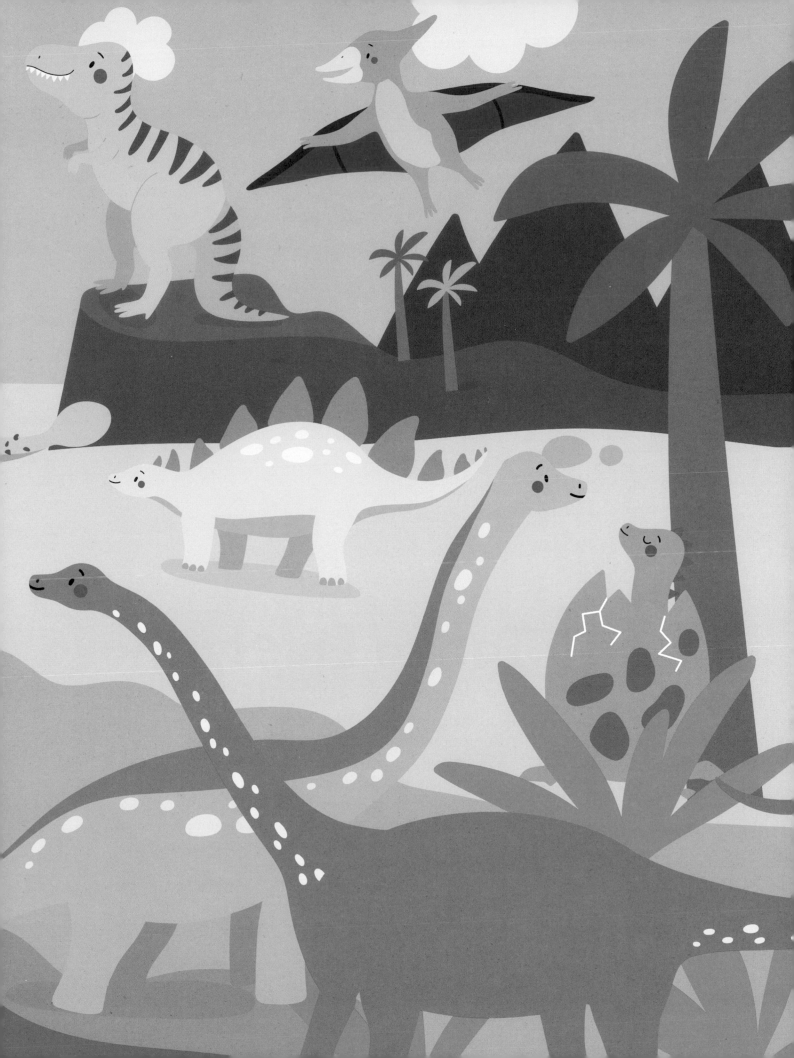

Brimming with creative inspiration, how-to projects, and useful information to enrich your everyday life, Quarto Knows is a favorite destination for those pursuing their interests and passions. Visit our site and dig deeper with our books into your area of interest: Quarto Creates, Quarto Cooks, Quarto Homes, Quarto Lives, Quarto Drives, Quarto Explores, Quarto Gifts, or Quarto Kids.

© 2019 Quarto Publishing Group USA Inc.

Artwork © Tanya Emelyanova, except cover fingerprint art, pages 14-15 (birds), 18-19 (paint swatches and strokes), 25 (astronaut doodle), and pages 26-41 © Shutterstock; page 9 (flowers) © Lisa Martin and Damien Barlow; pages 14-15 (watercolor and acrylic techniques) © Elizabeth Gilbert.

First published in 2019 by Walter Foster Jr., an imprint of The Quarto Group.
26391 Crown Valley Parkway, Suite 220, Mission Viejo, CA 92691, USA.
T (949) 380-7510 **F** (949) 380-7575 **www.QuartoKnows.com**

Walter Foster Jr. titles are also available at discount for retail, wholesale, promotional, and bulk purchase. For details, contact the Special Sales Manager by email at specialsales@quarto.com or by mail at The Quarto Group, Attn: Special Sales Manager, 100 Cummings Center, Suite 265D, Beverly, MA 01915, USA.

ISBN: 978-1-63322-710-1

Printed in China
10 9 8 7 6 5 4 3 2 1

About Tanya Emelyanova

Tanya Emelyanova was born in Siberia. After graduating with a degree in advertising she had been working in branding and advertising for a few years before she decided to embark on illustration and pattern designer career, because drawing and creating always was her true passion. She is combining digital and analog materials in her work to create cute and fun illustrations. Now Tanya lives in Saint Petersburg with her husband and a big gray cat.

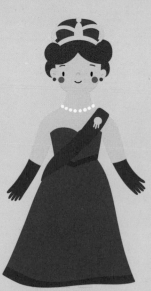